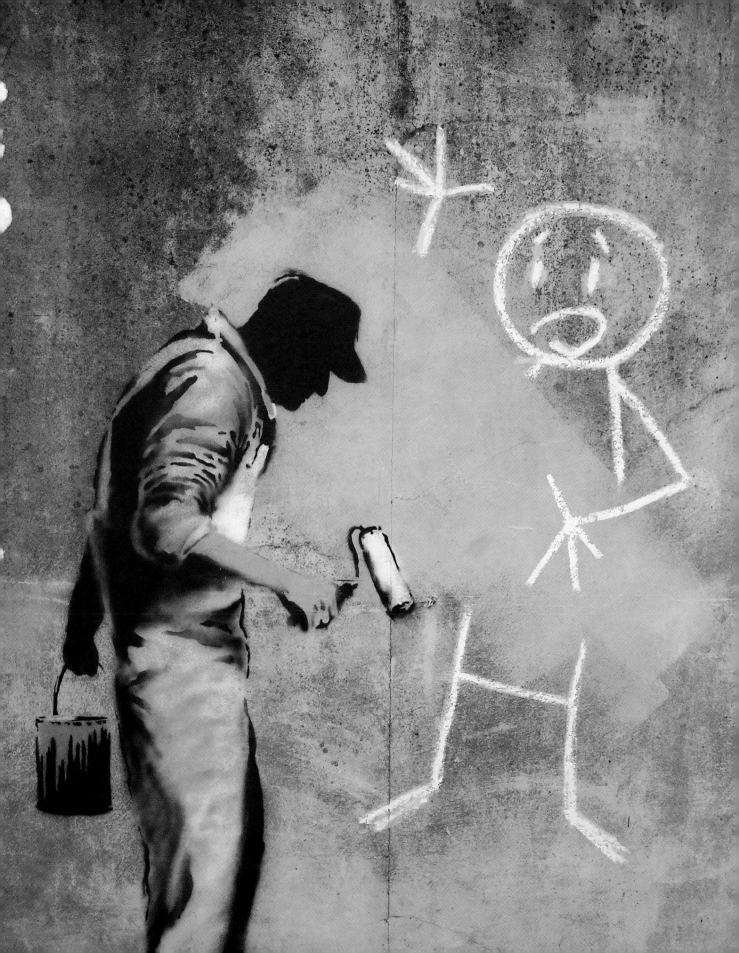

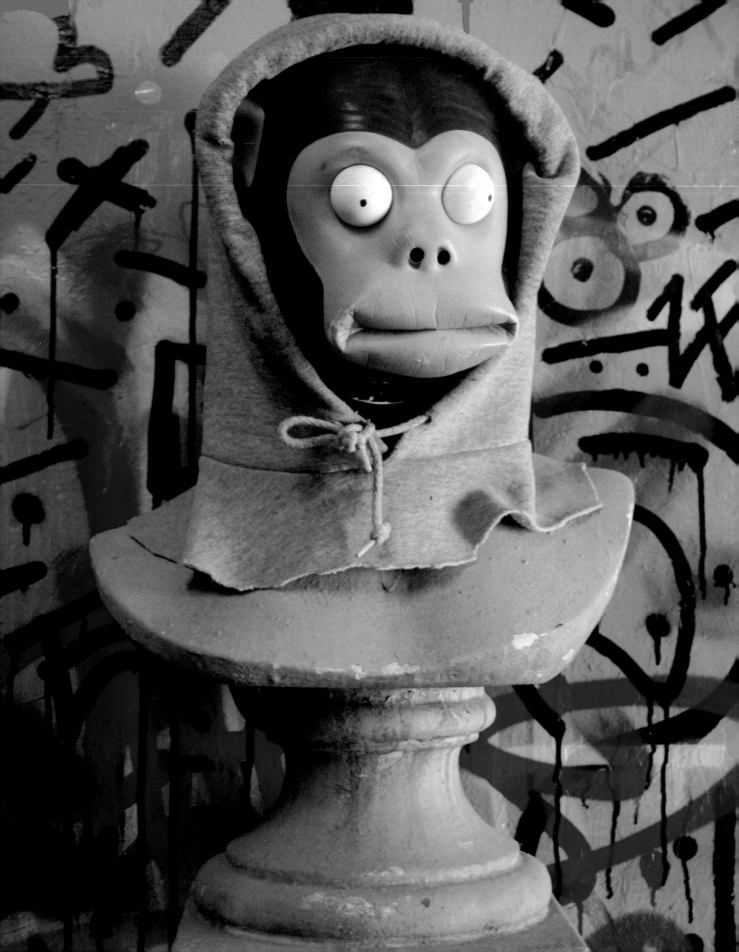

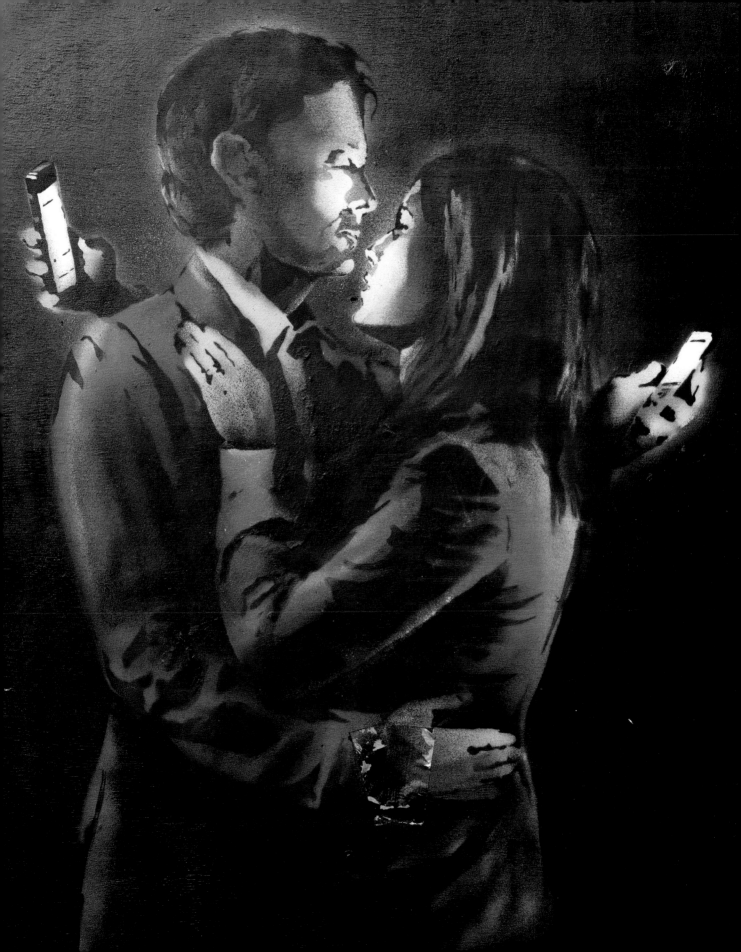

Why all the other books about Banksy are s*.**

They. are. boring.

Trust me. I haven't read them. But you can tell just by looking at them.

They done all this research and s*** and hung out with Banksy, sucking up to him and stuff and it's all b*******. So if you only buy one book that cashes in on Banksy, buy this one, and steal the others. But if you do collect them all, you're going to look like a right fanboy. So best off just buying this one really.

<div align="right">CarpetBombingCulture 2012</div>

A catalogue record for this book is available from the British Library.

ISBN. 978-1-908211-78-1

2020:13

First published in Great Britain in 2012 under the imprint of Carpet Bombing Culture

Email: books@carpetbombingculture.co.uk

© Pro-Actif Communications

Compiled and Edited by: Gary Shove

Words by: Patrick Potter

Design by: Lee Crutchley

Printed on natural recyclable products (ie paper).

CARPET BOMBING CULTURE

www.carpetbombingculture.co.uk

QUEUE HERE TO SAY BOOKS ABOUT BANKSY AREN'T AS GOOD AS THEY USED TO BE.

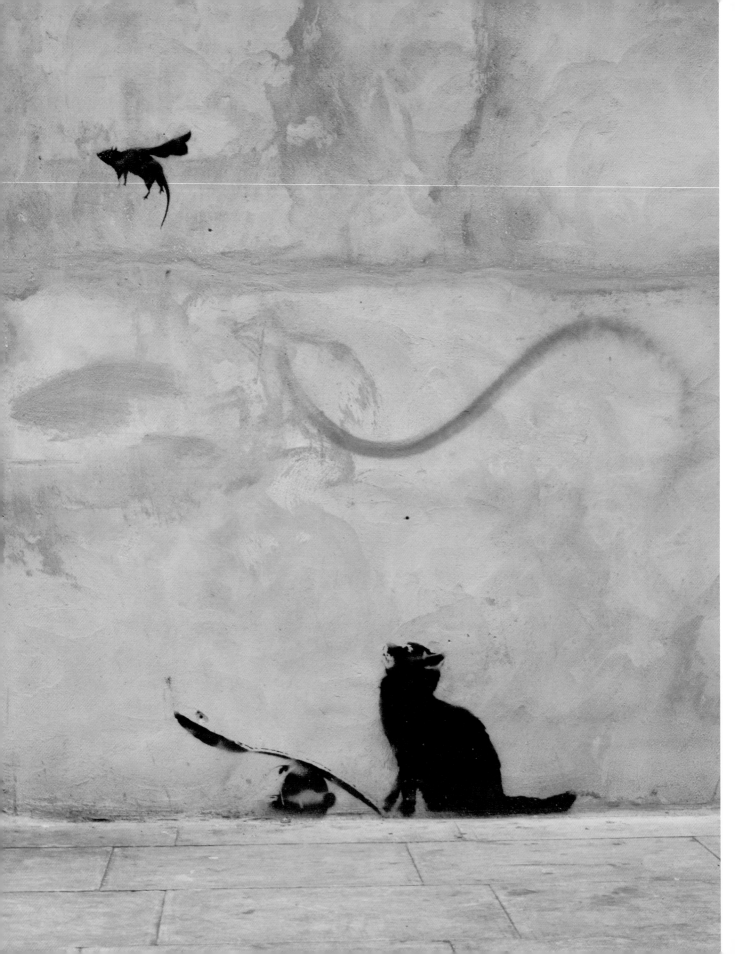

DISS-CLAIMER

When Carpet Bombing Culture approached me to write this book I tried to hide. They found me with a pack of hunting ferrets holed up in a Bedouin village in the Moroccan mountains, earning a crust by dancing for the menfolk by firelight. They drugged me and I woke up in London several days later. Write a book about a man who may or may not exist, about whom nothing is really known for certain, filled with pictures of art that may or may not even be his? Surely the research budget must be immense? I cried. They slapped me in the mouth. 'We must strike now while the corpse is still warm!', they snarled. 'We go to print in three days.' The copy was written on the back of a stack of Di Faced Tenners in a cellar in Shoreditch. The ink was my tears. I distinctly remember setting fire to a little boat and setting it adrift in an old rusted bath full of tramp's piss, a symbolic gesture, a farewell to any hope of ever being taken seriously as a writer. The devil take the past! I am now defiled. As are you for wanting to be a part of this charade in the first place. As ever, Carpet Bombing Culture brings you a tissue of lies, half lies and three quarter lies to satisfy your naive and monstrous hunger for meaning*. Go. 'Enjoy'.

*That goes for the pretty pictures too. If you're reading and we've included an image by some third division chancer and miss-attributed it, give us a shout. Simply ring our Customer Services Hotline Number 0800-Banksymyarse (press option 3) and put us right.

*LEGAL DISCLAIMER: If you are a law enforcement official, work for the government or if your sole purpose for reading this tome is to use the content or the opinions expressed within, against the artist featured or compilers themselves in any way, then you must put down the book immediately without reading any further.

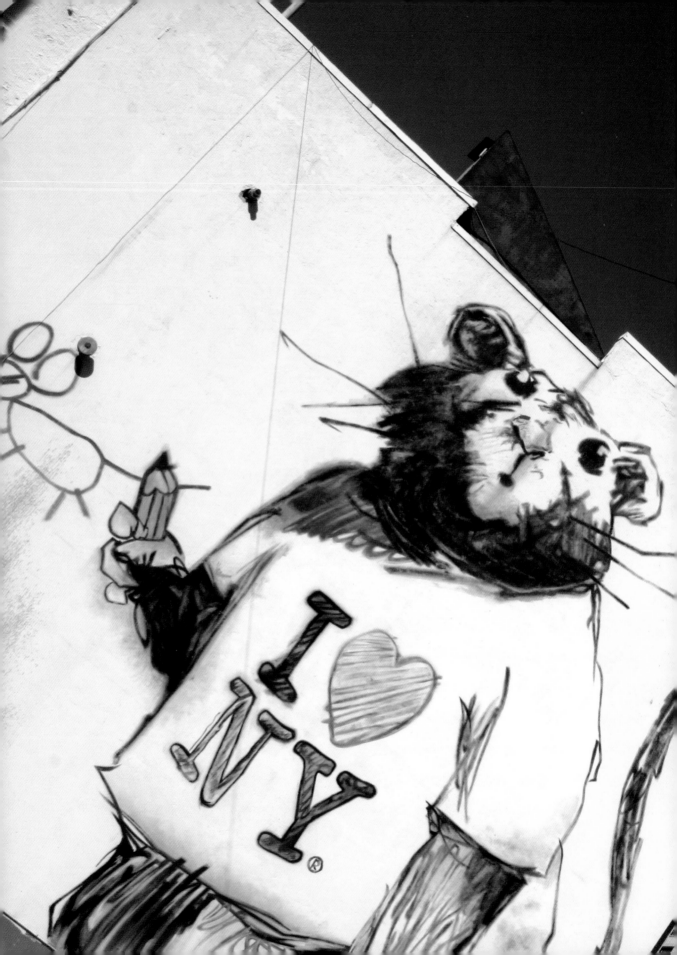

IF YOU CANNOT WIN, KNOCK OVER THE TABLE.

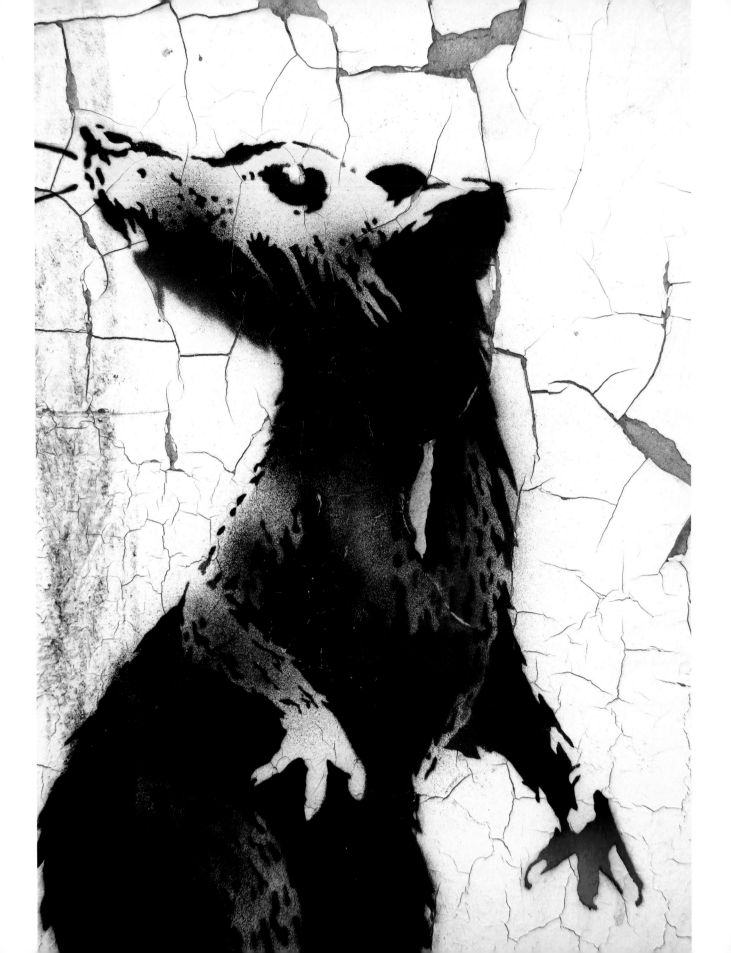

YOU ARE AN ACCEPTABLE LEVEL OF THREAT

(If you were not, you would know about it)

Graffiti is a form of guerilla warfare. It is a way of snatching power, territory and glory from a bigger and better equipped enemy. Banksy once characterised it as 'revenge'. But revenge against who and for what? In the early 1990s we witnessed the rise to power of a political class based on spin and big smiles. Tony Blair declared the class war over. The idea that all you needed to succeed was a positive attitude took hold in the UK as corporate culture grew more and more dominant. Meanwhile the trains were sold off to make millions for a cabal of financiers, largely at the tax payers' expense.

"Just doing a tag is about retribution. If you don't own a train company then you go and paint on one instead."
Banksy, Simon Hattenstone Interview, the Guardian 2003

Throughout this period Banksy remained steadfast in pointing out that this 'Cool Britannia' thing was all shit. He was the little boy who said that the emperor isn't wearing any clothes. His campaign was massive and sustained like a well planned military action. He seemed to be everywhere you looked.

He reminded us all that we are the rats. In the sense of being an underclass he was right, social mobility dropped throughout the New Labour years. The gap between the 'haves' and the 'have-nots' rapidly increased. The state surrendered control over capital at the same time as it increased control over civil society under the guise of anti-terror laws. New Labour dismantled civil liberties as enthusiastically as it screwed up the welfare state. But Banksy's rats celebrated a tough survival instinct too. He made them inventive and cunning - qualities you need in the ruthless culture of today. Not only did Banksy's street work remind you that power does exist and it works against you, but also that power is not terribly efficient. It can be and should be deceived.

Banksy is a thinking street artist.

If he were not would he paint something like this...

"There are crimes that become innocent and even glorious through their splendour, number and excess."

And that is the grand parody in all of Banksy's work. Through repetition and scale, any voice can become powerful. Which just goes to show how flimsy the basis of power really is. We are all vulnerable to this cacophony of noise we hear, this nightmarish choir of ideas directed at us through advertising and mass media. It's inevitable that it hypnotises and confuses us. Great street art reveals that process and makes it laughable. It shows how so much of power is just theatre, using a certain symbol, design or way of communicating. By laughing at the spectacle we undermine its power and make room for a bit of original thought.

But just a bit of room mind. No more than an acceptable level of threat.

DEAR BANKSY,

ALRIGHT, I NEVER BOTHERED EVEN TRYING TO TRACK YOU DOWN. I'M SORRY. I SUPPOSE I SHOULD HAVE ASKED SOME PEOPLE ABOUT YOU. I JUST THOUGHT IT'D BE EASIER TO MAKE IT ALL UP. THEN AT LEAST I WOULD KNOW HOW MUCH WAS TRUE. I DO LOVE YOU, AND HATE YOU AND FEEL INDIFFERENT TOWARDS YOU. IN FACT, I'M WATCHING YOU RIGHT NOW. I'M IN THE PHONE BOX. JUST OVER THE ROAD.

I GUESS THAT IN SPITE OF ALL THE NOISE ABOUT YOU, I FEEL LIKE I'VE GROWN UP IN THE SAME BRITAIN YOU HAVE, AND WATCHED IT GET UGLIER AND GREEDIER AND MORE VICIOUS BY THE YEAR. SO BY THE LAW OF INVERSE PROPORTIONS, IN A FUCKED UP SITUATION, PEOPLE BEING POSITIVE JUST PISS ME OFF, AND PEOPLE HAVING THE COURAGE TO BE NEGATIVE, CHEER ME RIGHT UP. THAT'S WHY I'VE STILL GOT TIME FOR YOU. EVEN THOUGH I PROBABLY SHOULD GET BORED AND WANDER OFF, I STILL GET A KICK OUT OF THE LATEST BIT OF VANDALISM. LIKE MOST STREET ART GEEKS, I'VE GOT YOU ON GOOGLE ALERTS.

SO I GUESS, THANKS

LOVE,

JOE PUBLIC

PS. ISN'T IT ABOUT TIME YOU MOVED TO LA?

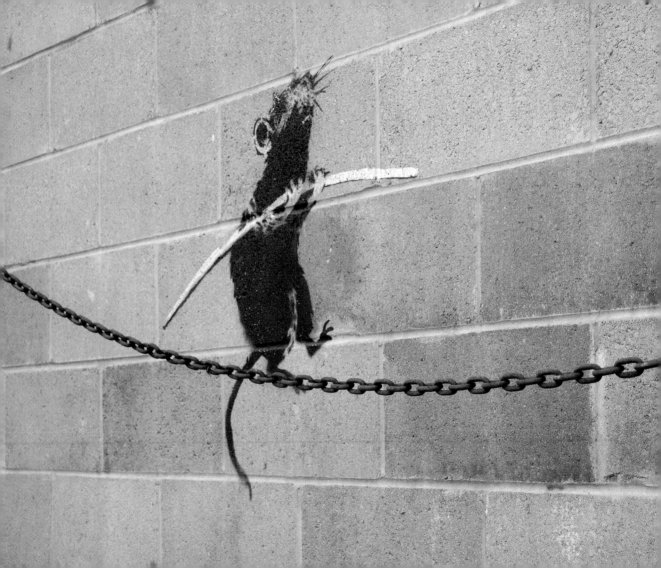

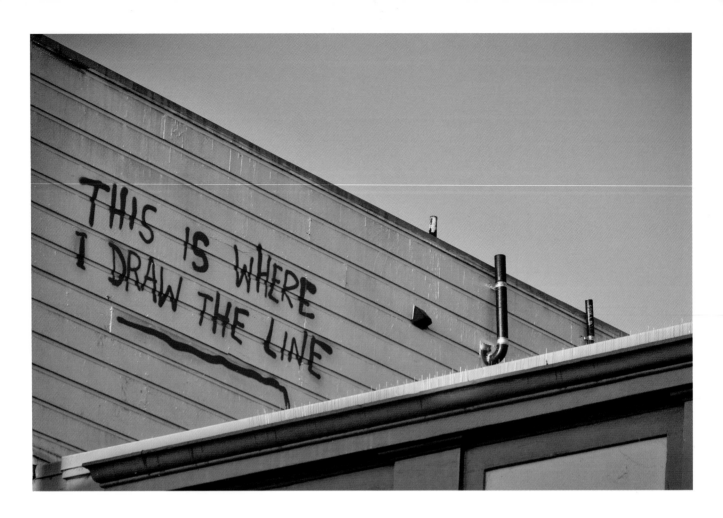

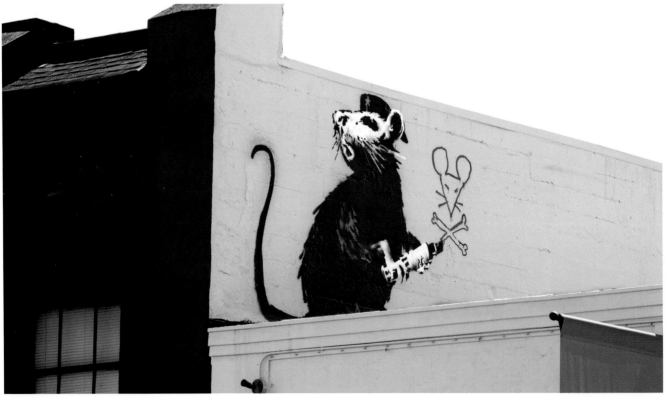

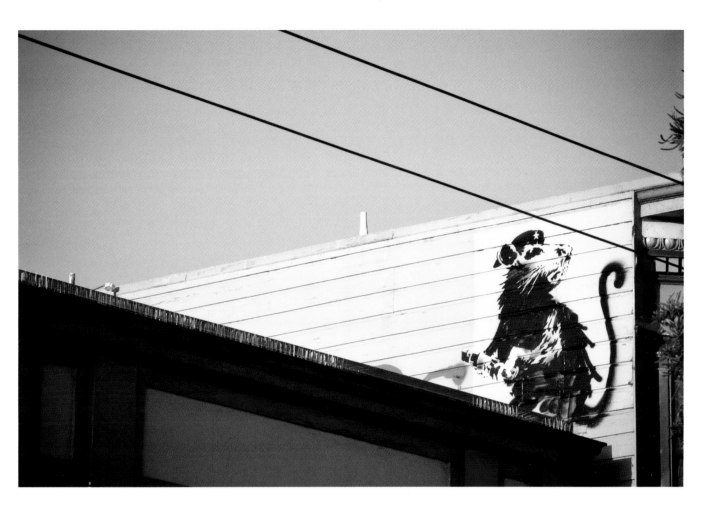

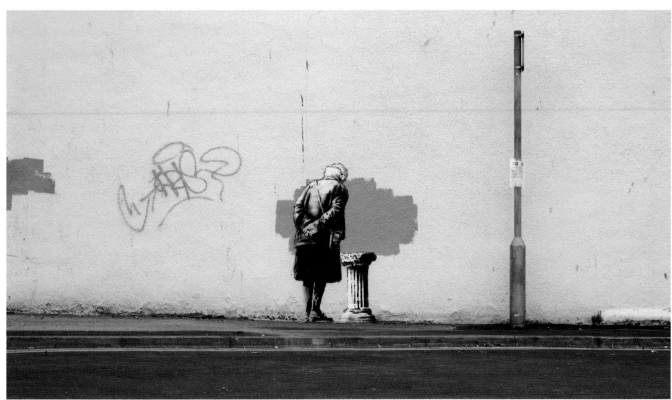

BANKSY BASICS

(The Beginners Guide)

It is possible that you have just arrived in the UK having fled your war torn fatherland in sub-saharan Africa, having sold everything you own, to risk almost certain death at the hands of the immigration mafias that transported you, gaffer taped to the underside of a haulage truck, through weeks of torturous conditions to deposit you in old London town.

Now, having almost successfully completed your asylum application, you find yourself faced with one more hoop to jump through, the dreaded - 'Life in the UK Citizenship Test'.

So you may have correctly guessed that there are several questions about 'Banksy' in the 'Life in the UK Citizenship Test'* and you have come here to find out who, or indeed what, 'Banksy' is.

If this is you then congratulations. You've nailed English pretty damn quick. We all studied French for five years and we can't speak a bloody word.

*This is a 'Joke' - a classic piece of British, 'Piss Taking'

Banksy is an anonymous street artist from Bristol who rose to international fame between the late 1990s and the present day chiefly by illegally spray painting stencil designs across the major cities of the UK and North America. The culture of graffiti is ancient but its most recent form was inspired by the explosion of hip-hop culture in the late 1980s in the USA which at that time began to inspire young people in Bristol, including a young Banksy.

Bristol in the 1990s was a hugely important scene in UK youth culture, generating a truly unique, British flavoured response to hip-hop influences in music and art. It was also, and continues to be, a city with a radical left wing community. All these factors no doubt inspired Banksy who was linked with 3D from Massive Attack among others.

The 1990s also saw 'Rave' culture (and New Age Travellers) criminalised by the 'Criminal Justice Act', an act which spawned a protest movement

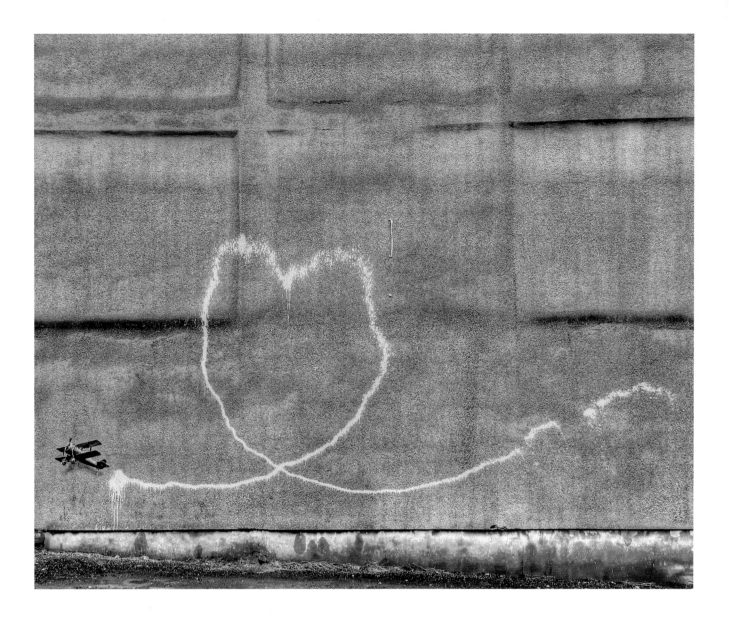

that politicised many, including Banksy, who would also have remembered the Poll Tax Riots and the Hartcliffe riots in Bristol, both events he later cited as influences on his political ideas.

Like the big players in the USA, Banksy and his crew started out spray painting nick names and occasionally characters, freehand. Banksy, later in the 1990s, gave up on freehand painting, for the most part, and started using stencils for the majority of his work. Banksy himself cited the increasingly rapid police response times making detailed free hand work impossible.

Banksy painted an image of a classic, wildstyle piece of graffiti apparently dying in a hospital bed for the Walls on Fire event in 1998. Was this a statement of intent? Whatever the reasons for the switch to stencils, Banksy's style consolidated with the move into something instantly recognisable and consistently effective in its ability to communicate an angry, yet funny view of modern life, using animals, particularly monkeys

and rats to parody and draw attention to the general 'fucked upedness' of our culture.

Banksy left Bristol to hit London hard in 1999 with a campaign of stencils in the capital that gained him rapid notoriety. At this stage many cultural commentators like to believe that Banksy was executing some sort of masterful five year marketing plan laughing evilly to himself all the while knowing that he was soon to become a millionaire by pedalling ideas he didn't really believe in.

Ignoring for a moment the difficulty of consistently faking a political stance for over a decade while being, we can only imagine, pretty damn skint, the idea that anyone at that time could have predicted that spending night after night doing graffiti and running away from coppers was a sure road to financial paradise is simple lunacy. It would take six years from this point for him to reach the kind of headline grabbing auction prices that would break him into mainstream fame. That's six years of being a full grown man

with no discernible career running around in the city at night, disappointing his mother in awkward and infrequent phone calls. Nobody could have predicted his success, let alone him. End of story.

In the years that preceded that famous LA Exhibition in 2006 in which Angelina Jolie paid a small fortune for three pieces and Banksy sealed his fate as the most famous street artist in the world, Banksy was extraordinarily prolific. Apart from the street work it was the stunts that really propelled him to fame. Breaking into Barcelona Zoo, releasing his own version of Paris Hilton's CD, placing an inflatable Guantanamo prisoner in Disneyland and tagging 'Mind the Crap' on the steps to the Tate Gallery, and infiltrating several major museums to put up his own work all served to attract media attention. But they were headlines that put a smile on your face and made you think. He was making street art into something else, a kind of performance art - very much mimicking the way major Brands work in order to attack established values.

Banksy didn't so much knock on the closed doors of the art world. He kicked them down.

The bizarre final act was the acceptance of Banksy into the fine art market when in 2007 the auction house 'Sotheby's' sold one of his pieces. Then,

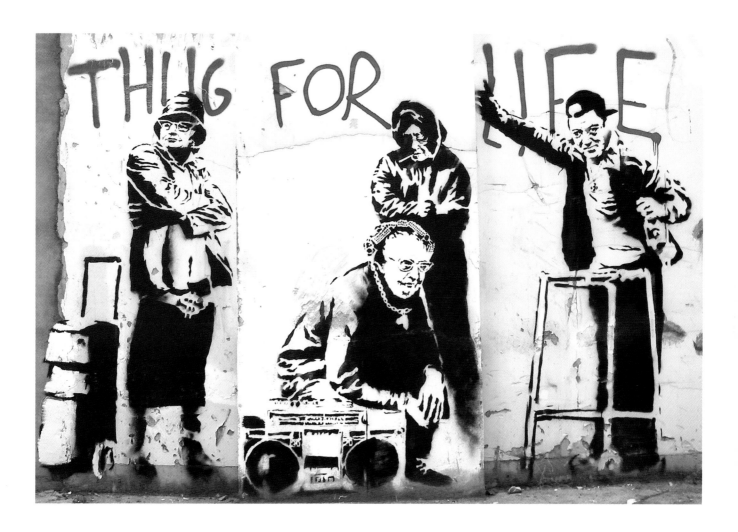

with staggering 20/20 hindsight everybody claimed that this is what Banksy was aiming for all along. Banksy himself was gob smacked, responding incredulously with 'I can't believe you idiots buy this shit'.

Camp Banksy came to terms with its new found capacity to literally print money and began to use the power for subversion. Apart from various charity works in his own provocative style, a movie it seemed was inevitable. 'Exit Through the Gift Shop' was a disorienting hall of mirrors, fun to watch but ultimately leaving you with the feeling you'd been conned but you still weren't sure exactly how. The one thing you can be sure of is that it is taking the piss out of the super cool hipster art market just as viciously as

'Mind the Crap' attacked the super educated, hedge fund 'fine art' market.

All this anti-art sentiment comes off as negative, unless you look at it in context. Banksy sees himself as the liberator, the knight errant kicking the pricks to remind you that your ideas about art are just as valid as anybody else's. He attacks the establishment to remind you of your own power, not just for the sake of it. The point is, art should be truly democratic, truly a part of everybody's life and not just another gang bang for the over privileged.

That's the message.

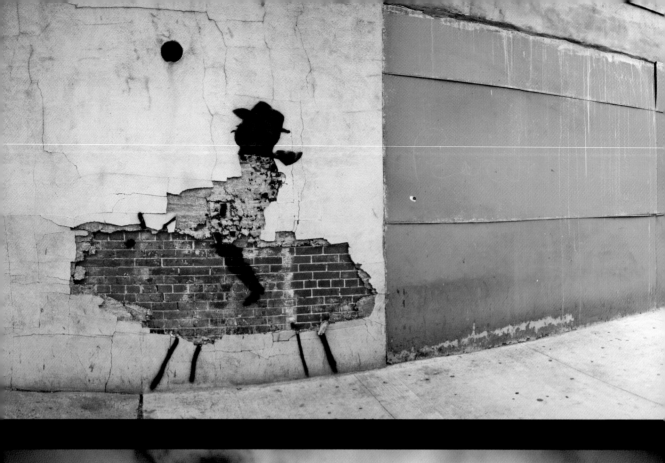
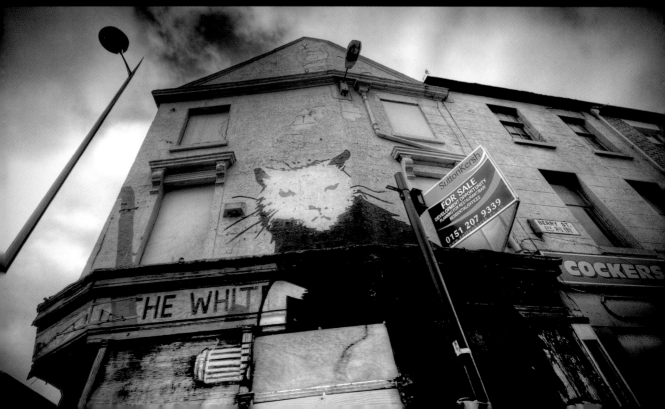

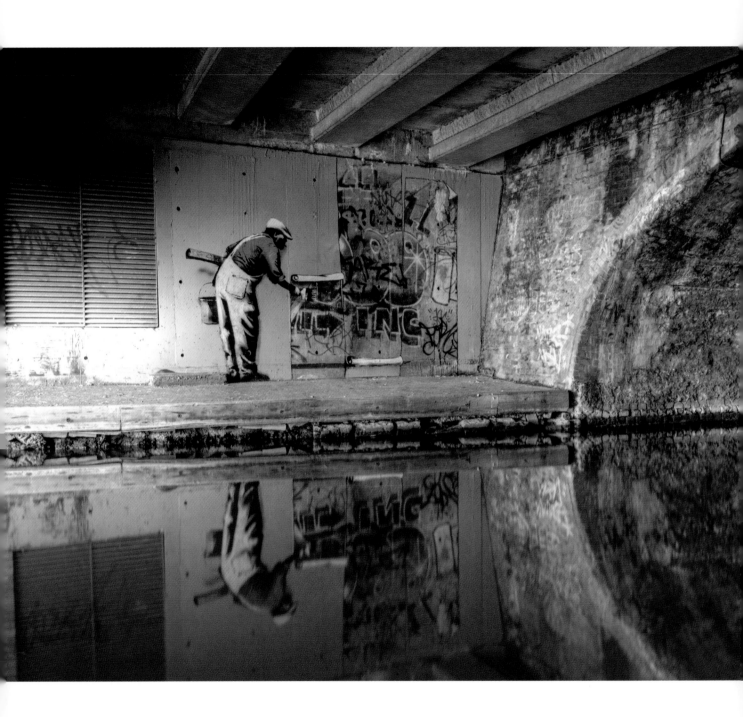

TO BUFF OR NOT TO BUFF?

(That Is The Question)

It must be hard. You're a town councillor. You licked enough arse and talked enough bollocks for long enough to get a 'cushtie' little job down the Town Hall. Great holidays. Great perks. Park anywhere you like. One morning you get a phone call, you drop your Krispy Kreme into your Starbuck's and spit gooey crumbs all over your ancient keyboard.

"A what!? A Banksy!?"

Then the Sword of Damocles is hanging over your head.

To Buff or not to Buff? Well first - are you in Bristol? Because if the answer is yes - then hold off the man with the bucket and brush, because the city wants to preserve the work of its most famous citizen, well, at least since Stephen Barker (Mac Daddy of the 17th Century Bristolian slave trade.)

What about Islington? Surely this is a trendy enough borough to start building perspex boxes around A-Lister vandalism? No. Wrong. Buff it.

Even Hackney council has been known to buff. Although they promise to ask building owners first, much like a conscientious street artist would.

In the USA? Shoot first, paint it grey later. That's right. Grey.

NB: 'Buff' is also Bristolian slang for 'Sexy'. E.G. 'Owrlight moy lover? Yor lookin buff t'day'

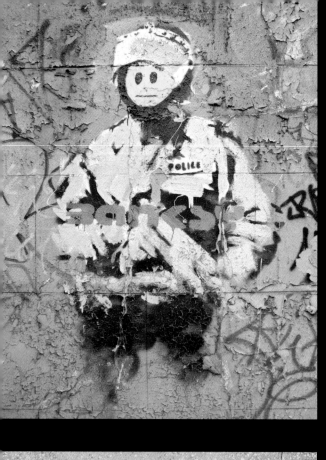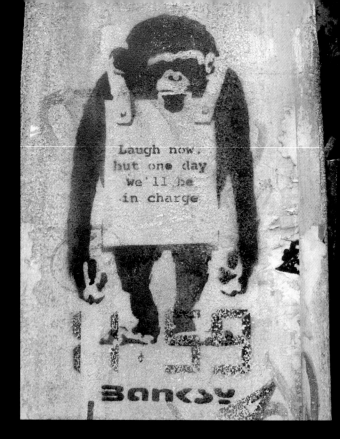

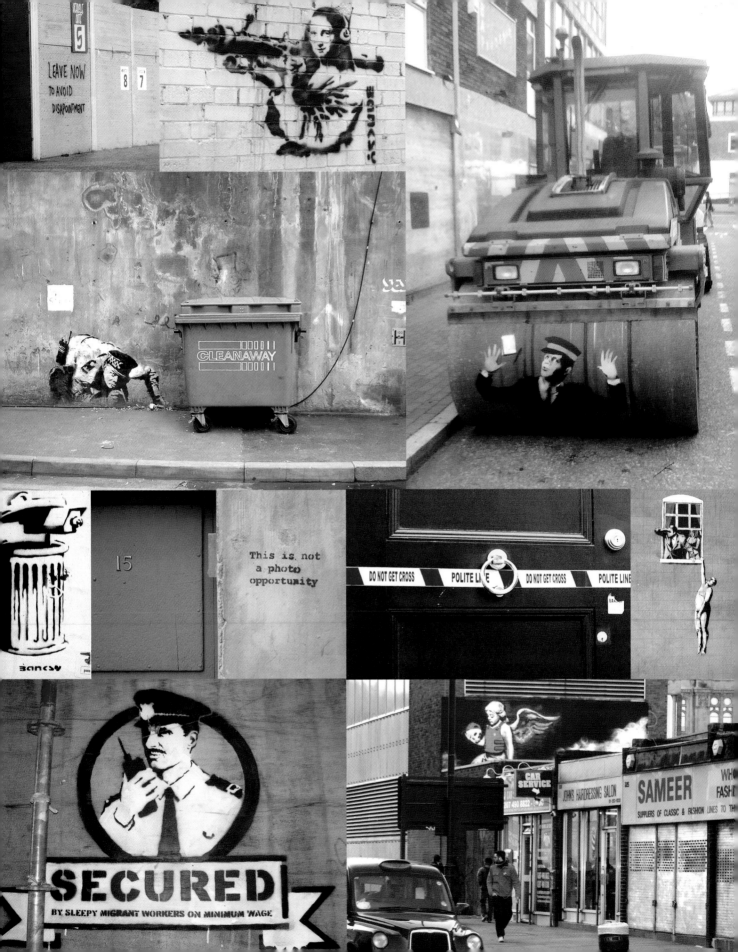

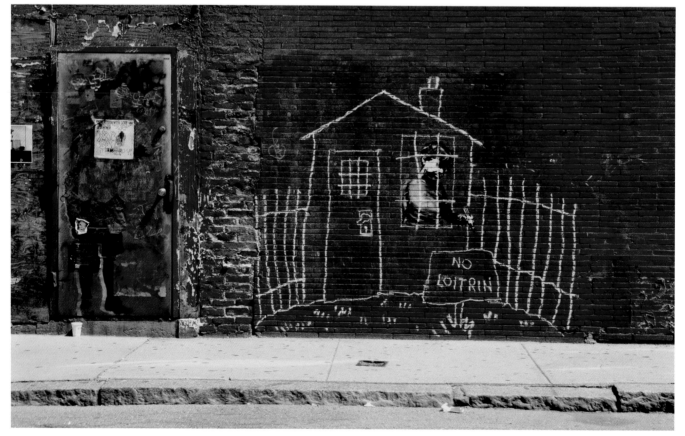

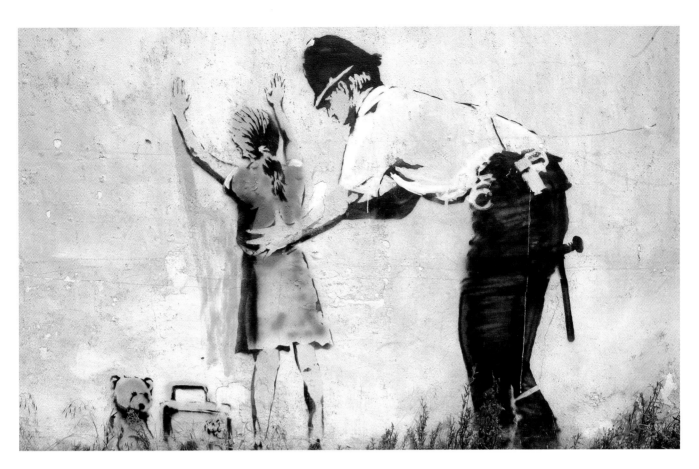

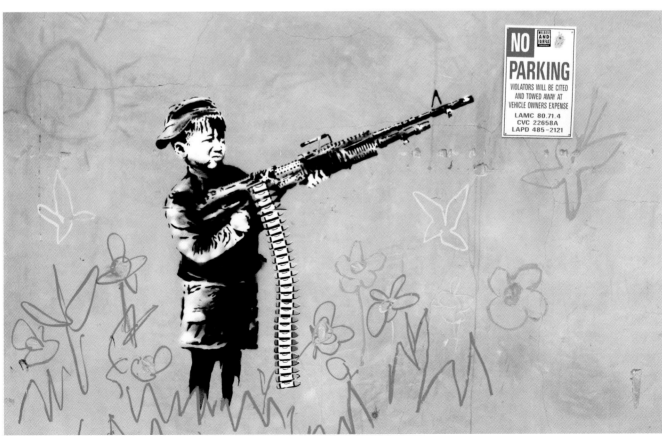

NO PARKING
VIOLATORS WILL BE CITED
AND TOWED AWAY AT
VEHICLE OWNERS EXPENSE
LAMC 80.71.4
CVC 22658A
LAPD 485-2121

THE POWER OF DENIAL

"Never underestimate the power of denial."

(AKA - Why we don't want to know.)

In the apocryphal gospel of Bristol, discovered written on silver Rizla in hash oils, during a raid on a squat in Stokes Croft, Banksy's disciples were asked by the Romans - 'Did you know him?' And his disciples said no. The Romans asked again, 'Are you sure?' And again Banksy's disciples responded - 'Yes, never met the guy'. Then finally they asked one more time, 'And this Banksy character, did you knock about together?' And again the disciples said, 'Never mate, didn't happen.' Then the cock crowed and they fell to their knees and wept for they understood they had betrayed him.

To this day this is why everybody from Bristol will always say yes, if you ask them if they know Banksy.

Even when it is bullshit.

Saying that you know who Banksy is and then refusing to say, gives you instant mystique.

We know who Banksy is, and we're not saying.* ;-)

Unfortunately the staff at Britain's finest newspaper, the Daily Mail, didn't quite get this important element of the Banksy myth/game/religion and thought that trying really hard to find out who he is and not really succeeding then trumpeting a few bits of circumstantial evidence would give them mystique. The ploy failed. Although the paragon of the modern newspaper*, the DM has less mystique than a pile of audition tapes for Big Brother.

*ahem.

But wait! Maybe they are right about R**** G**********?

No they are not.

They are not because we refuse to believe it. This is the power of denial. It has served humanity for centuries. Our myths are far more important to us than some twat with a real life. We don't want to find out that Robin Hood was a mere fantasy cooked up by bored french courtiers any more than we want to discover the bedroom secrets of Simon Cowell.

Banksy will live forever with Jack the Ripper and the Man in the Iron Mask in a beach hut down by the Ipanema Bay of the collective imagination. And that is as it should be. Even if he came forth tomorrow and revealed herself. We still wouldn't have it.

Will the real Banksy please not stand up?

Many thanks.

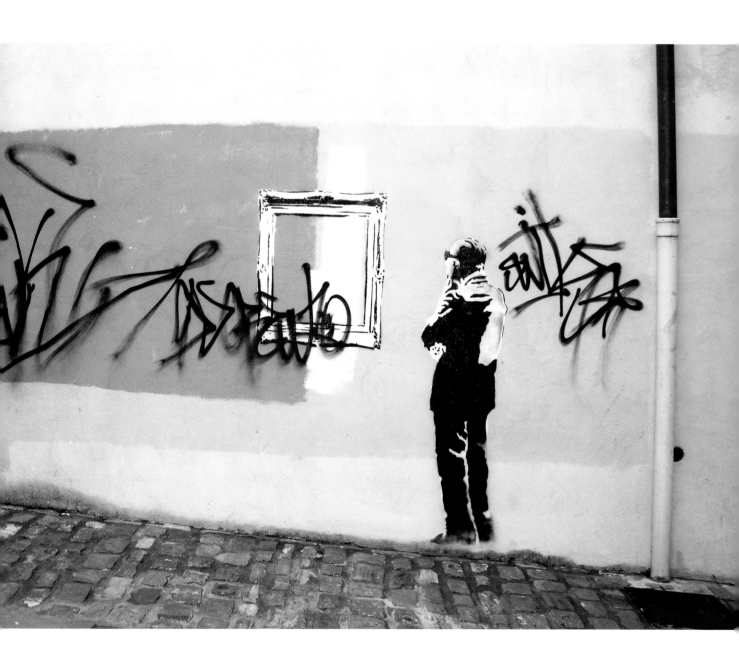

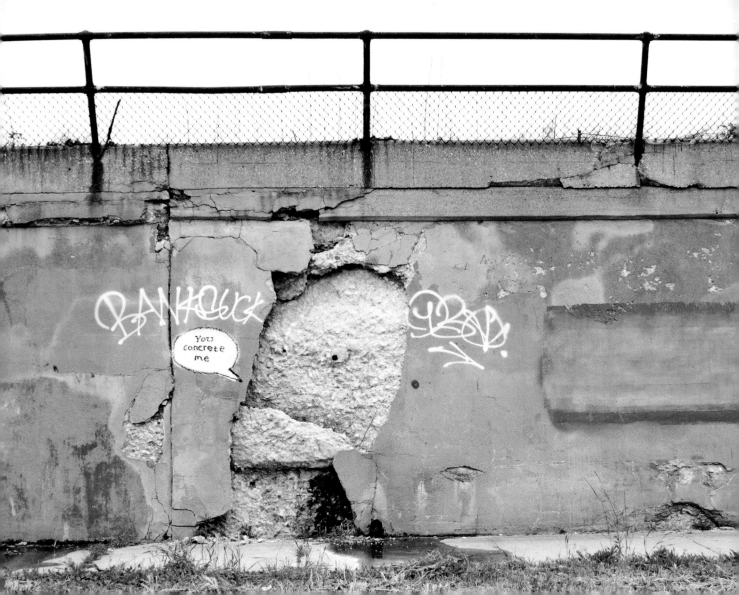

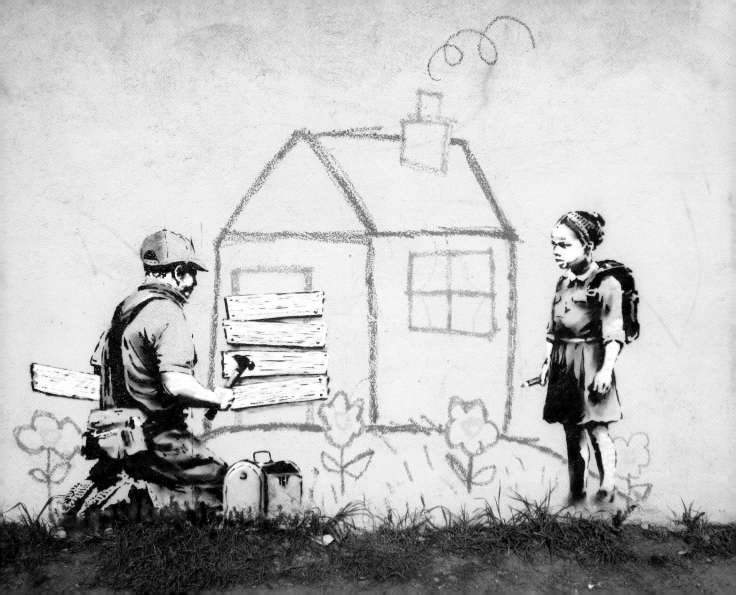

VANDAL INCORPORATED

(Spreading the Gospel)

What does Banksy have in common with Fatboy Slim, Krishnan Guru Murphy and Crawley Town FC?

The answer is: Jo Brooks' Public Relations Firm.

If you want to rent this question for your pub quiz or local radio competition please forward 10 bitcoins to Carpet Bombing Culture with the message BANKSY GEEK.

Surely this is madness! What self respecting outlaw would use a PR firm? Well, as we went to press, Swoon is also on the books, as is the website 'Pictures on Walls' and the art agency 'Black Rat Projects' who represent some of the cream of the scene including D*Face and Roa.

We would love to know exactly what kind of work Jo Brooks does for Banksy. How do you do reputation management for someone who makes a career out of breaking the law?

Jo Brooks is of course based in Brighton, a city so cool people shit twenty bags of organic sinsemilla and tattoo comedy moustaches onto their fingers.

It's also a city brimming with radical lefties, trying to negotiate some sort of existence in between their ideals and their desires for unfettered access to the latest Apple products.

Like Banksy, the problem for people who dream of a better world, is that they have to live in this one. John Lydon saw the joke in that, saying when the Sex Pistols split up…

"Ever get the feeling you've been cheated?"

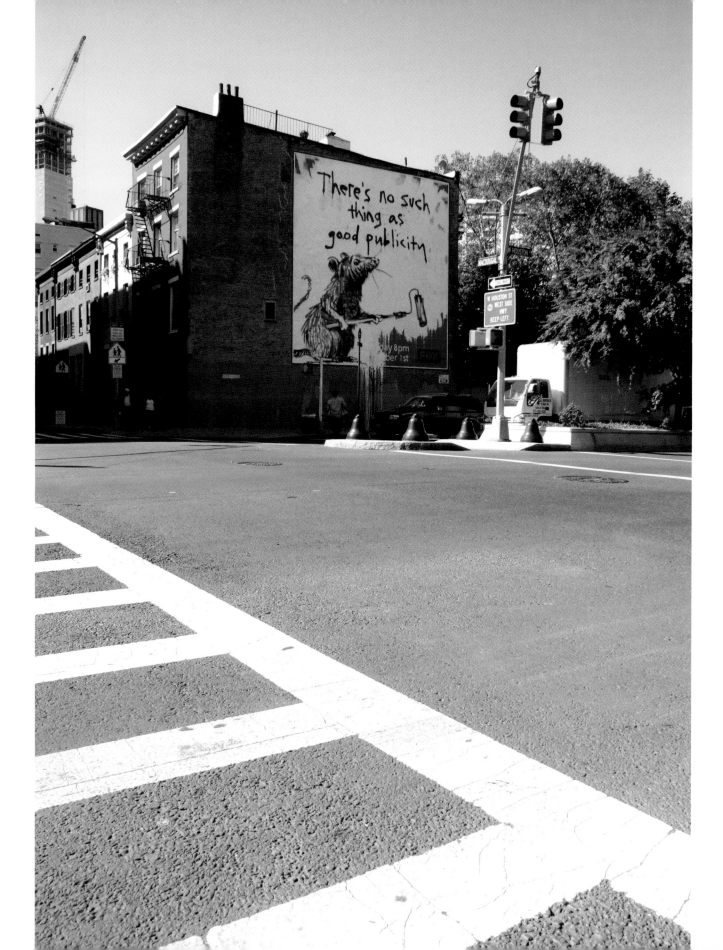

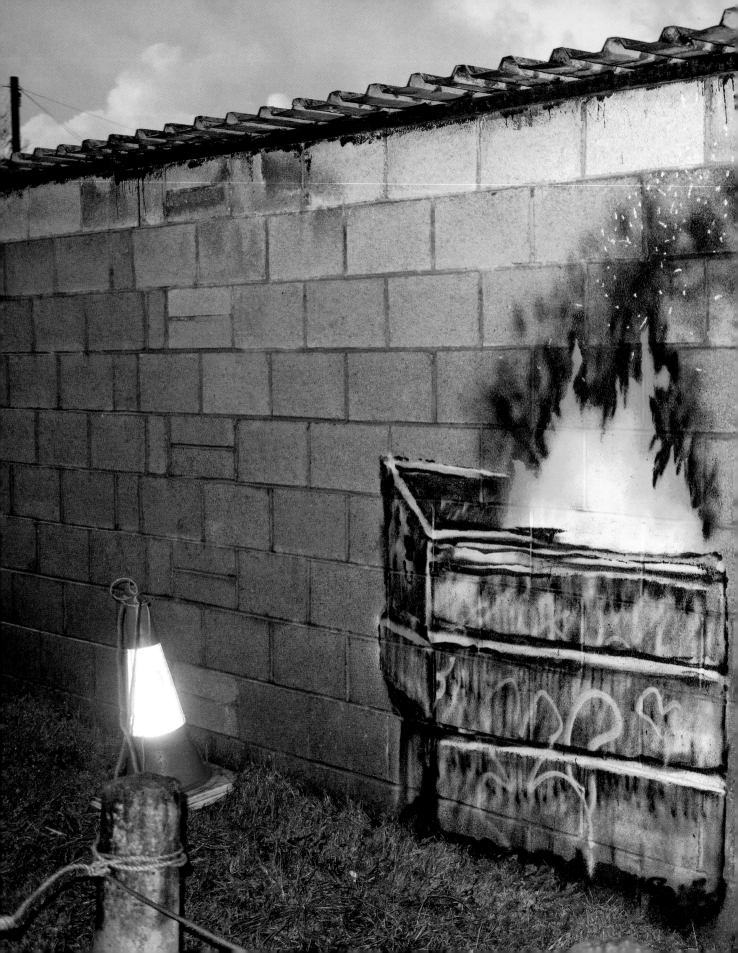

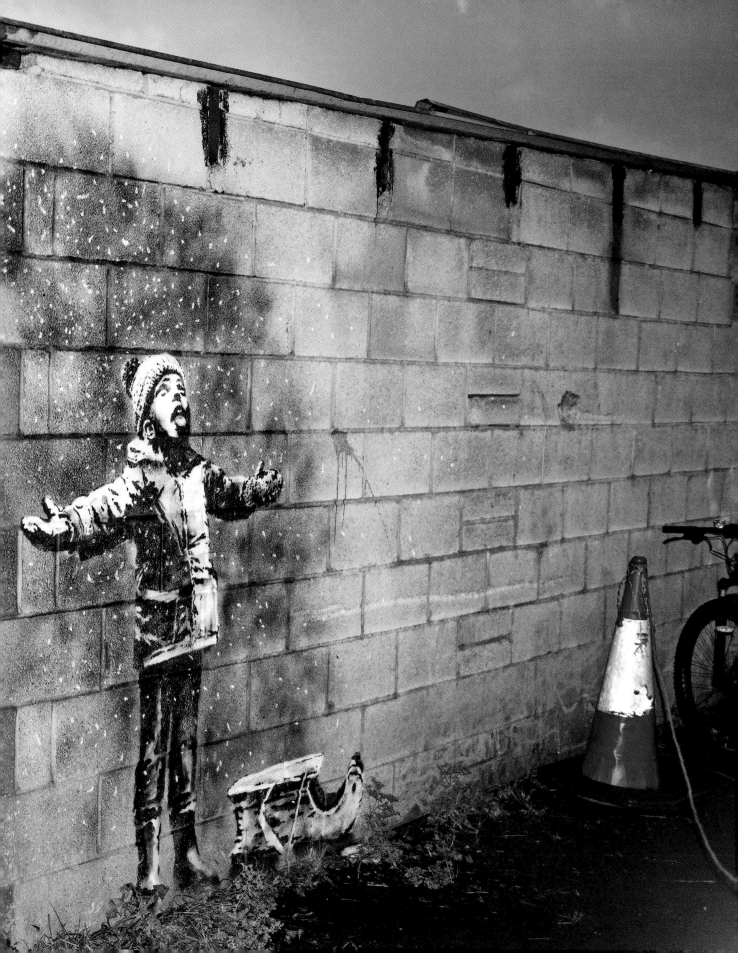

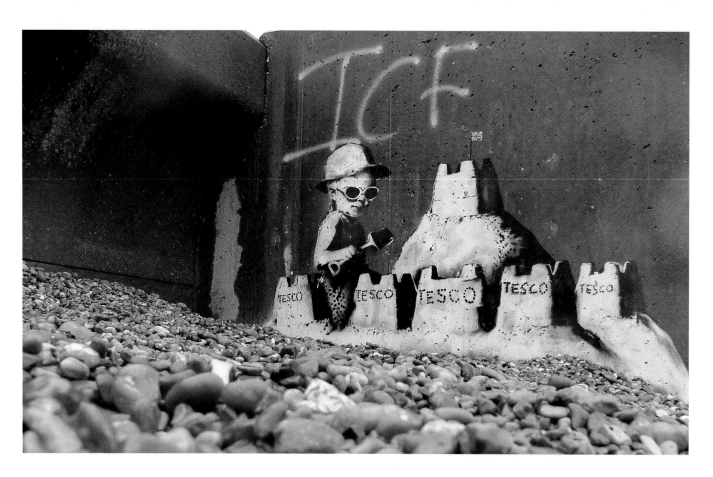

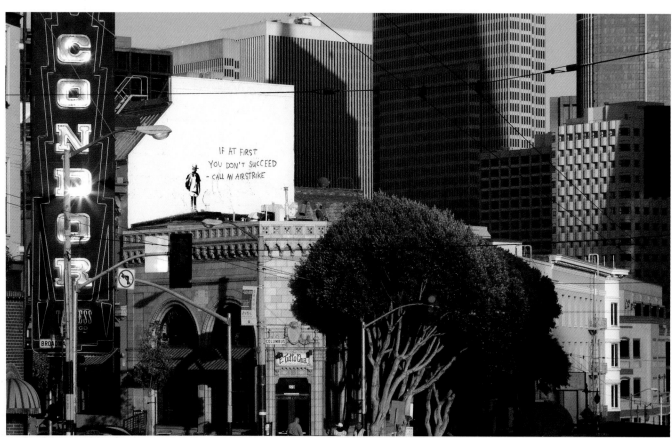

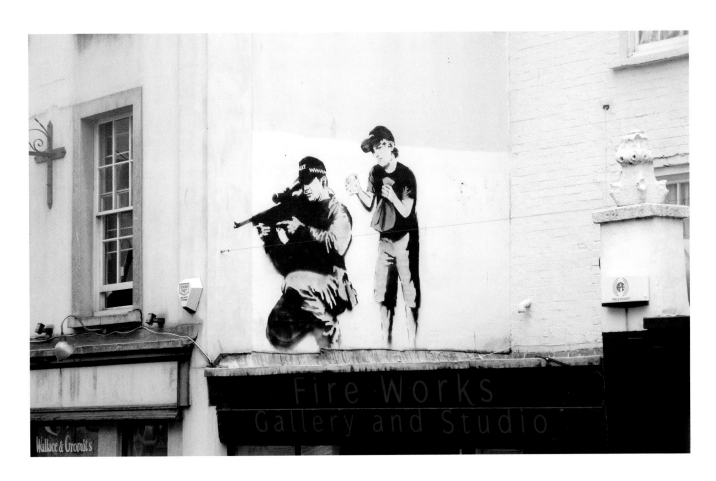

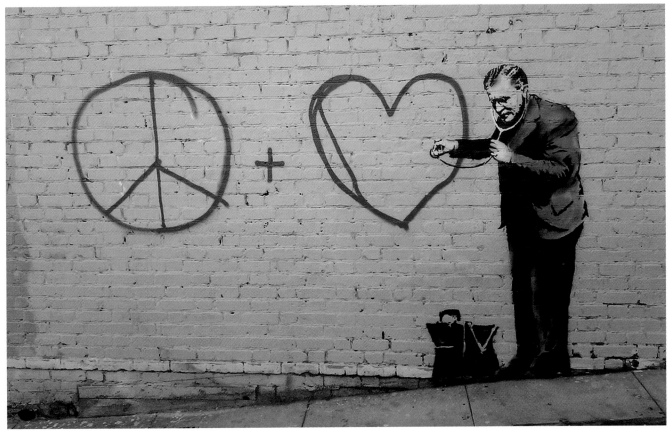

BANECDOTES
#1

BANKSY AT THE SOUTH BANK AWARDS, GETS SMASHED, EATS ALL THE CANAPES

This is a great anecdote courtesy of Melvyn Bragg, the host of the South Bank Show, a long running arts programme on UK's ITV. Bragg invited Banksy to the South Bank Show Awards and was surprised to find that the Scarlett Pimpernell of Stencils accepted outright. Ripples of excitement pass through the genteel crowd at the Savoy Hotel, rumours abound that the great secret of Banksy's identity is about to be revealed. Then a rather rough edged fellow arrives and tucks in to the posh scran before proceeding to get wasted on fine wines. Is this Banksy? No, it later transpired that Banksy had given his ticket to a gentleman sleeping rough in The Strand.

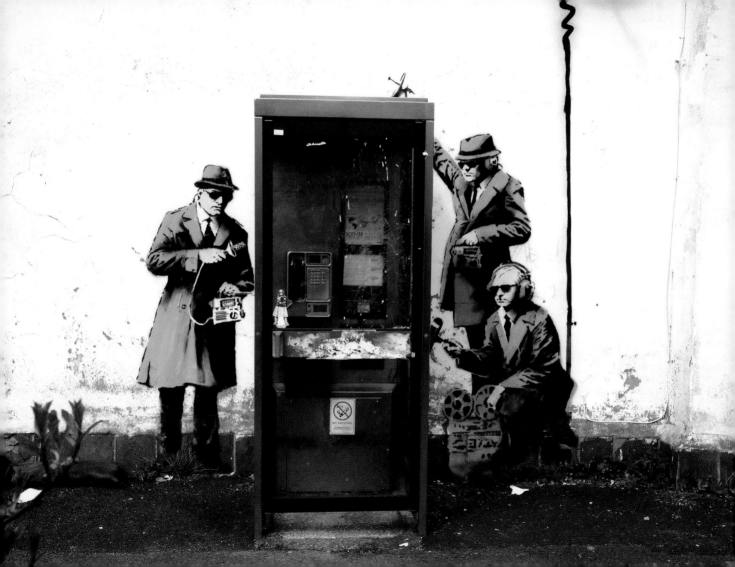

WRITE YOUR NAME.

THE FIRST THING THEY TEACH YOU AT SCHOOL.

WRITE YOUR NAME.

SIGN FOR YOUR FIRST BANK ACCOUNT.

WRITE YOUR NAME.

AT THE TOP OF YOUR EXAM PAPER.

WRITE YOUR NAME.

ON THE BACK OF YOUR BEDROOM DOOR WITH A DRIPPY PEN.

WRITE YOUR NAME.

TO LOG IN TO FACEBOOK.

WRITE YOUR NAME.
WRITE YOUR NAME.
WRITE YOUR NAME.

AS IF YOU EXISTED.

AS IF YOU WERE UNIQUE.

AS IF YOU WERE SEPARATE.

IN YOUR NAME.

THE THINGS YOU OWN ARE IN YOUR NAME.

YOUR NAME.

THAT WHICH OWNS, THAT PART OF YOU WHICH MAY POSSESS THINGS.

AND THAT PART OF YOU THAT POSSESSES YOUR CRIMES
AND YOUR CRIMES AGAINST POSSESSION.

WRITE YOUR NAME ON THE POLICE REPORT.

WRITE YOUR NAME ON THE CAUTION.

YOUR NAME WAS WRITTEN ON YOU.

WRITE YOUR NAME.

ONE NATION UNDER CCTV

(Pop Quiz!)

Spot the reference? Of course, it's Funkadelic's 1978 album title - 'One Nation Under a Groove' (later the inspiration for 'One Nation' the eponymous mid-nineties rave club). Minus ten points if you thought it was a reference to the line out of the USA's creepy pledge of allegiance "One Nation Under God." (You can have five points back if you knew that the 'Under God' bit was only added in 1954.)

In the UK it's more common to pledge allegiance to the path of marijuana. Which is of course a Cypress Hill lyric.

Anyway, "One Nation Under CCTV" is An Acerbic Critique (piss-take) of a nation (Broken Britain™) where the only thing holding us together is the weak social sellotape of ten billion CCTV cameras and a shared pathological hatred of walking behind somebody who is walking slower than you.

Banksy allegedly used three levels of scaffolding to paint this huge piece on the side wall of a Post Office car park off Newman Street, Westminster, London, England in the Spring of 2008. The piece, which lasted roughly a year, focussed on an old favourite target for Banksy - the closed circuit television camera, or CCTV.

England has ten billion* CCTV cameras, just like a vast "Big Brother" set. Which is ironic because "Big Brother" was named after a character in a book about an England with ten billion CCTV cameras.

*Nobody is quite sure but estimates range from a lot, to a fuck of a lot.**
**1.85 Million

Joe Public loves CCTV cameras because Joe Public loathes, fears and despises his fellow man. (Do you? We didn't really check this fact.)

Richard Wilkinson (google him) recently proved that this was an effect of relative income inequality. In certain* countries where the gap between income levels is sharp and concentrated in a small area (London has some of the richest and poorest areas in England) there are lower levels of trust. This is a great situation for people who sell security. There's never been a better time to get into the fear business. Which is ironic because we've never had less violence in our lives.

*Countries where real slum style poverty is not an issue.

Funkadelic were singing about unity through music. CCTV cameras sing about unity through fear of retribution. Banksy's 'One Nation' highlighted this rather melancholy notion. Although it is quite a heavy subject, the artwork was shot through with comedy. As ever, the punchline comes from the placement. If CCTV is an effective technology then how the hell could he paint a piece that size directly underneath a CCTV camera?

An extra punchline was thrown in free when the council put a brand new, super fancy, publicly funded camera up to protect the Royal Mail car park, after the piece was buffed. Shutting the stable door?

And yes it was a 'huge grey wall', in a car park. Hardly as if the work damaged an area of outstanding natural beauty. The buffers cited possible health & safety issues. Nobody wants to see street-art tourists getting squished by post vans do they? Anyway, all art is temporary. Even the Mona Lisa is falling apart.

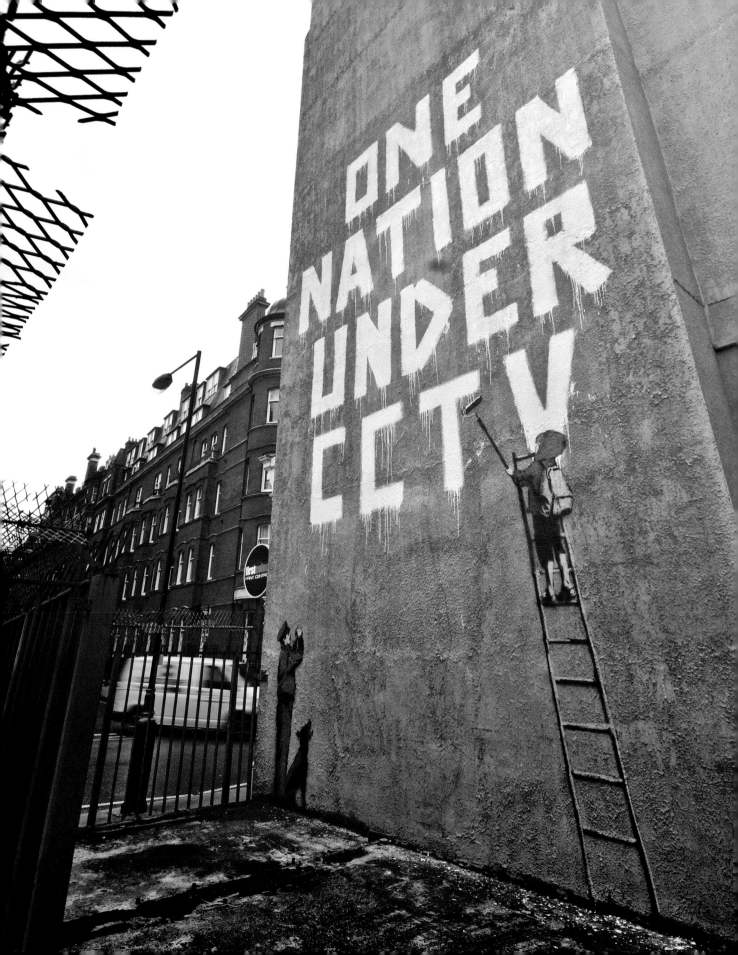

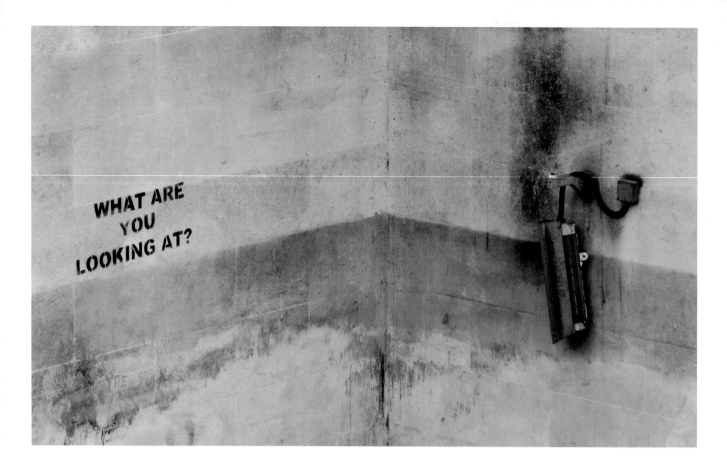

I NEED SOMEONE TO PROTECT ME FROM ALL THE MEASURES THEY TAKE IN ORDER TO PROTECT ME.

BANKSY

One Nation can be seen as the culmination of a long running theme in Banksy's work. It's not the first time he has targeted the humble security spy cam, and hopefully not the last either. As far back as 2001 Banksy was painting "This is not a photo opportunity" in the direct line of sight of a CCTV cam at the Swiss Embassy car-park. Deliberately tagging spots with cameras such as the 2003 lamp post tag at Tottenham Court Road was always a great gesture of defiance. And the iconic "What are you looking at?" tag in Marble Arch lasted five years, staring down the camera on the opposite wall.

In 'One Nation' the tubby security guard is standing watching the young vandal up the ladder through the lens of a compact camera. Like the Alsation at his feet neither character is actually intervening in the crime taking place, they're just watching it. The act of taking a photograph supersedes the need for any real action. This is another little Banksy irony. Taking photographs of crime is not in any sense solving or providing a solution to crime.

Cameras are largely psychological as law enforcement tools, more like scarecrows in a field than an actual force of justice.

Banksy likes to remind us that the security forces that hem us in are largely bored and underpaid and are probably not watching the screen anyway. Just like scarecrows, it only takes one crow to land on its head and the game is over.

So what do the tubby little guys in the control room actually watch all day anyway? Well, surprisingly enough the answer is - titty.

"Based on 600 hours of research from CCTV monitoring rooms, findings showed 'suspect targets' most likely to be filmed were "disproportionately young, male, black and working class." Black men were twice as likely to be filmed as white men, women were often tracked by camera operators for the 'titillation factor,'" - The Maximum Surveillance Society

So that explains why Banksy is able to erect three storeys of scaffolding and spend an entire night painting on the wall. He is white and he has no boobs.

"Smile you're on CCTV"

BIG BROTHER IS WATCHING YOU

(You Can't Fool the Children of the (CCTV) Revolution)

It goes without saying that CCTV is the natural enemy of the graffiti artist but in a perverse way Banksy is a product of surveillance culture. The CCTV boom started in the late 1980s and soon enough the window of opportunity for placing graffiti became much shorter. Banksy cited this as a reason for using stencils in one interview, although, contrary as ever, he has also said he was just shit with a spray can. Whichever you believe, it is the efficiency of stencils that makes them ideal for the prominent positions Banksy goes for. So, in a way, Banksy's style is a product of CCTV.

CCTV cams are hugely popular with British voters which makes them hugely popular with British politicians. Despite the complete absence of evidence to prove that they reduce crime rates, promising more CCTV and making it easier for private individuals and companies to use CCTV is an easy vote winner for politicos on the campaign trail.

"There is no evidence that CCTV reduces crime, but there is research, including a study commissioned by the government, which reveals that it increases distrust between people and promotes fear of crime." - Anna Minton (social affairs writer), February 2010

Argument A

If you believe the fairy story that the police and various private security forces exist to protect you from swarms of genetically inferior humanoids known as 'Criminals' from the planet 'Criminus', as many do - then CCTV is no doubt a comfort, lulling you with the notion that a benevolent big brother is looking out for you in the school yard of society so you can carry on with whatever weak, comfortable, selfish vision of life you choose to pursue.

Argument B - (See, this article is proper balanced and that.)

If you believe that crime is the product of an unequal society and the only way to cure it is to address social causes and that the police spend most of their resources protecting the wealthy from the poor, then CCTV is less comforting, it is like a little flag of surrender, each one showing that we have given up on each other just a little bit more, further invading the realm of everyday life with the control of a corrupt and monstrously greedy big brother something akin to the red eye of Sauron.

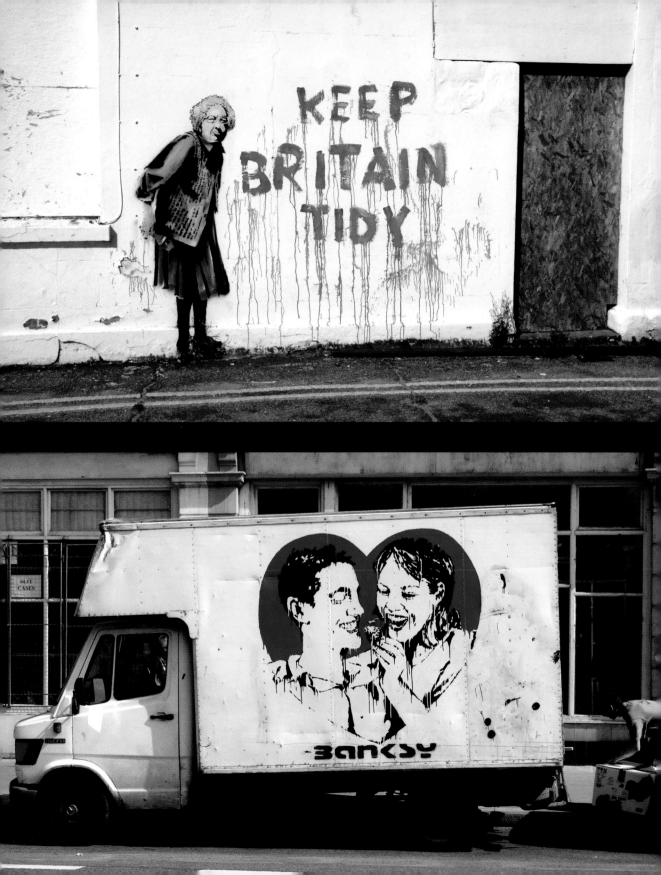

WELCOME TO THE HOOD

(Art and rebellion)

Looking back to the imagery contained in One Nation Under CCTV, it's no surprise to see the kid up the ladder is hiding his face in his hood. Which brings us to another phenomena of the age of CCTV, and another recurring subject for Banksy, the 'Hoody'.

"I wear my hat low and my hood high."

 Inja - Hat Low Ft Fallacy, SkinnyMan & Mr Thing

If you live in the city and you want to be naughty then it makes plain practical sense to wear your hood up. Even if you don't want to be naughty it makes plain practical sense to look more dangerous than you are, if you live in a rough area, so pretty soon, everybody is wearing their hood up.

"CCTV keeps the Hoi Polloi in its place." - Middlesbrough City Council

Hoodies, Yobs, Chavs or as they used to be known - the poor, are the monster under the bed of middle England (wherever that is). And Banksy evidently identifies with the Hoody characters in his work. Is Banksy the hoody with the Keith Haring dog? Is the giant image of a hoody with a bleeding heart at Cans another side of Banksy? It is one of the few Banksy pieces with no obvious punchline.

There is a vicious circle at the heart of all this. CCTV treats people like criminals. The more you treat people like criminals the more they take on that role. Yet it is a stupid, wrong headed notion to identify someone as a criminal. Anyone is capable of criminal behaviour. Calling someone a criminal is like calling someone a ZARGON. It is useless. It achieves nothing. It doesn't tell us why they did what they did or how we can persuade them not to do it again. It is a deliberate attempt to avoid facing up to any social problem. Just like David Cameron did with the London riots.

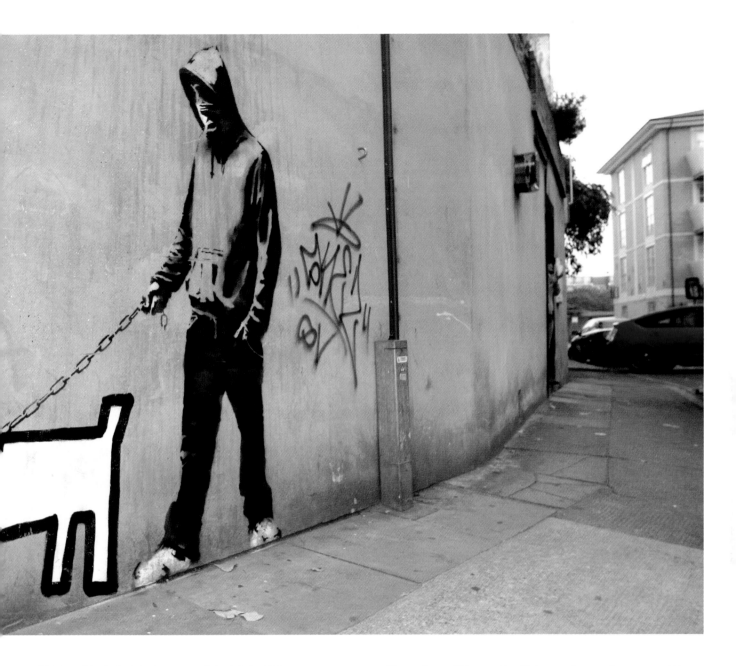

"This is nothing but criminality, pure and simple", David Cameron

This kind of thinking is not new. It goes back to 1846 when people referred to those who committed any type of crime as 'morally insane' and they believed that criminals were a genetic sub-species that could be identified by certain shapes of face. This was the year that Eliza Farnham used her role as matron of a women's prison to produce a book of etchings of inmates' faces to help found the fledgling science of Phrenology.

Phrenology could show who was a criminal and who was not by the shape of their skull. In 1876 Cesare Lombroso followed up by using the camera to photograph many more 'criminal' faces for an influential book on the subject. Having finally figured out how to identify 'criminality, pure and simple' the only problem left for the Victorians was what to do with the bastards now Australia was full. (Lobotomy)

The modern politician would publicly scorn these notions, we would hope, but all the same the solution provided these days seems to be aggressive sentencing and more surveillance than even George Orwell could have predicted. Which is ludicrous because we already know what causes anti-social behaviour. Relative income inequality.

The London riots took place in a city where the top ten percent earn 273 times more than the bottom ten percent, and they live, quite literally in some cases, next door to each other.

Against a wrongness of that magnitude, a little rebellion seems quite fluffy and cute doesn't it?

Perhaps that's why we like Banksy.

HE IS A COMPLETE CLOWN
AND WHAT HE DOES HAS ABSOLUTELY
NOTHING TO DO WITH ART.

BRIAN SEWELL - VETERAN ART CRITIC

DEAR BRIAN, WHEN CRITICISING ART IN RETURN
FOR MONEY, PLEASE TRY TO REMEMBER WHO THE
PARASITE IS IN THIS RELATIONSHIP..

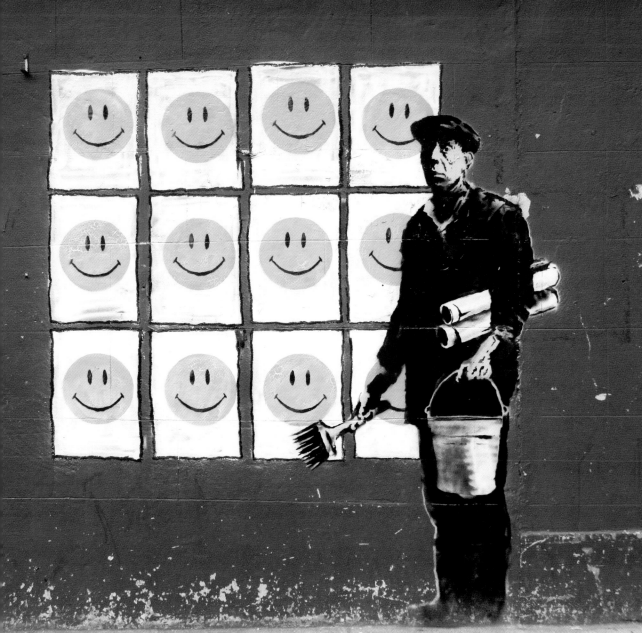

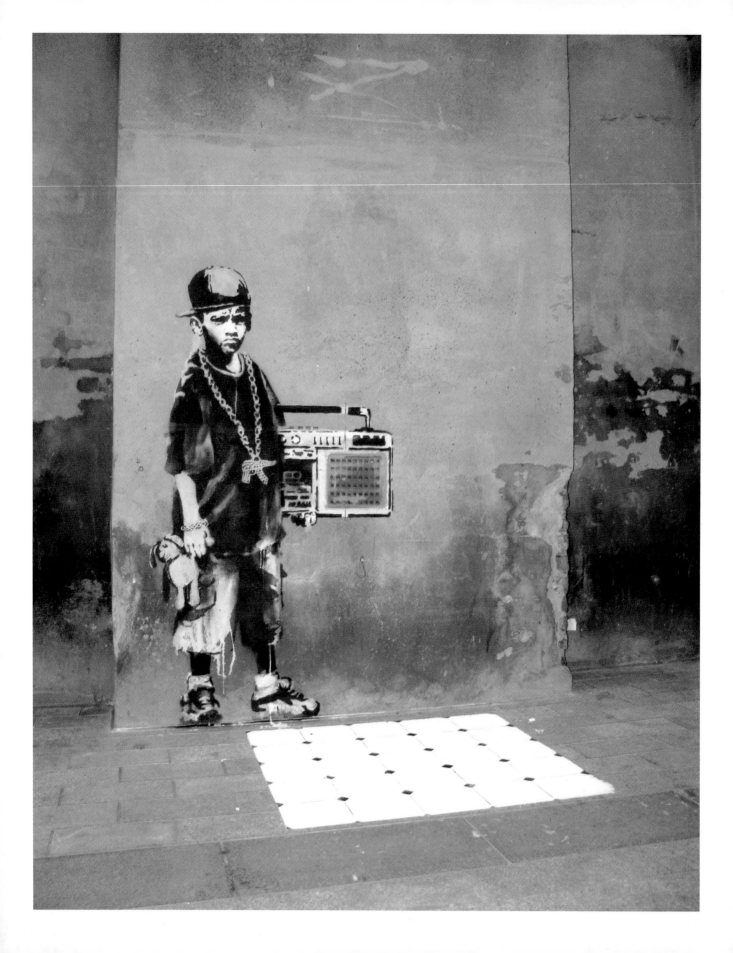

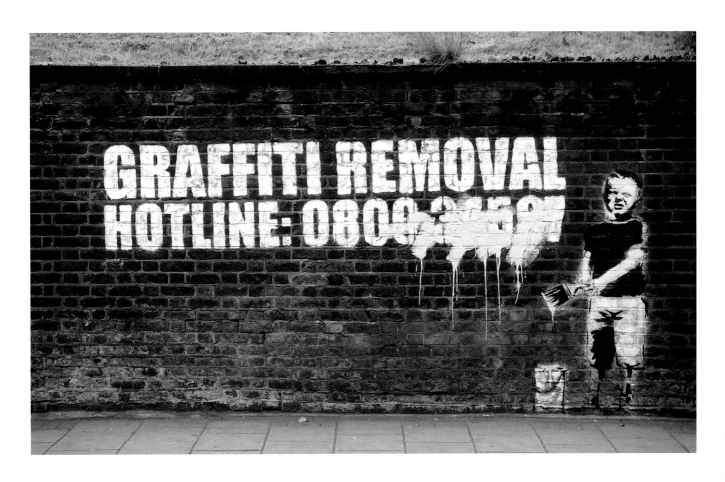

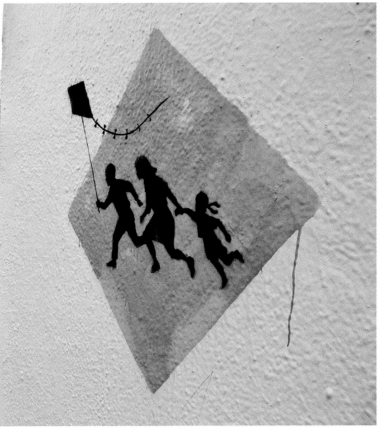

EVERYBODY
IS IN THE PLACE

(In My Opinion)

"I haven't shopped at a supermarket since the cunts banned me for wearing nothing apart from flip-flops, England shorts and a pair of fake tits." - Rob F, Off of the 'internet'.

Somebody once asked us, 'Why do you think Banksy sometimes features a supermarket brand in his work?' Rather than simply admitting we didn't know, we made up the following answer.

Some supermarkets might allegedly* be really horrible to farmers. Banksy is possibly from Bristol where some people could be farmers. He might even be part farmer himself. Supermarkets put pressure on supply chain prices and farmers have to swallow it because supermarkets are so big, they make their own rules. This means the farmers have to do everything cheaper and quicker to survive which might mean chemicals and shite conditions for animals etc. Banksy might love animals.

*Concerned about libel laws? Use: allegedly!

Some supermarkets might aggressively barter down prices in garment production helping to maintain abysmal working conditions for garment workers. Banksy might love garments.

And finally, some supermarkets could pose a threat to small businesses. Banksy might prefer shopping 'local'.

One supermarket chain inadvertently started a massive ruckus in Bristol, Banksy's 'Tierra Patria', after they controversially decided to open a shop in the People's Republic of Stokes Croft.

Cue the local Police storming a squat and causing a riot. Although their timing seemed almost deliberately designed to agitate the local community, they did find petrol bombs in the squat so felt justified in causing the fracas which ended up with the store getting trashed anyway. Own goal?

You may see things differently. That's your prerogative.

Yeah, I spelled prerogative correctly.

Deal with that.

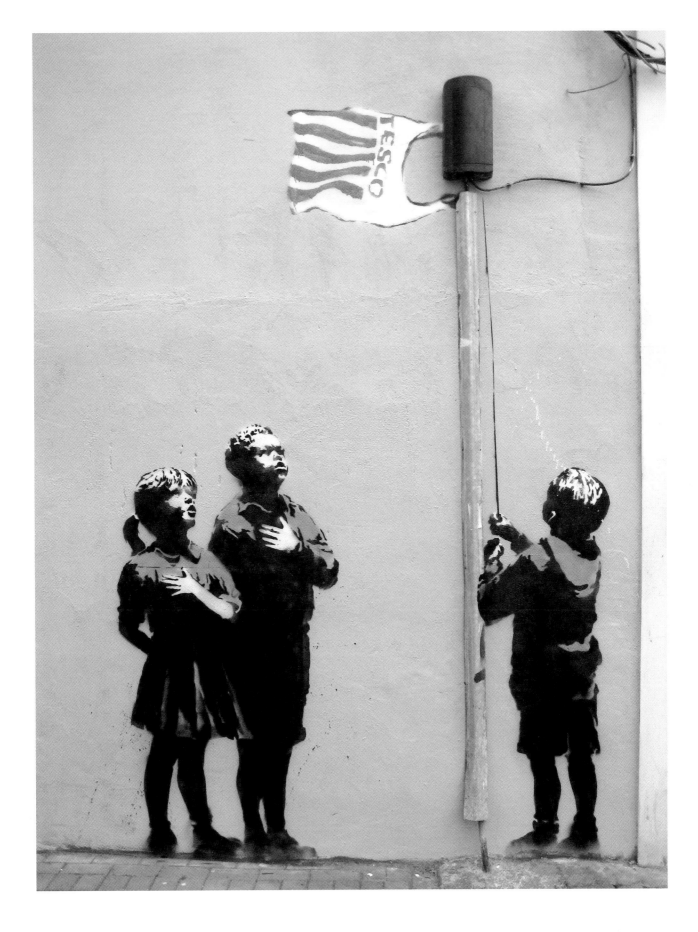

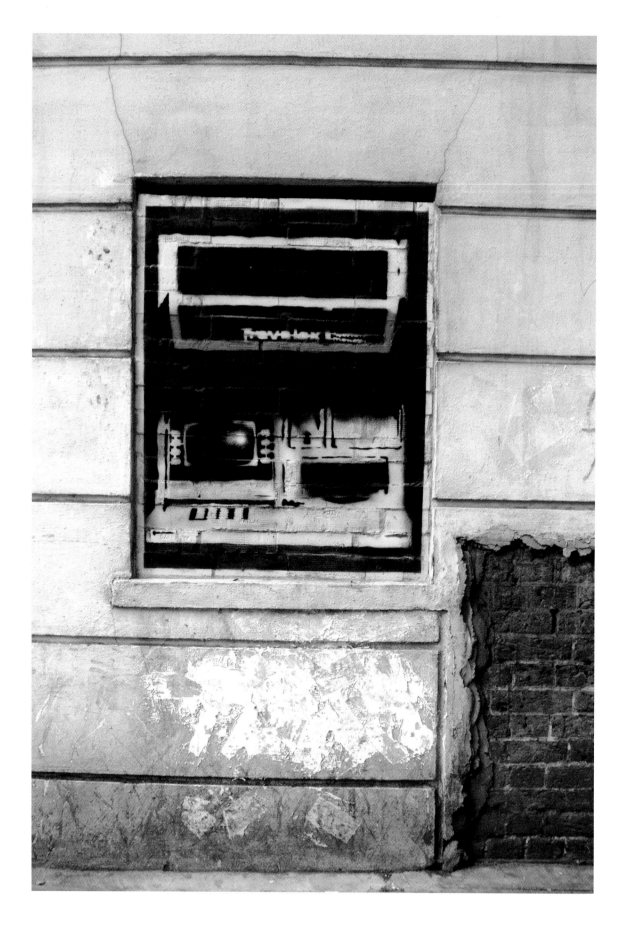

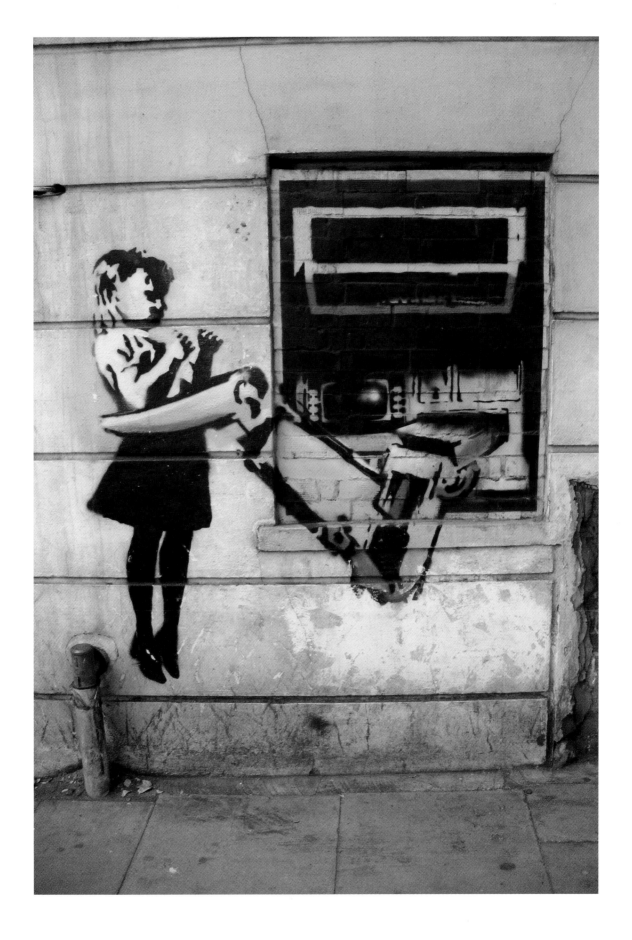

THERE'S NO FUTURE IN EUROPE'S DREAMING

SPAIN 51.4%

GREECE 46.6%

SLOVAKIA 35.1%

PORTUGAL 30.7%

ITALY 30.1%

IRELAND 29.3%

POLAND 27.8%

HUNGARY 25.9%

BULGARIA 25.6%

FRANCE 25.6%

SWEDEN 23.2%

UK 22.3%

BELGIUM 21.1%

NETHERLANDS 8.6%

GERMANY 8.1%

YOUTH UNEMPLOYMENT 15-24, SEASONALLY ADJUSTED
NOVEMBER 2011, SPAIN DECEMBER 2011, GREECE SEPTEMBER 2011.
SOURCES: THE SUNDAY TIMES, EUROSTAT, ONS, SPAIN'S NATIONAL STATISTICS INSTITUTE

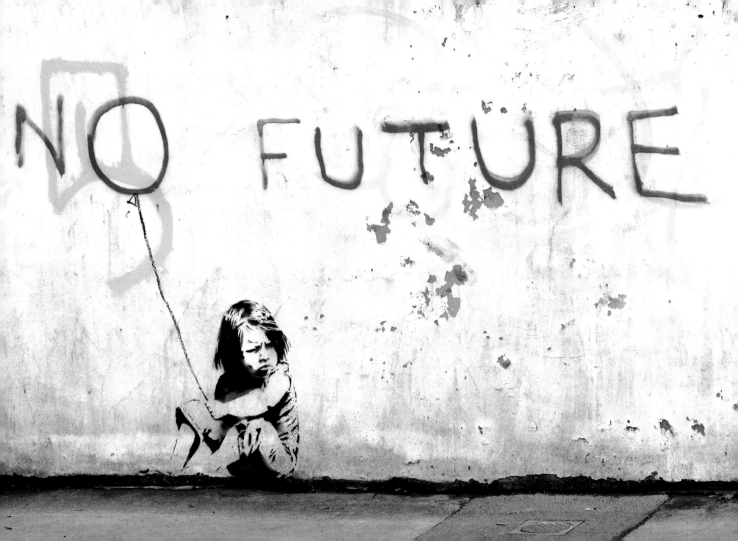

BANECDOTES
#2

BANKSY DOES ALL
HIS OWN WORK,
OR NOT

"The Artist provided digital renderings of hand-drawn sketches, which our paint team was able to transfer directly, with 100% fidelity, to these four massive wallscapes."

This is Colossal Media talking about the campaign that Banksy hired them to do to publicise his 'Village Pet Store & Charcoal Grill' in New York, 2008.

The company spent months liasing with Banksy's 'team', whoever they might be, and negotiating spaces with landlords and other 'media' (advertising) companies to put up the pieces which featured classic Banksy rats but executed in a far more detailed, hand sketched style than usual.

Some might see this as hypocritical, in fact some undoubtedly will, but Colossal certainly felt it was all in the game plan for Banksy. Their statement suggests that the use of an advertising company was intentionally subversive in itself.

"The placement of fine art on advertising spaces, by an advertising company, was in and of itself a major focal point of the project. Colossal's role in the project was to function as any other artist's tool- as a means to an end." - Colossal Media

Accusing Banksy of being a fine artist? Brave move.

As ever, we leave it up to you and your coven of pub table debating experts to figure out.

Paint your answers on the walls of the town...

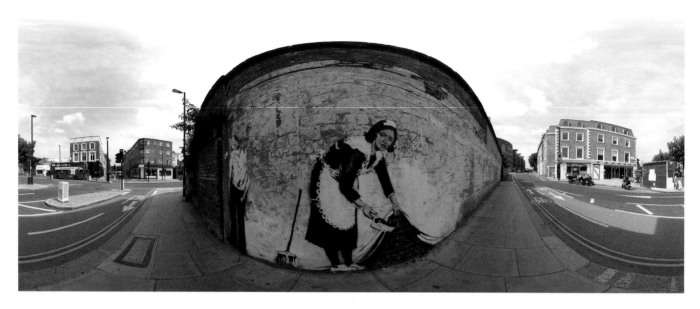

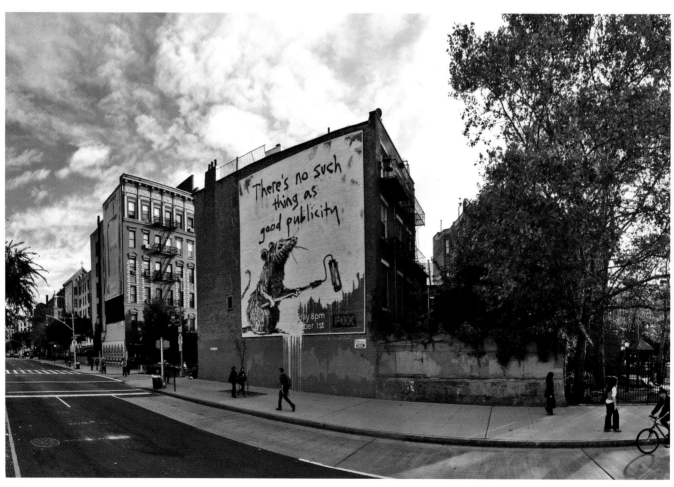

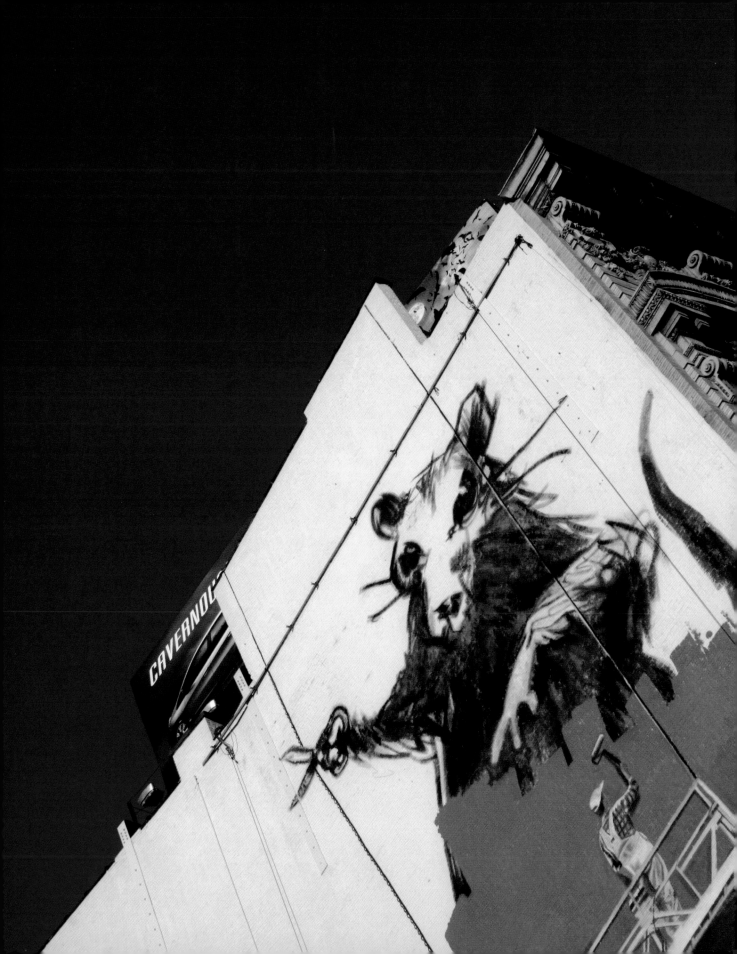

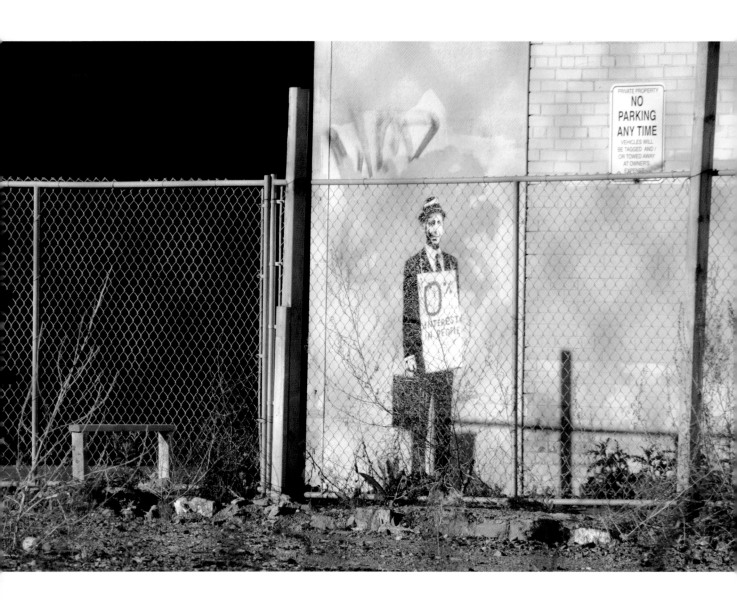

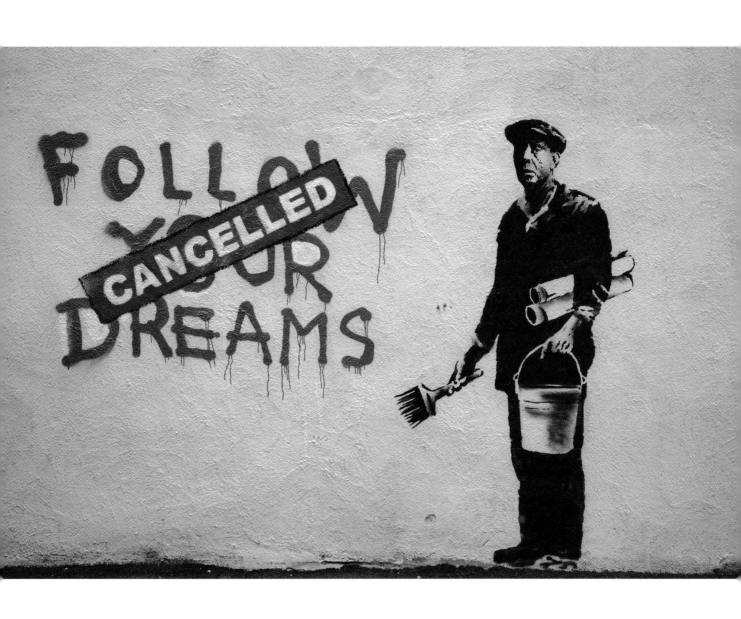

LIVE THE DREAM. ENDURE THE NIGHTMARE.

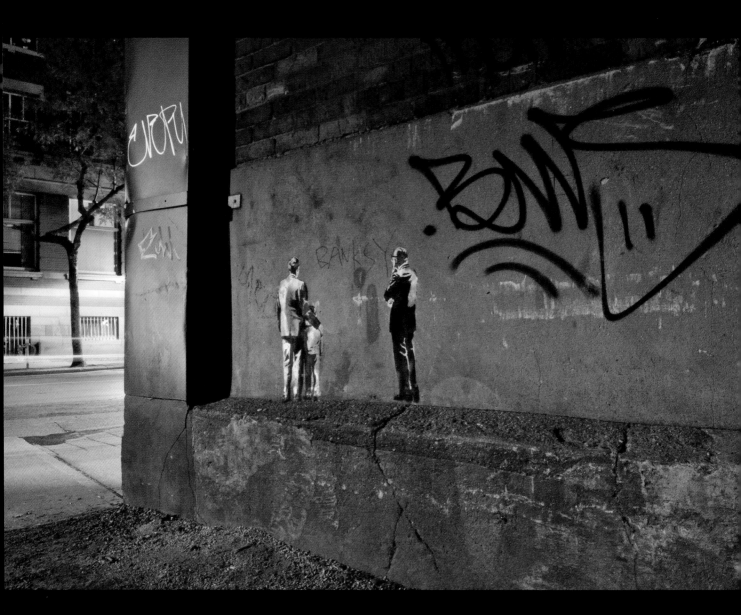

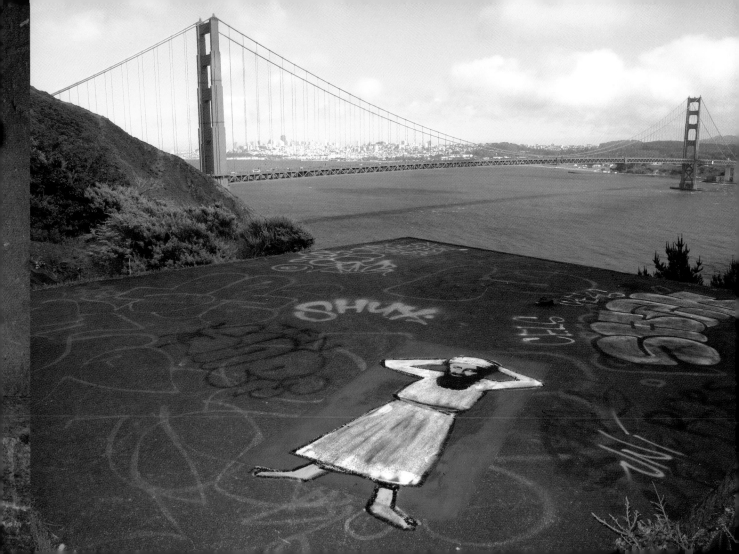

NOLA RISING

(Banksy vs The Grey Ghost)

Hurricane Katrina hit New Orleans on August 29th, 2005. The ensuing storm surge breached the drainage canal levees protecting the city of New Orleans. The city was flooded.

Soon after the natural disaster took place, a local artist named Rex Dingler founded an art activist group called 'NOLA Rising' with the intention of raising morale in the devastated city through public art.

"NoLA Rising believes that participation in the visual arts not only helps to beautify our vibrant community and celebrate our cultural heritage, but also empowers the individual by facilitating creativity and aiding in the discovery of personal potential." - Rex Dingler

Although active in various forms, Rex is widely considered a street artist and a considerable part of NOLA Rising's activity as a loosely affiliated group consists of stickering, wheatpasting and painting in the streets. Other activities include community art swaps, mural projects, arts education and arts therapy.

In August 2008 Banksy went to New Orleans to paint several pieces. The action was intended to draw attention to the slow recovery of the city and criticise the perceived lack of political will to put money into the clean up. Throughout the traumatic events and the years that followed, there had

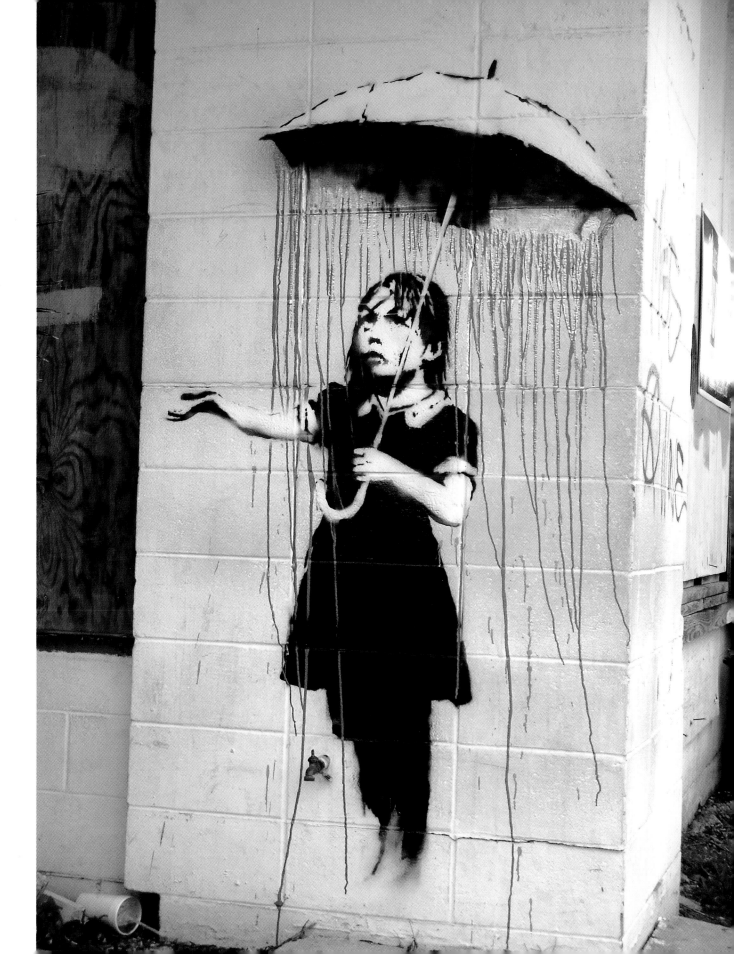

been allegations of federal neglect and institutional racism. Some news coverage appeared to show a government more concerned with shooting looters than rebuilding affordable housing.

"Police and military at one point were told to even prioritize on shoot to kill policies if people were caught looting. Thankfully, as media reporters showed, many sort of disobeyed this order." Anup Shah, Global Issues

Not to mention how rapidly the clean up operation was turned to the advantage of some companies with deep ties to the Bush family dynasty. Could it be that unimaginable fortunes were made out of the disaster far quicker than families were rehoused?

The American dream indeed.

Rex welcomed Banksy's 2008 intervention with open arms, blogging the event assiduously. He believed that it would help to raise the city's profile as a culturally vibrant and bohemian place, an aura that New Orleans had always held.

However, not everybody felt the same way.

Banksy, like Rex and the NOLA Rising crew before him, came into conflict with a shadowy figure known as 'The Grey Ghost'. The ghost is a one man anti-graffiti crusader whose Modus Operandi is to paint over any street art he finds in New Orleans with a simple lick of grey paint. This odd approach to buffing leaves little or larger grey squares all over the city.

The man behind the 'Grey Ghost' is one Fred Radtke and he isn't really all that shadowy. In fact he has an unintentionally hilarious blog representing his registered NGO, 'Operation Clean Sweep'. An avowed subscriber to broken window theory, Radtke titles all his posts in full caps FRED RADTKE SPEAKS OUT and selects pro-street art articles from around the web to

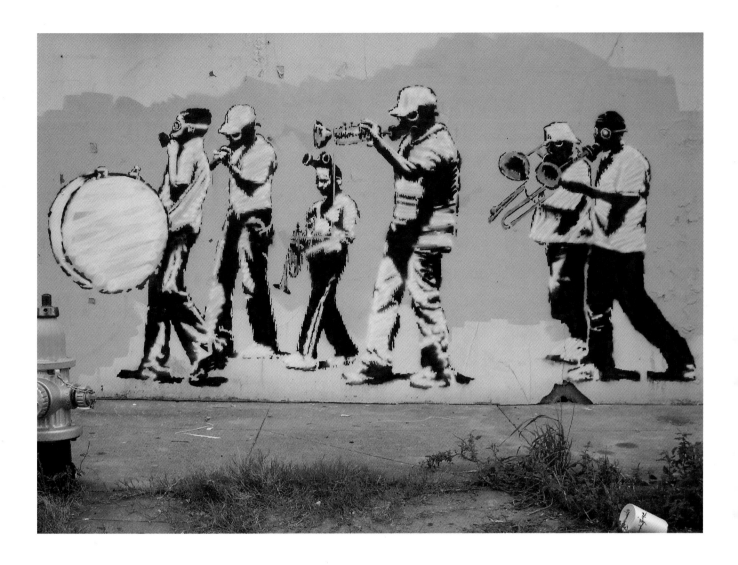

treat with his own delicious vitriol. Check it out, you know you want to.

"Mr. MacCash, either you are pregnant or you are not pregnant, there is no in between." - Fred Radtke

Radtke has previously had endorsement from the Mayor of New Orleans, although there is some controversy over whether or not he is allowed to buff walls on private property where the owner has given express permission. Indeed Radtke was arrested for buffing a Harsh & Grail mural in 2008.

To Banksy, this was all a fantastic opportunity for some source material.

"I came to New Orleans to do battle with the Grey Ghost, a notorious vigilante who's been systematically painting over any graffiti he can find with the same shade of grey paint since 1997. Consequently he's done more damage to the culture of the city than any section five hurricane could ever hope to achieve." - Banksy

Banksy painted various images of the grey ghost as a faceless zombie in an overall, buffing pretty flowers or horrified stick men, drawing attention to the stifling of expression at the heart of Radtke's crusade to protect whoever he thinks he is protecting.

Amusingly, one of the Grey Ghost pieces was protected with plexi glass making it pretty much unbuffable. For the win?

Years later Banksy expressed some doubts over the whole experience.

"Three years after Katrina I wanted to highlight the state of the clean-up operation. Only later did it dawn on me that if you choose to do this by drawing all over their stuff, you're actually only slowing down that clean-up operation." - Banksy

Meanwhile, Rex Dingler and NOLA Rising are going from strength to strength.

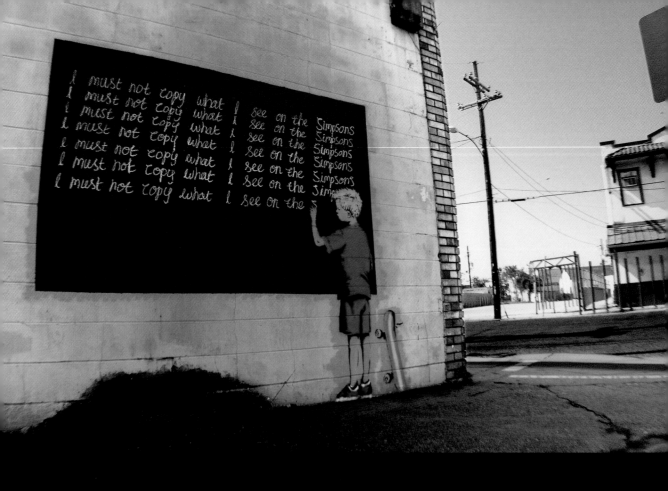

I CAME TO NEW ORLEANS TO DO BATTLE WITH THE
GREY GHOST, A NOTORIOUS VIGILANTE WHO'S BEEN
SYSTEMATICALLY PAINTING OVER ANY GRAFFITI HE
CAN FIND WITH THE SAME SHADE OF GREY PAINT SINCE
1997. CONSEQUENTLY HE'S DONE MORE DAMAGE TO
THE CULTURE OF THE CITY THAN ANY SECTION FIVE
HURRICANE COULD EVER HOPE TO ACHIEVE

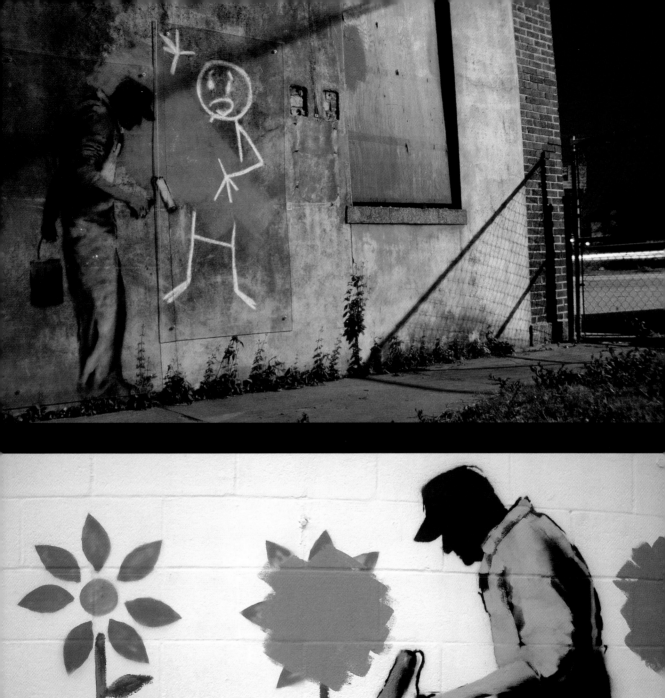
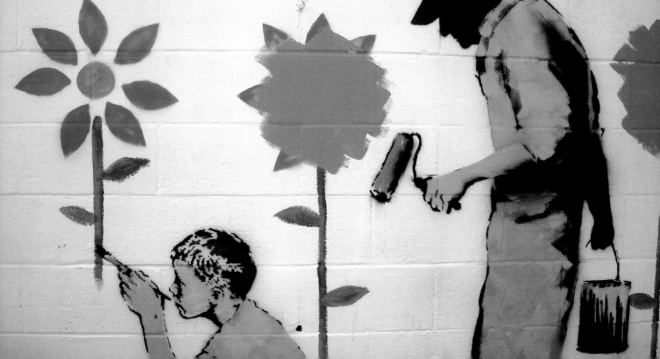

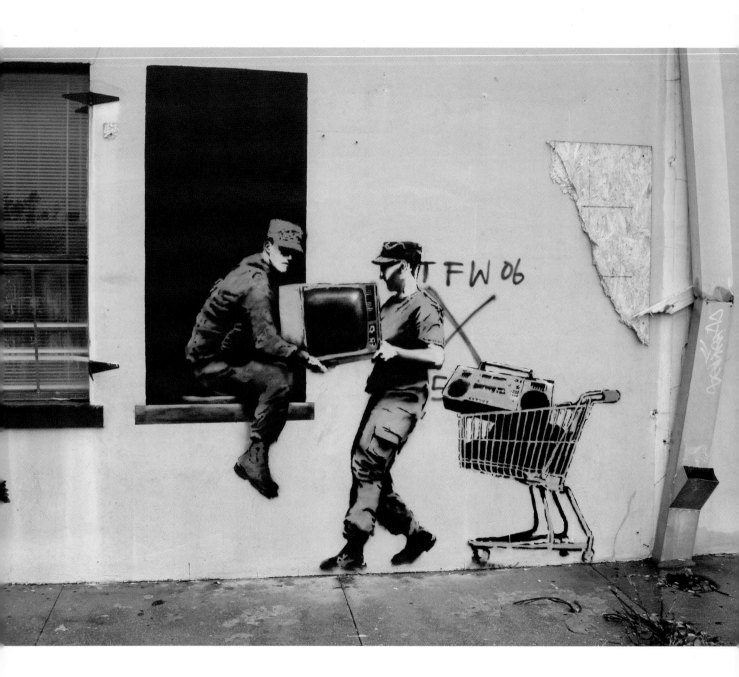

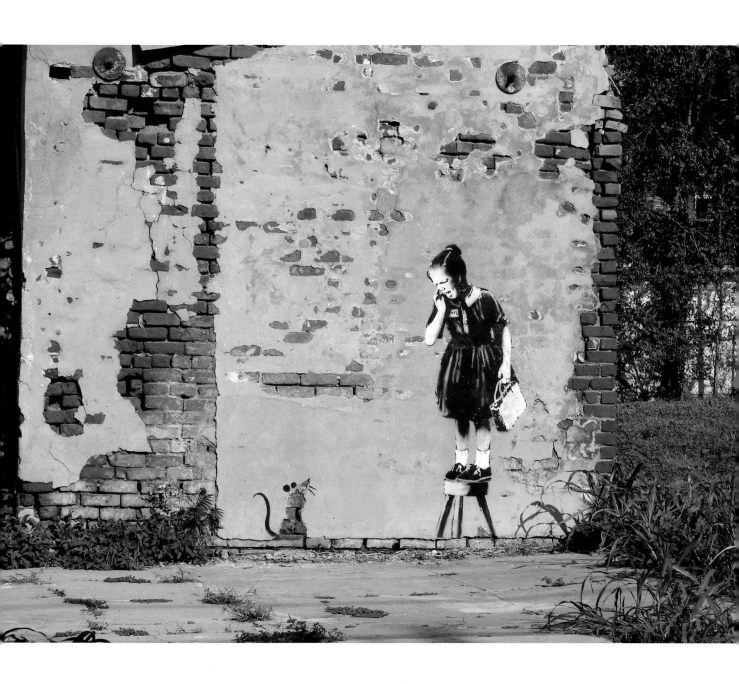

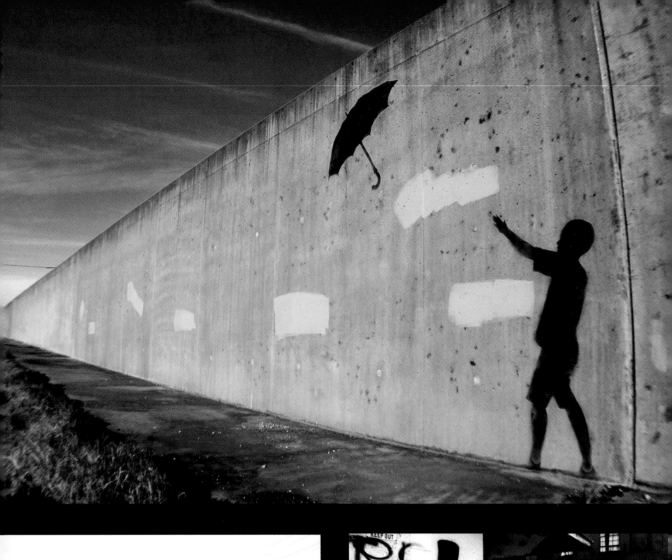

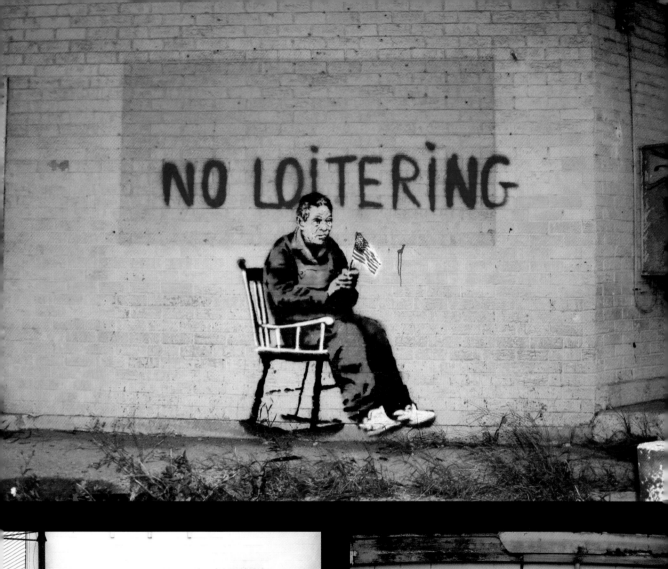

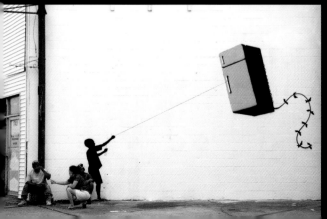

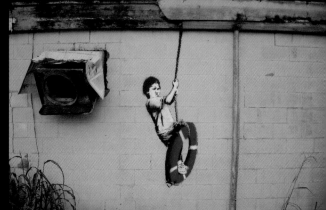

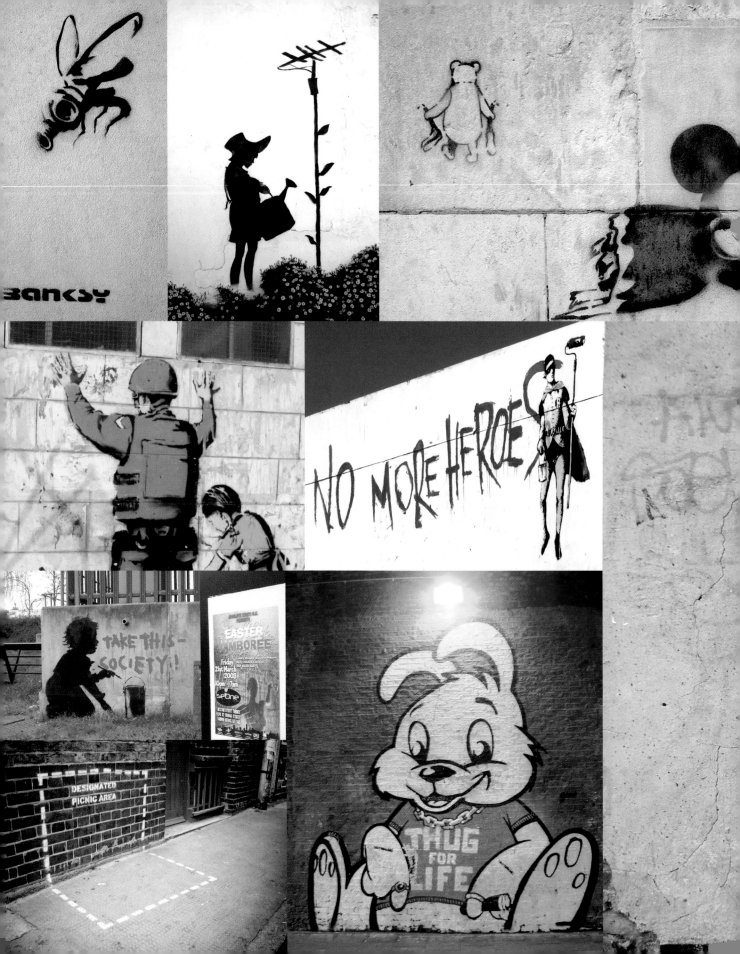

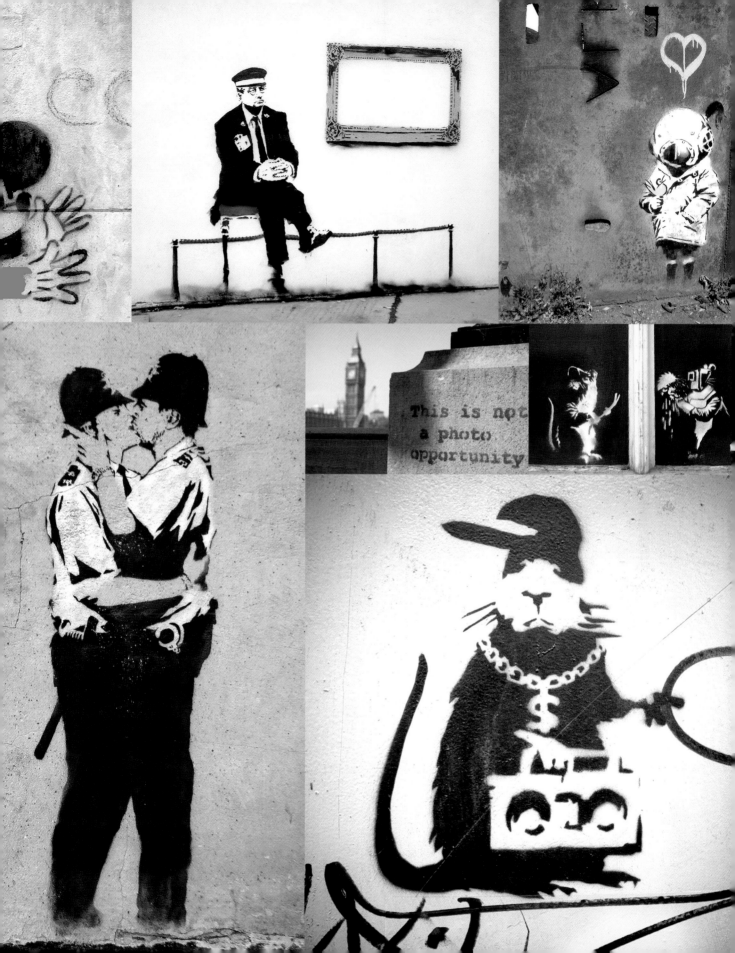

This is not
a photo
opportunity

BANECDOTES
#3

FREE THE DOLPHIN

In 2008 Banksy launched an installation in NYC's super cool West Village area. The 'Village Pet Store & Charcoal Grill.' was set up in secret and launched without warning so that initially, the show worked as a hoax. People didn't realise it was 'art' until it was too late to run.

One of the pieces at the show, which used surrealism and wit to draw attention to the inconsistencies in our attitudes towards animals, was a coin op dolphin ride for kids, caught up in a tuna fishing net.

During the night before the show an angry young woman was drawn to heroically intervene and free the fiberglass dolphin from its net, unknowingly captured on camera by Banksy's, by now hysterical, crew.

Who says Americans don't understand irony?

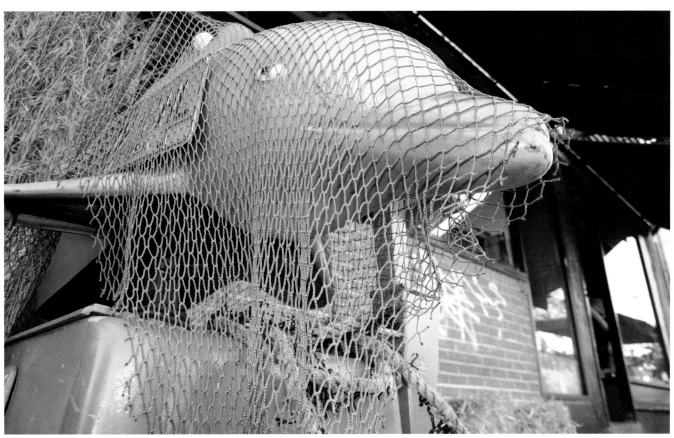

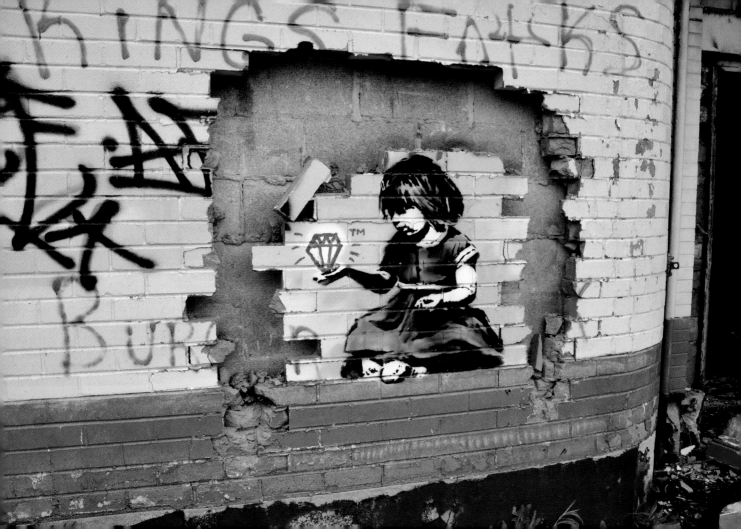

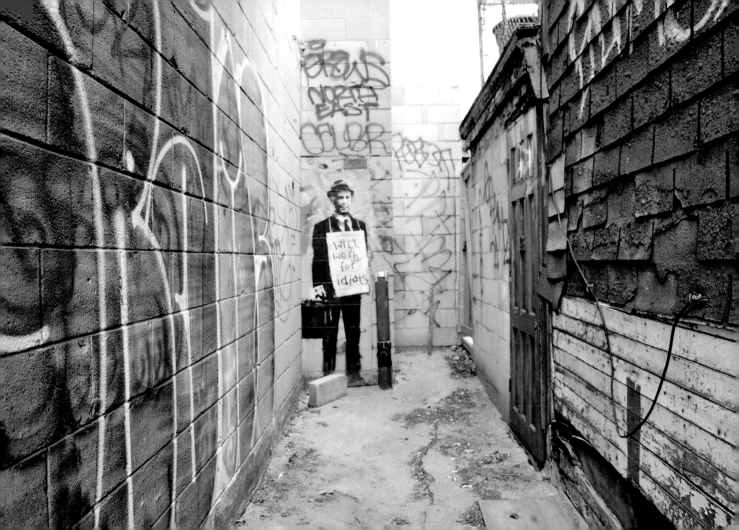

BANKSY
TAKEN OUT OF CONTEXT

(Have Powertools will Travel)

"Ah, that's the key to graffiti, the positioning."

<div align="right">Banksy, Simon Hattenstone Interview</div>

Well, think about it; if you write your name on your own living room wall, it's not graffiti, it's interior design. Positioning can't get more crucial than that. Where it is determines what it is.

(Surely, graffiti on a legal wall is actually a mural?)

So much of Banksy's street art depends on its position to make it really work. Some like 'This Looks a Bit Like an Elephant' depend entirely on location for effect. Some get a great punchline out of a strange location, such as the Penguins at Barcelona Zoo. Some are just, well, in the right place and at the right time, such as his 'I don't believe in anything, I'm just here for the violence' placards at the 2003 May-Day march in London.

In art school, they call this 'site-specific'. And it's very interesting how non-gallery work plays with its environment, something that street-art is often very good at. Banksy once talked about that little moment of discovery when you come out of the pub and you see that monkey on the wall. It is a small, intimate and uplifting effect far removed from the oppressive space of a Fine Art Gallery which tends to make us feel Under Educated and Out of Our Depth. It is art meeting you on your own turf.

Even though Banksy did embrace doing gallery shows, and found he could express ideas in a gallery that he couldn't in the street, as they were too controversial, he is a street artist first and foremost and much of his art works better 'in situation' than it ever would on your living room wall.

For years everybody was happy to leave Banksy's work where it lay, except of course the council and their clean up squads.

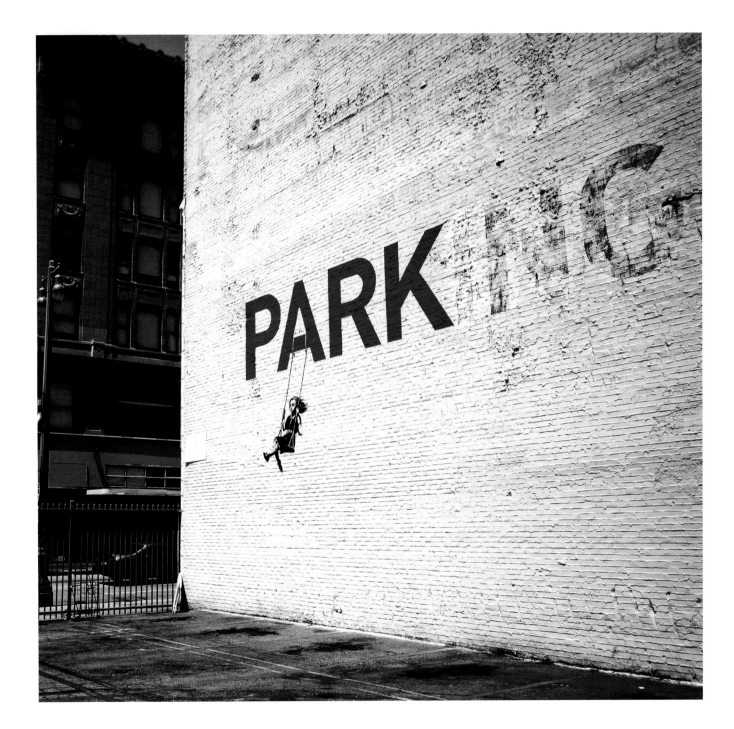

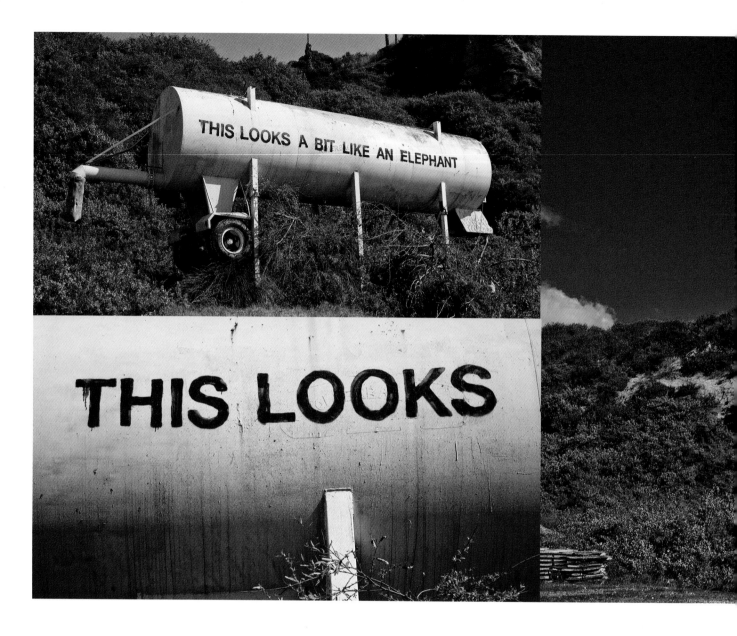

Then all of a sudden, Banksy snowballed, the value of his gallery work shot up and people soon realised that the crazy money being thrown at his art would include his street work too.

People started bringing the streets to the gallery. Literally. One chunk of building at a time. The urge to make a quick buck took hold and art dealers began to find ways to get whole doors and walls into the auction houses to sell. The problem that arose for the sellers was authenticity. How could someone be expected to pay tens of thousands of dollars for a piece that was not certified genuine?

Banksy stopped signing his work many years ago, for obvious reasons. Verifying his street work would be like signing his own arrest warrant. But even so, the work is intended for everybody and taking it off the streets to make a quick buck putting it into private ownership is somewhat against what Banksy stands for.

So the response from camp Banksy was to set up Pest Control in 2008, a service to authenticate genuine Banksy prints and paintings at the same time as refusing to authenticate street work. Their refusal to do so has worked to drive the re-sell value of street pieces down.

"Pest Control does not authenticate street pieces because Banksy prefers street work to remain in situ and building owners tend to become irate when their doors go missing because of a stencil."

Pest Control, Press Statement

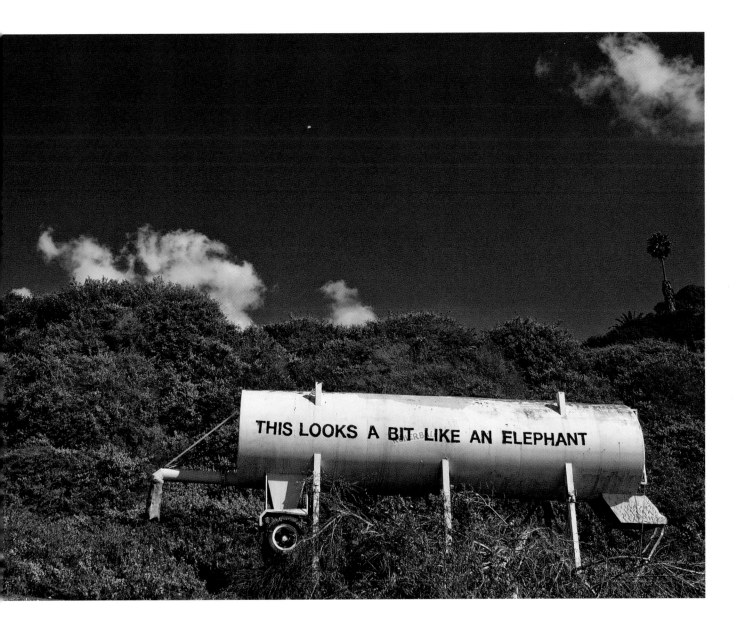

As a counter attack, a group called Vermin was set up to offer an authentication service for street work. It didn't really work. Sotheby's & Christies now refuse to sell street works.

This tendency reached a head when the Keszler Gallery in New York acquired two of the street pieces from Bethlehem painted during the Santa's Ghetto event in 2007. The works in question had already been removed by two local men and were then subsequently shipped stateside.

"We have warned Mr Keszler [the gallery's owner] of the serious implications of selling unauthenticated works, but he seems to not care,"

Pest Control, Press Statement

The implications seem to be that the gallery owner is comfortable with the situation and to prove it they're asking a small fortune for each.

So what do you think? Granted, the little guy in Palestine can hardly be blamed for trying to make some scratch, but now those pieces intended for Bethlehem are on show in a gallery in the Hamptons. The Hamptons is one of the most privileged places on earth, a beach resort for the richest of New York's traders and getters.

The middlemen claim they rescued the pieces from oblivion. Keszler claims he loves Banksy.

Obviously not enough to respect the artist's wishes though, eh?

HOW TO TURN INVISIBLE

(Karma and the Urban Chameleon)

You will need:

A High Visibility Vest

A Hard Hat

A Clipboard

Some Business Cards

An Unmarked Van

Banksy takes advantage of a powerful psychological bias in order to make himself invisible in the urban environment. Urban life is hectic and information comes at us from all directions at once. In order to cope we use filters to screen out information and decide what to do without having to assess everything in detail. So we basically 'skim read' our environment, and, just like ninjas, pickpockets and journalists, good street artists take advantage of this tendency.

When we see a high vis jacket combined with a clipboard our brain is more than satisfied that everything is as it should be, regardless of what the chap is actually doing. These garments are symbols of authority and we have a powerful tendency to accept authority, probably going back to our cave-man days when the silver-back could toss you out of the troop for backchat.

Scientists tested this theory by getting people to administer electric shocks to a 'volunteer' (actor) in the next room. Although the test subject could hear the screams and even hear the 'volunteer' begging for mercy, they continued to administer higher voltage shocks when told to do so by a man dressed up as a doctor. Take the man out of the doctor's costume and the test subjects refused to do it.*

This is combined with the 'invisible gorilla effect' - when walking the streets we tend to only focus on information relevant to our current objective, for example, getting home.

When people are asked to watch a video of six people passing a basketball and told to count the passes, 50% of viewers will fail to see the gorilla that walks on screen halfway through the film and beats its chest toward the camera before walking off shot.

So, when walking home off the beaten path, you're more likely to be scanning the terrain for candidates out to mug you and consequently the invisible street artist (resplendent in utility clothing) is overlooked. Even if you do see, you immediately filter him out because of those 'authority' symbols. If you're really suspicious, and brave, and ask him what the hell he is doing, he can hand you a business card and tell you to call his boss in the morning. Boom. Double authority. You walk away.

The only question that remains is, how does anyone ever get caught?

*Stanley Milgram, 1961

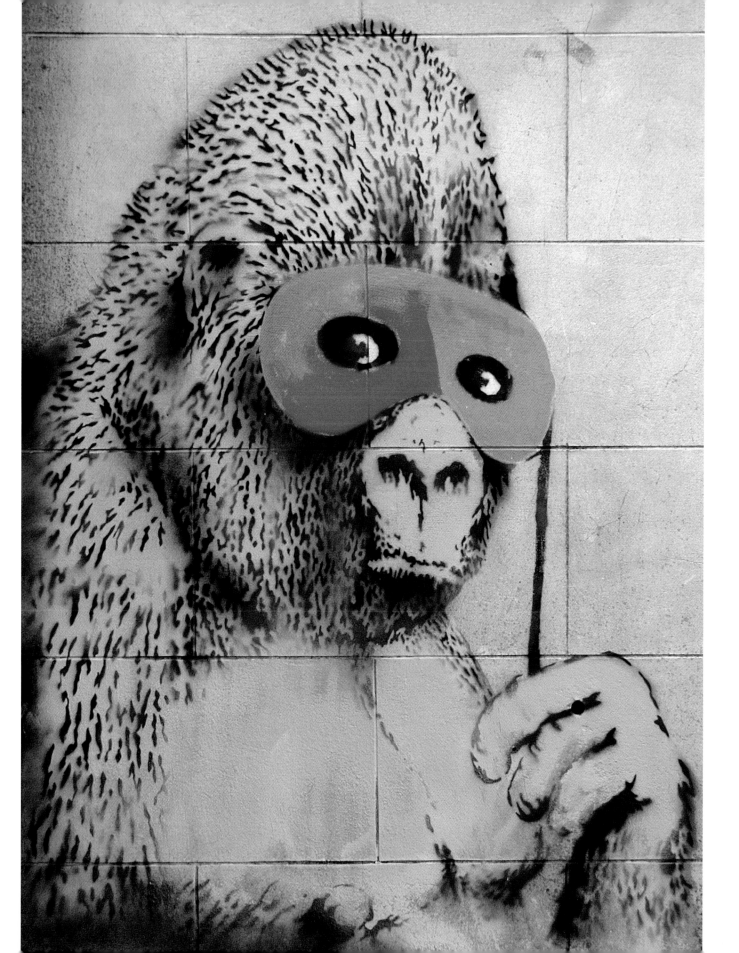

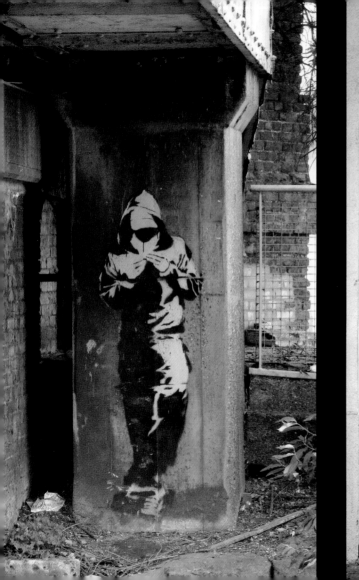
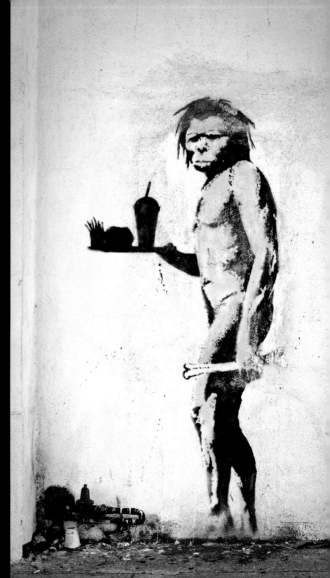

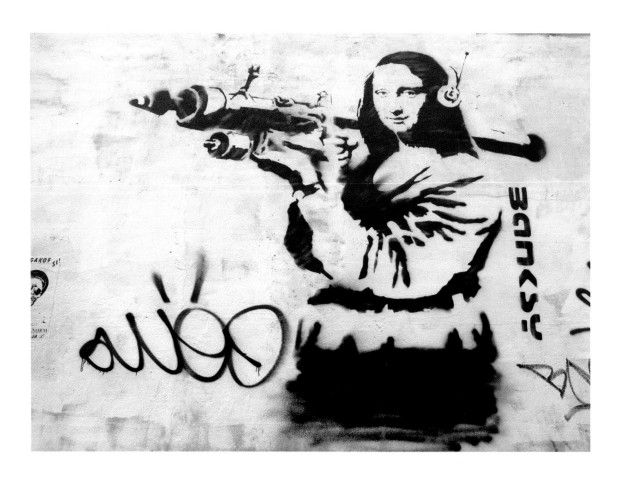

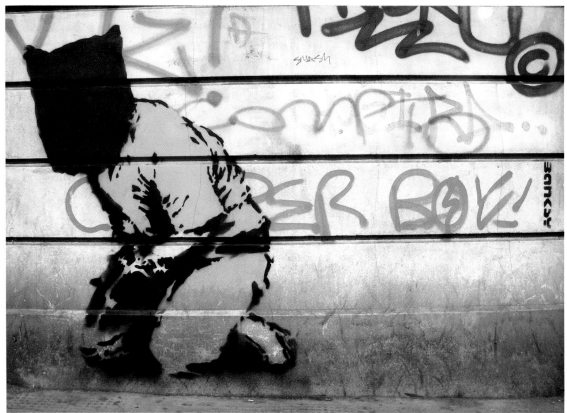

ANIMAL ARMY

(Hasta La Vista Heavy Weaponry)

2000, Banksy is at the Mayday 'Riot' in Parliament Square, London (There was no riot.) He paints a huge Mona Lisa with a bazooka on her shoulder. Hours later it is dogged:

"Only boys with small willies paint girls with big guns."

Possibly true, but you get the feeling that Banksy doesn't paint guns because they're cool, he is trying to make an anti-war statement. (And maybe because they're cool too.)

Early Banksy seemed to feature a lot more bombs, rockets and bazookas than more recent work. He is still drawn back to the absurdity of modern warfare but he seems to approach it differently now. The elephant with a rocket, the helicopter gunships with bows in their hair and the little girl hugging the bomb gave way to more sophisticated images like the sniper with the little boy about to burst a paper bag, or the image of a realistic child soldier in the scrawled environment of a child's drawing.

These images can be really arresting at their best. They've evolved from the kind of cartoonish carnival of Banksy's animal army to controlled irony, designed to reveal the foolishness hidden in plain view in our society's values.

BANKSY IS CLEARLY A GUFFHEAD
OF MASSIVE PROPORTIONS, YET HE'S
OFTEN FETED AS A GENIUS STRADDLING
THE BLEEDING EDGE OF NOW. WHY?

CHARLIE BROOKER - GUARDIAN ONLINE, 2006

MR BROOKER, CUTTING EDGE GATEKEEPER,
IS OBVIOUSLY STUNNED BY THE IDIOCY OF
THE GENERAL PUBLIC. HE'S RIGHT OF COURSE.
WE CAN ALL AGREE ON ONE THING:
EVERYONE ELSE IS AN IDIOT.

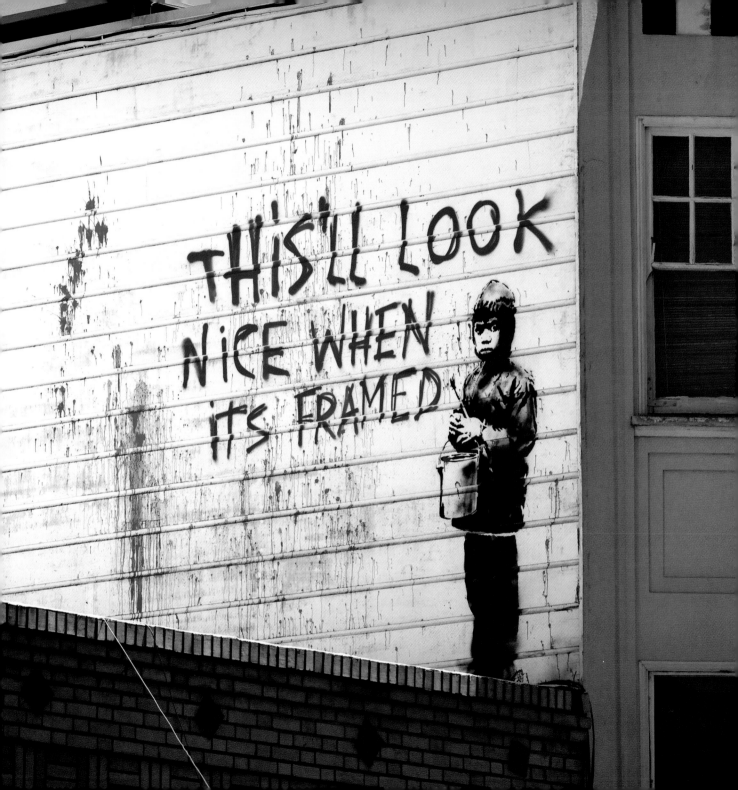

THE NAKODAR CURRY HOUSE MIRACLE

(It's Twice as Spice)

They say Banksy never strikes twice in the same place but that all changed in November 2011 at the Nakodar Grill in Glasgow, purveyors of fine curry at an excellent price, (call early to book your table in advance). It seemed odd to art experts at the time that Banksy should re-visit a stencil he hasn't used in a very long time - the Mona Lisa with a Bazooka. He must have spent ages looking for it. No wonder then that he had to do a new one that looks very little like the original, and is a lot smaller, and looks a bit of a rush job. Almost as if, it wasn't even him...

Banksy freely admits to working in states of advanced intoxication. Experts calculate he must have had about fifteen cans of Tenants Super Strength to come up with a piece this 'shit'. Marcus Macleod of Brae Gallery is in the process of trying to get it authenticated. This may take some time, possibly 'never', but for now he is fairly sure 'it looks like the real thing' (if you take GHB before you look at it). Or perhaps it is a collective hallucination?

The Nakodar Grill, as Glaswegians have always said - is a work of art.

"Aye, the Nakodar Grill? It's a work of art, y'ken?" - A Glaswegian

And now it seems almost certain that Banksy regularly goes there to sober up after a heavy night on the swally in old Glasgae town. Nobody knows why he should choose to paint there twice, but the lucky restaurant owners aren't going to look that little gift horse in the mouth, they couldn't have planned it better themselves. It was almost as if they had made it all up. So if you're ever in Glasgow looking for a fine curry, ahem, Banksy 'original' - you know where to go.

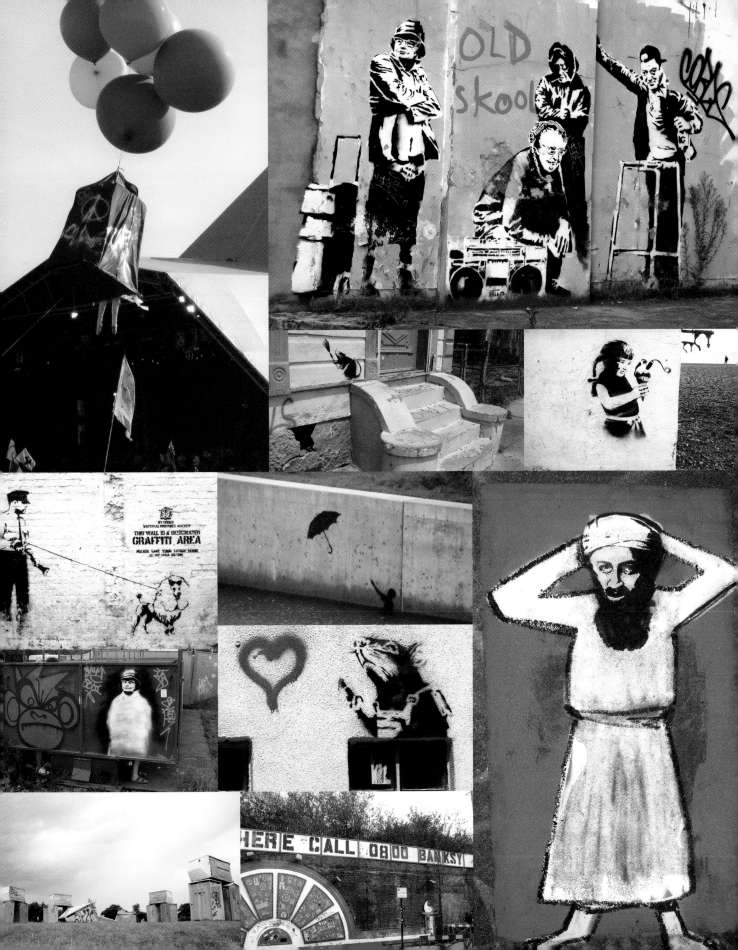

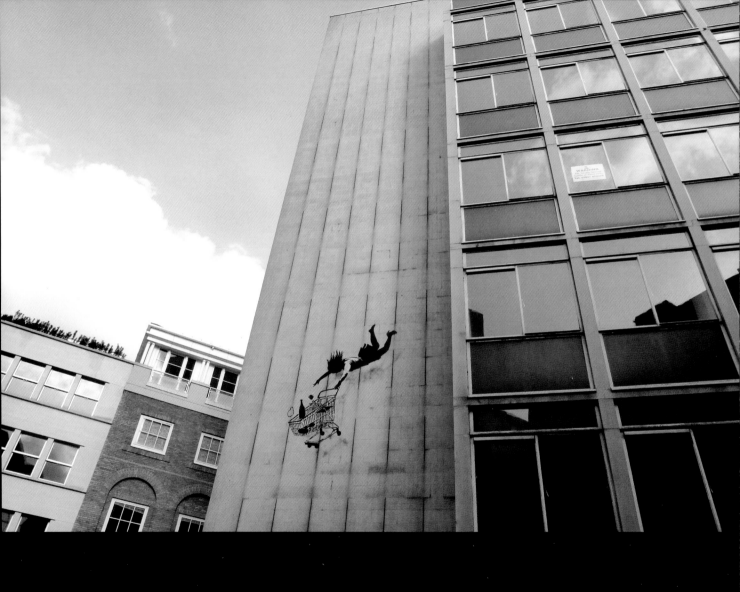

THE POET PRODUCES POEMS.

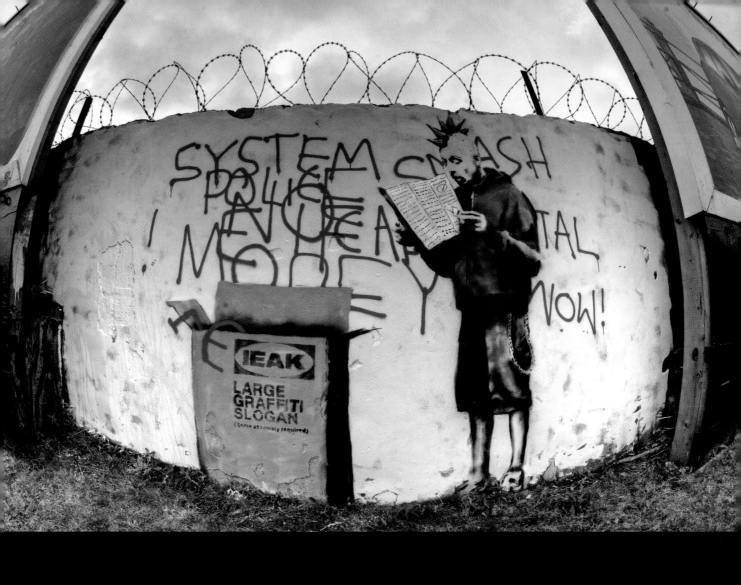

IF YOU CAN DO ALL THREE AT ONCE,
YOU'LL REALLY CONFUSE THE SHIT OUT OF THEM

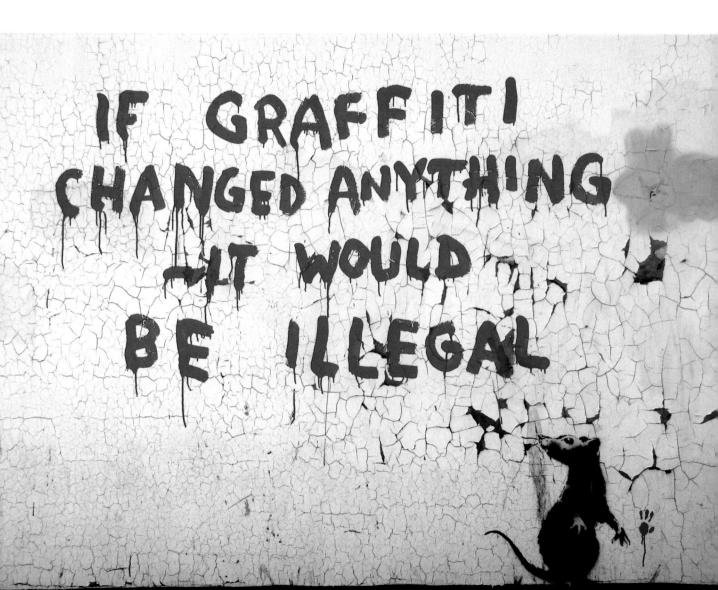

BLATANTPROVOCATION

It's not 'street art' if it isn't illegal. It is just art in the street. Street art is exciting because it is an attack on property, an attack on boredom and a reflection of the territorial power struggles hidden in plain view in the urban environment. This is why it may be nice to have legal walls and suchlike but it is always necessary to come back to the street.

It would cease to be an adventure if it were just another leisure activity. In a society that has reduced all human activity to a set of commodity exchanges the only adventures left are anti-social.

This is why it is irrelevant to divert the debate towards 'quality'. Like the 'right on' councillors who decide that some street art has 'value' as 'real art' and sanction it - or the pundits in the pub who say they like Banksy but don't like tagging. More tolerant people seem to think that the point is how nicely executed the image is. Hardliners disagree…

"If someone painted the Mona Lisa on the side of your building, it's irrelevant if it's great art, what matters is if you want it there."

Elyse Parker, Director of Toronto's Public Realm, Daily Brew

Either way, both of these viewpoints suggest that the law has full moral authority and the only concern is that it be applied with different emphasis. It is the view that 'the system works'. Both graffiti and street art come from completely the opposite perspective - 'the system is corrupt and therefore any way we can attack it is legitimate'.

If we lived in a functioning society these attacks would be rendered irrelevant. The argument implicit in any act of vandalism, from tag to full scale mural, is that we do not live in a functioning society. This wall that Elyse believes YOU decide if YOU want it there or not, to WHOM does it belong? HOW does it belong to them? WHY does it belong to anyone?

The city is lived in by people who have no rights of ownership over it.

The urban environment is in the hands of absent landlords at the end of long chains of middle men, propping up a tiny class of prospectors using the city as an investment portfolio. And for what? The relentless, obsessive accumulation of wealth.

This kind of ownership is an illusion. Painting on the walls challenges that illusion.

It momentarily breaks the spell.

BANECDOTES
#4

A BRIEF HISTORY OF STENCIL GRAFFITI

French artist Ernest Pignon-Ernest stencilled an image of a nuclear bomb victim back in 1966 to protest against his own country's nuclear armament.

American John Fekner started doing political stencils in the late 1960s, famously painting 'Wheels over Indian Trails' on the Queen's midtown tunnel in 1979.

Contemporary to both was Hugo Kaagman of the Netherlands who still calls himself the Stencil King and layers up huge numbers of stencils in colourful murals packed with symbols.

In the late 1980s two more Frenchmen, Blek le Rat and Jef Aerosol started painting stencils as a reponse to inspiration from the NYC hip hop scene. Paris got hip hop long before London did.

Blek le Rat moved onto wheatpasting pretty quickly after being busted for stencilling. His trademarks include images of himself in a suit and of course, a rat.

Blek enjoyed a renaissance of sorts through Banksy, initially saying he was quite happy about people drawing comparisons but later grumbling that he felt a bit ripped off. Banksy issued a statement through his own site saying he was not influenced by Blek but rather 3D from Massive Attack.

Carpet Bombing Culture also issued a statement through their own book saying they did not just rip this whole article off of Wikipedia.

Honest.

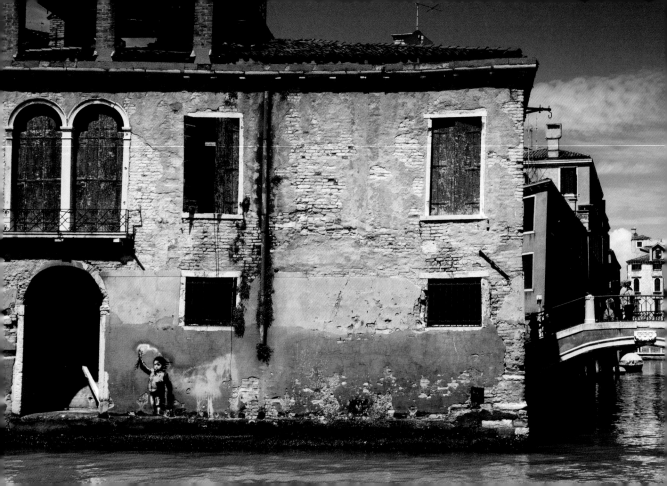

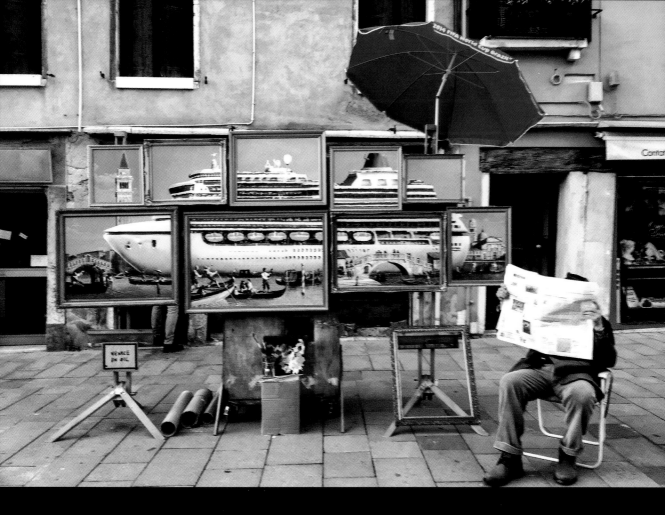

Banksy gatecrashed the Venice Art Biennale of 2019 with two pieces. The first, a display of paintings which was set up in St. Mark's Square. The nine oil paintings in traditional gilt frames formed a large image of a cruise ship in the Grand Canal surrounded by Gondolas. It's nicely reminiscent of Canaletto's paintings of the eighteenth century Grand Canal, with the Doge's barge replaced by a whopping great cruise ship. A gentleman sat with the paintings under an umbrella on a camping chair, reading a newspaper nonchalant. Probably not Banksy, but hey who knows - and he was soon moved on by the polizia locale.

Another piece, a stencil of a migrant child wearing a life jacket and holding a flare, went up in Dorsoduro, Venice, on a canal front wall. Is it a flare? It's smoking neon pink in a cloud that billows out behind her. But the thing in her hand looks like a bundle of weeds or something. There is a wind blowing her hair and the smoke away from her and the placement suggests she has just made it to the edge of the water, or perhaps she is just about to set sail.

Some journalists have interpreted the cruise ship as a protest about the damage that cruise ships are doing to the infrastructure of the fragile city of Venice. There has been a campaign to ban them from the city, and back in 2017 ships larger than 55,000 tons were banned from the city centre. Another black mark against the cruise industry came to light the same year when a report showing that the average cruise ship pollutes as much as running one million cars a day.

I may be wrong, but there seems to me an obvious connection between the two pieces of work - two different ways you can get a boat to Italy. It's about the two ends of the spectrum of inequality in our time. We live in a world of floating pleasure palaces, luxury hotels built on water, which is simultaneously a world of desperate families stuffed into inflatable rafts and left to drown, all of which is happening in the same sea, the ocean at the centre of the world - the Mediterranean. This is good old-fashioned political art, with a moral purpose - and we still need it, because it's still all too easy to ignore the rafts while we drink prosecco at the Art Biennale.

THERE ARE FOUR BASIC HUMAN NEEDS;
FOOD, SLEEP, SEX AND REVENGE.

BANKSY

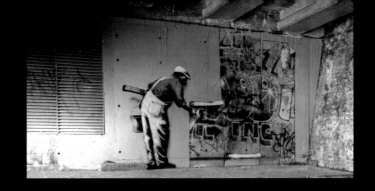

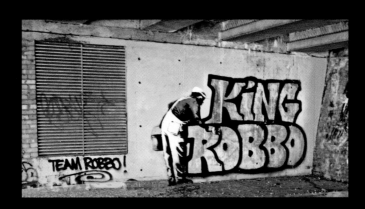

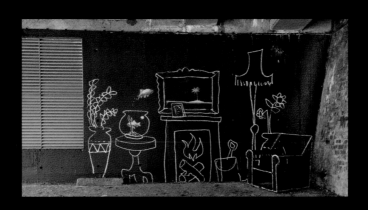

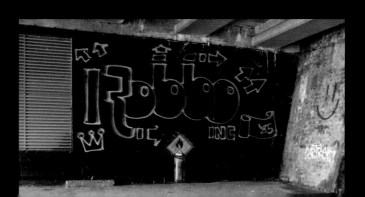

HANDBAGS AT DAWN

(Banksy vs Robbo)

It was billed as the final showdown between Graffiti and Street Art. Two legends slugging it out at Camden canal for the honour of their respective art forms. It was a battle that set internet discussion holes alight with virile banter and spirited trolling. Then it all got rather sad and serious with an unexpected turn of events.

King Robbo was a genuine original. In 1985 he was one of a tiny handful of individuals bringing graffiti culture to London. When his piece went up by the canal it was groundbreaking work. It enjoyed a longer life than most pieces although it was badly dogged by 2005.

Banksy clearly felt it was so out of shape that nobody would mind if he gave it a bit of a remix. If we believe this was his motive, the sleight was unintentional.

Carried out in 2009, Banksy's workman was depicted wallpapering over the original Robbo piece and was a typical piece of optical illusion and visual comedy for the Bristolian chancer. Robbo, who had by now retired from the game, personally came back to the canal and upped the ante to paint KING ROBBO in such a way as it appeared that the Banksy character was painting it.

Perhaps it should have ended there. It didn't. Someone, possibly Banksy came back and added - FUC to complete the piece and take things up another level. A move any schoolboy would be proud of. Was it an angry Banksy fan, or the man himself defending his rep?

At this stage it seems it all gets complicated. Lots of Banksy pieces are dogged in reasonably witty ways. He is accused of all the usual crimes, copying Blek le Rat and dredging street cred from the city of London.

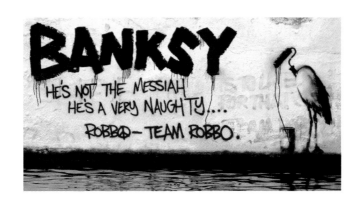

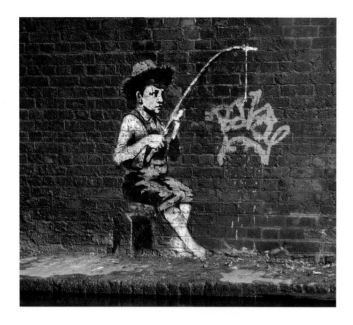

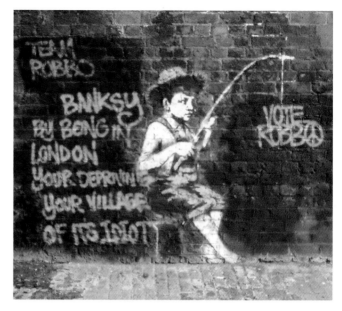

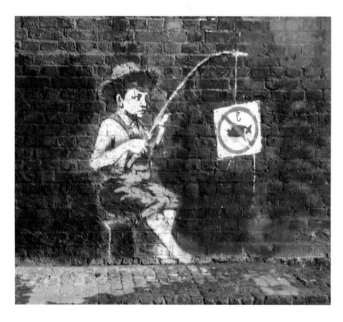

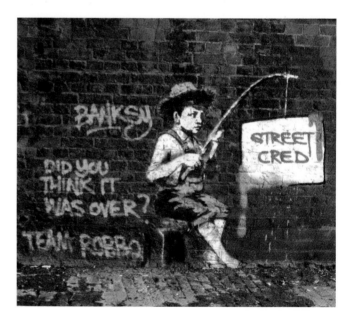

Robbo has a team of supporters so it's difficult to say who actually did what. The spot is retouched by Team Robbo back to KING ROBBO. Then it gets painted black. Which creates the perfect canvas for a lovely painting of Top Cat leaning on a tombstone marked 'Banksy's Career'. Presumably, painting famous retro cartoon characters will now be returned to the foreground as the true spirit of street art.

January 2011 and nobody can figure out exactly what Banksy is trying to say with his retaliation, a primitive drawing of a living room with a goldfish leaping out of a bowl. Hmm.

Buffed again, the wall is painted black. Was it Mick Jagger?

Now it all gets real when tragedy strikes and Robbo sustains a head injury in a terrible fall that puts him into a coma.

Banksy drops the grudge against Robbo and paints a touching tribute to the big man, drawing the original outline of his 1985 piece back up with a candle depicted by a spray can.

Finally, Team Robbo step back into the breach once again, with a genuinely sympathetic piece that hopefully, if luck has it, will run and run for another 25 years.

Vive La King.

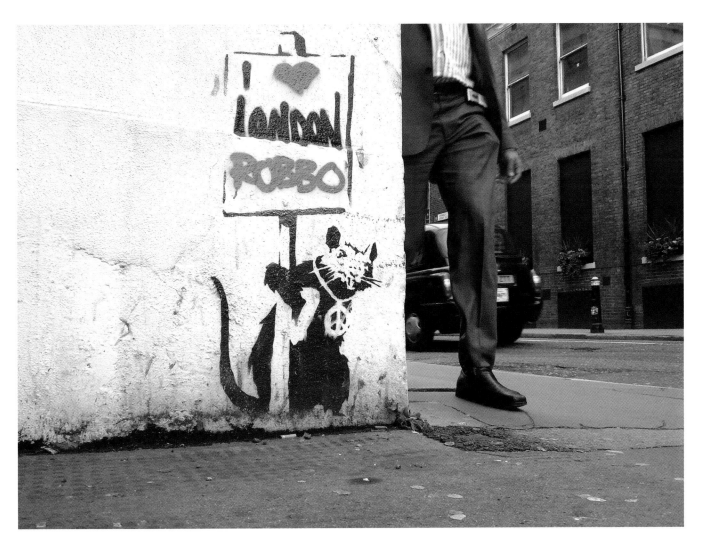

BANKSY - PARIS 1968 REVISITED

Banksy went to Paris in 2018 to paint a collection of murals with a loose theme of the migration crisis in Europe. We live in a time when there are more displaced people in the world than at the end of World War II. In spite of brief flowerings of compassion, Europe is generally getting more hostile towards asylum seekers.

It was also the fifty year anniversary of the 1968 student uprising in Paris. You probably wouldn't notice. It's not the kind of thing that gets much press. While everybody goes batshit trying to stir up misty eyed nostalgia for the First World War, only a few lefty intellectuals will raise a glass of beaujolais for the 1968 riots.

Briefly, tens of thousands of students and staff from the major Paris universities occupied university buildings, marched and clashed with the police. Then there were wildcat strikes and factory occupations on a massive scale. It was the closest thing to a revolution the modern western world has yet seen.

The most significant thing about 1968 was perhaps the ideas that drove it - they didn't ask for a Communist State or slightly better working conditions - they asked for new world, one in which everyday life would be completely different from the new consumerist capitalism and one in which Imperialism would come to an end. This widespread understanding that Imperial Europe had created the global inequality that leads to the migrant crisis of today, has slipped out of the public conversation about migration. Banksy is perhaps trying to bring it back.

Banksy makes a direct reference to 'Mai '68' with his mural near a migrant centre in Paris. The eight has fallen down, landing on a rat's head, looking suspiciously like Minnie Mouse's ears with her distinctive bow. Is this a barbed critique of France's failure to live up to the anti-consumerist ideals of 1968? After the revolution fizzled out, the road chosen - the Disneyfication of Paris.

Has Banksy been reading Jean Baudrillard, the postmodernist philosopher, who was working at the University of Nanterre, May 1968, and who later

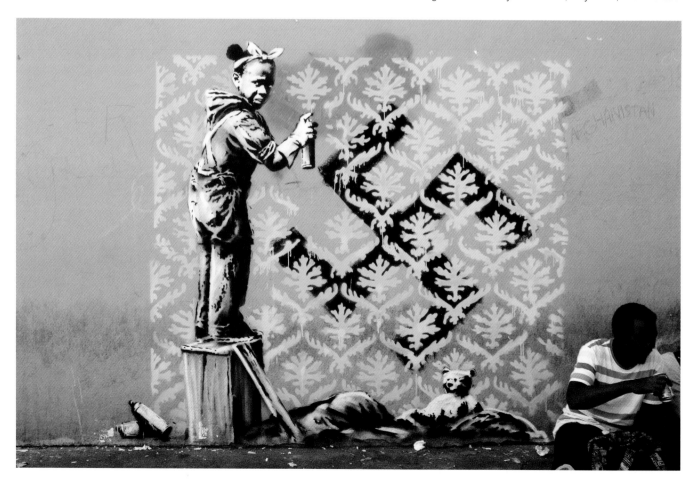

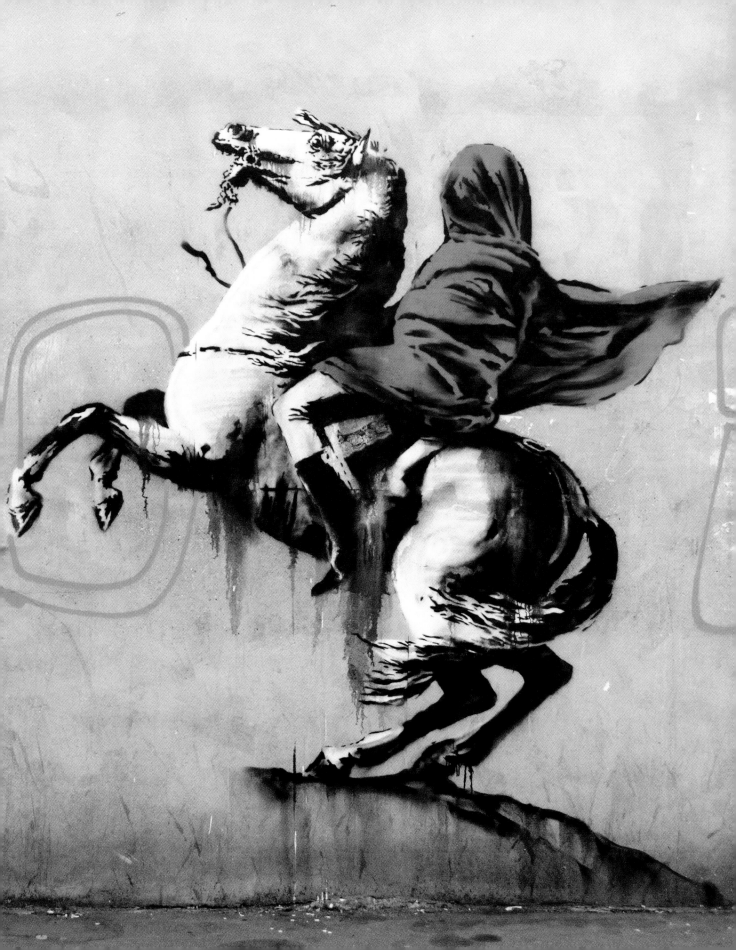

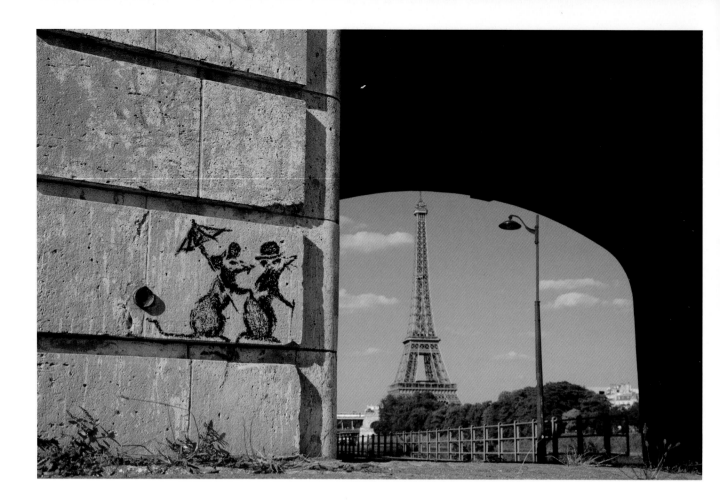

came up with 'hyperreality' in his famous work on Disneyland and Watergate? Or maybe he is slyly referencing EuroDisney. If you really want to know, ask him on Instagram. Who reads books anymore?zzzzz

The other story that is buried deep underneath all the World Cups, Brexit Bickerings and Love Island, is the migration crisis. And Banksy does like to shine a spotlight on the things we sweep under our collective rug. In this case the rug is Europe.

Since 2015, instability in South Sudan, Syria, Afghanistan and many other regions of Africa and the Middle East has led to a steady rise in the number of refugees in the world. Between 2011 and 2016 there was a 40% increase in the number of displaced peoples worldwide. There were 65.6 million displaced people in 2016 of which 22.5 million were classed as refugees. By the end of 2017 there were a million asylum applications to European states, although most refugees are hosted in countries outside Europe.

So far, so much number crunching. A little girl sleeping rough by the river Seine is the human reality, trying her best to live in a world that doesn't want her to exist. Art is better than Science at communicating these things. We are living in a time of mass migration. It is not going to go away. It will probably get a lot worse. Qu'est-ce qu'on va faire?

The image of Napoleon with a veiled face is a reference to France's law against wearing the Niqab in public, a controversial measure that illustrates the tension between the French state and it's population of roughly eight million muslims, legacy of France's imperial adventures in North Africa and the Middle East. The child in mourning near the Bataclan nightclub, strikes a sympathetic note with the victims of the 2015 terror attack.

Elsewhere, the rats are up to their old tricks. A nod to the fact that Paris was the 'birthplace of modern stencil graffiti' (see Blek le Rat) and that Paris is still a city of grotesque inequalities, from Champagne nights to the Banlieues. And of course, like a dog with a bone, there is a reference to capitalism - which saws off your leg and offers you a bone in return.

Fifty years after 1968, Banksy is still trying to imagine a world without capitalism. He's the one asking the questions that we all try to forget to remember.

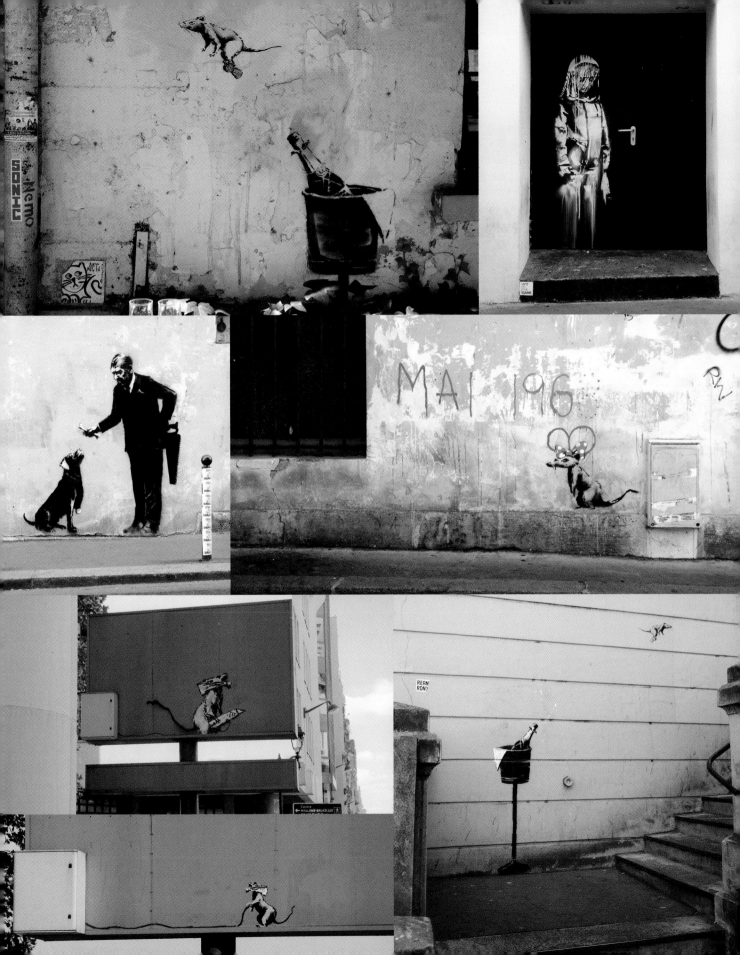

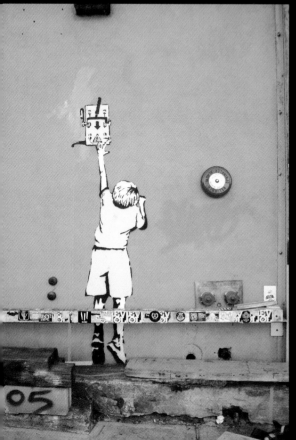

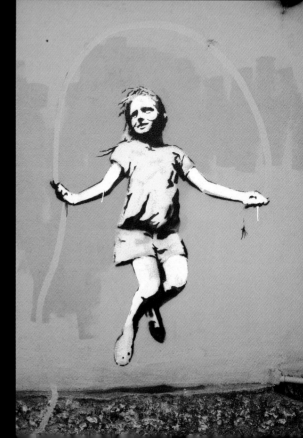

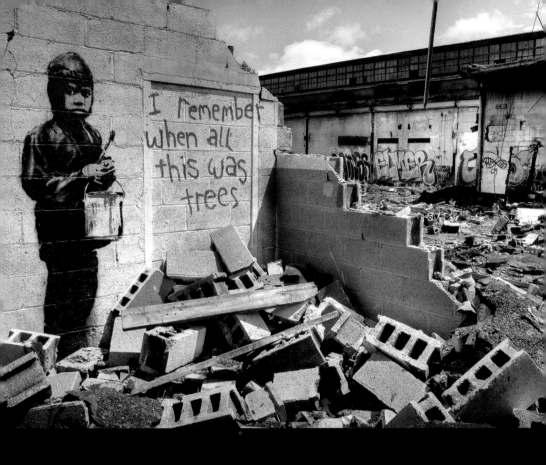

GRAFFITI IS ONE OF THE FEW TOOLS YOU
HAVE IF YOU HAVE ALMOST NOTHING.
AND EVEN IF YOU DON'T COME UP WITH A
PICTURE TO CURE WORLD POVERTY YOU CAN
MAKE SOMEONE SMILE WHILE THEY'RE HAVING A PISS..

BANKSY - BANGING YOUR HEAD AGAINST A BRICK WALL

VANDALISM
VANDALISED

(Banksy's Silent Disco)

It could only happen in Torquay. Or anywhere else.

Torquay, the Los Angeles of South West England, was robbed of its dreams of a world class Banksy themed nightclub when vandals melted a little boy to death with paint stripper outside the infamous Grosvenor hotel.

The innocent little boy, created by one Mr Banksy, had been wrapped up in cotton wool (actually, see-through plastic) but it was not enough to stop vandals vandalising the vandalism vandaliciously. It was hellish.

The boy simply melted away like heavy eye makeup in a torrent of tears, leaving only a lonely robot behind.

Police are investigating. The hotel is devastated and Torquay will never be the same.

The owner of the hotel said he had been intending to name its new nightclub "Banksy's" but would now be looking for a new name.

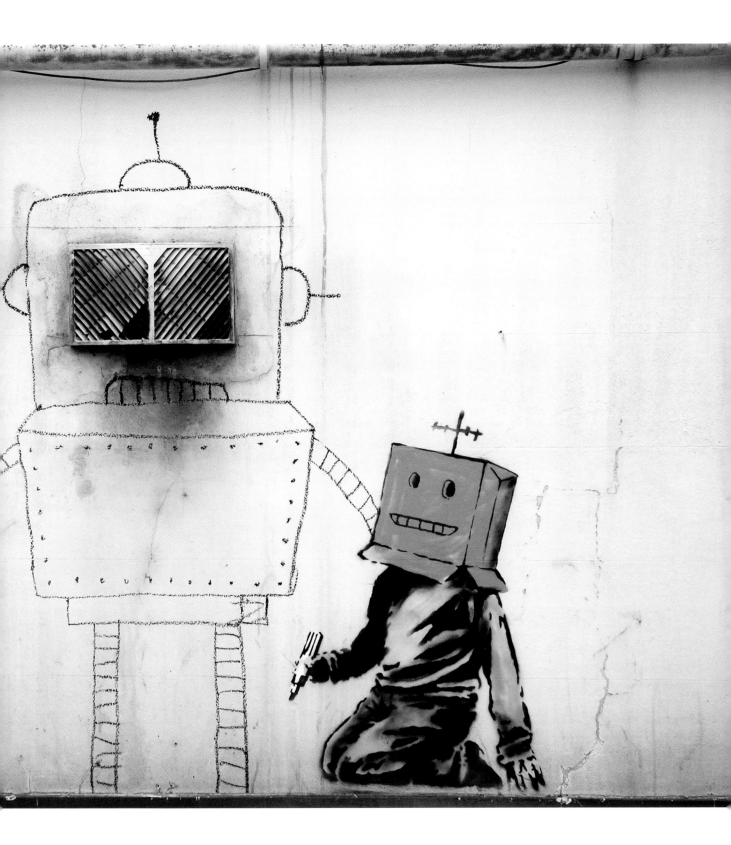

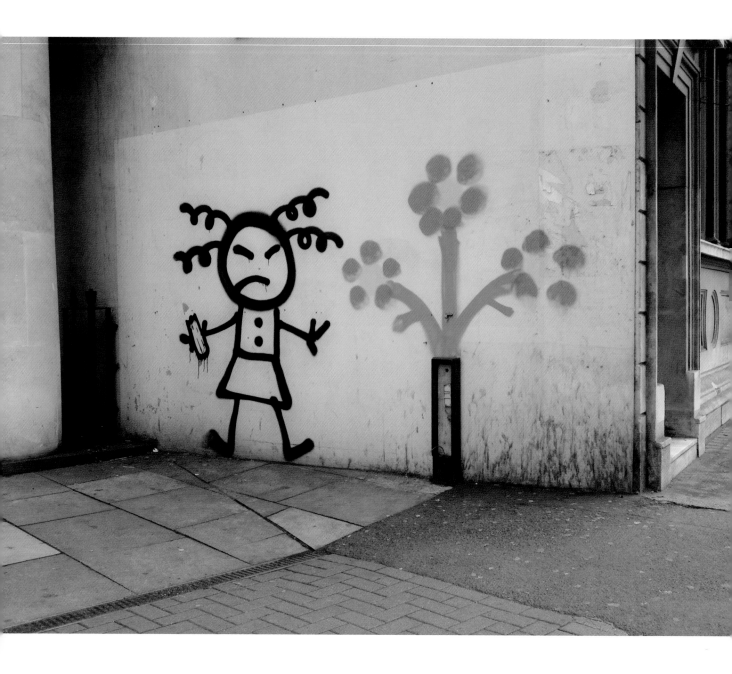

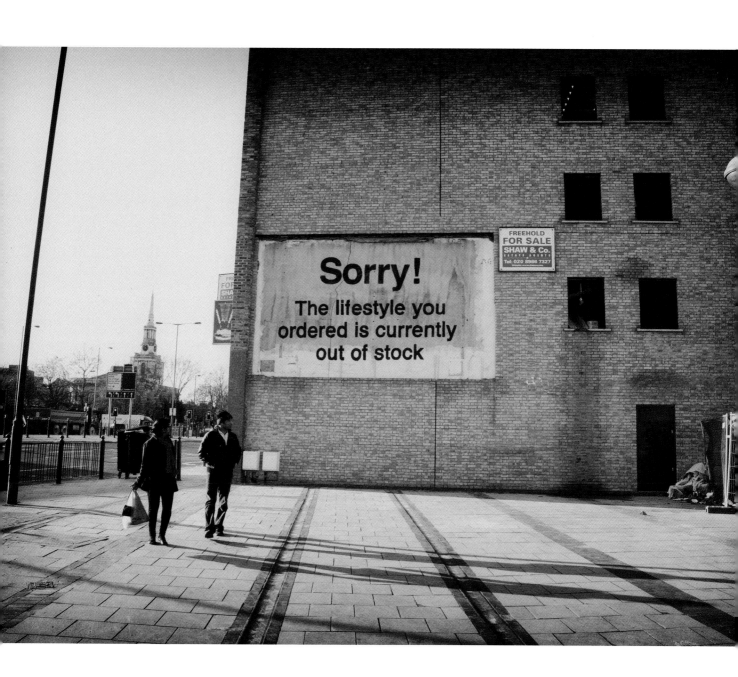

CASH FOR CREDIBILITY

(Buying into the counter culture)

It's a bit weird buying agit-prop art to decorate your dining room with. No matter how much you might agree with a hard hitting sentiment, nobody wants to see the little girl running from the napalm attack while they're having a bottle of wine with some friends on a Friday night, or do they?

Revolution lite, repackaged and sold back to the masses is nothing new. It's been going on since lifestyle advertising was invented in the 1960s, and its invention was concurrent with the birth of the counter-culture itself, the Hippy movement.

Taking radical gestures and absorbing them into a narrative that supports capitalism is a process which provokes a kind of defeatist self awareness in young artists who may genuinely wish to strike out against the machine but fear that it's always already an empty cliche, doomed to make a nice T-Shirt. (It was rumoured that back in the day Banksy did try out some T-shirt designs with a Bristol based screen printing outfit, but jettisoned the idea when he saw someone wearing one on the street).

That fear of being co-opted is massive for your common or garden left-winger. In fact, one of the most surprising things about Banksy doing what he was doing at the turn of the millennium, is that most people had completely given up on that kind of political agitation as hopelessly naive. As part of a very small current of rebel activity, Banksy, Reclaim the Streets, the Free Party scene and a couple of anarchist zines formed the tattered shreds of all that remained of the once mighty British left.

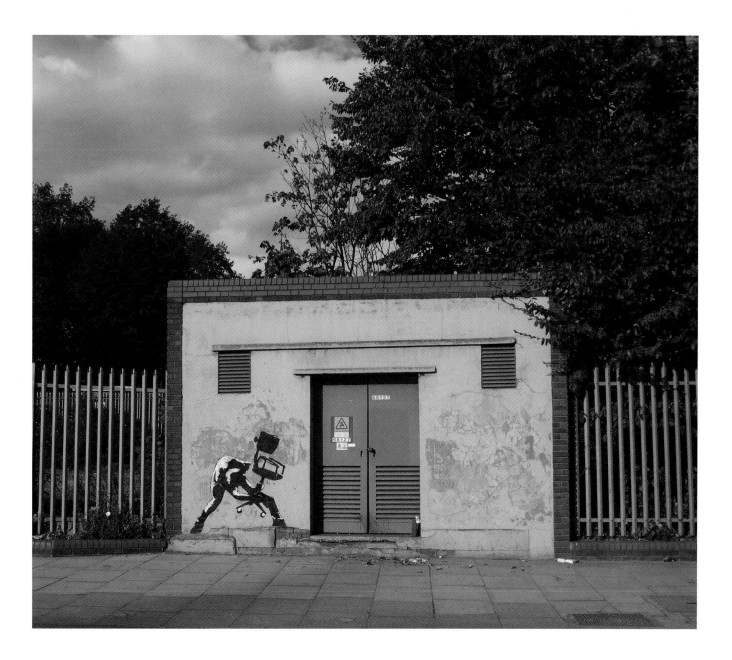

And of course the inevitable happened. Banksy was co-opted. Or was he? Was everyone too quick to proclaim that in criticising 'Brandalism' he, like Naomi Klein, had made himself a brand, victim of his own success, blah blah blah.

Even before the 1960s the left was struggling with this idea of being co-opted. The Parisian group calling themselves the Situationists came up with a strategy for counter attack. By taking symbols co-opted by the system and constantly remixing them in a spirit of play they could undermine any attempt to absorb their activities. They called it Detournement.

"The French word détournement means deflection, diversion, rerouting, distortion, misuse, misappropriation, hijacking, or otherwise turning something aside from its normal course or purpose." - Ken Knabb

Which is what street art, at its very best, can do. The situationist vision was that in time there would come a revolution of everyday life; people would learn to create their own situations rather than live as dictated to by the dead hand of history.

"Life can never be too disorienting: détournement on this level would really spice it up." - Guy Debord

In this spirit, if you really like Banksy, it's more important to copy him than to buy his stuff.

BANECDOTES
#5

WHO LET
THE DOGS OUT?

So Banksy done a picture of a hoody walking a funny dog which we found out was in the style of Keith Haring from reading other people's blogs. So then we had to pretend like we'd known who Keith Haring was all along. Actually that's the beauty of a tribute, innit?

Turns out Haring was an artist and social activist from Pennsylvania who died in 1990. He moved to New York in the late 1970s and became mates with Basquiat (look him up, we can't do everything for you.) Haring worked in lots of different media but became a street art pioneer in the 1980s when...

"He noticed the unused advertising panels covered with matte black paper in a subway station. He began to create drawings in white chalk upon these blank paper panels throughout the subway system. Between 1980 and 1985, Haring produced hundreds of these public drawings in rapid rhythmic lines, sometimes creating as many as forty "subway drawings" in one day."

Haring.Com - Official Site

This is Banksy's second art dog. The first was Jeff Koon's gigantic pink balloon poodle, rendered as a police dog. Does this mean Banksy likes Jeff Koons, a bona fide modern artist who has had stuff in the Tate? Curiouser and curiouser...

Incidentally, the Haring dog got...dogged.

SOMETIMES THE RIGHT THING TO DO...
IS THE WRONG THING.

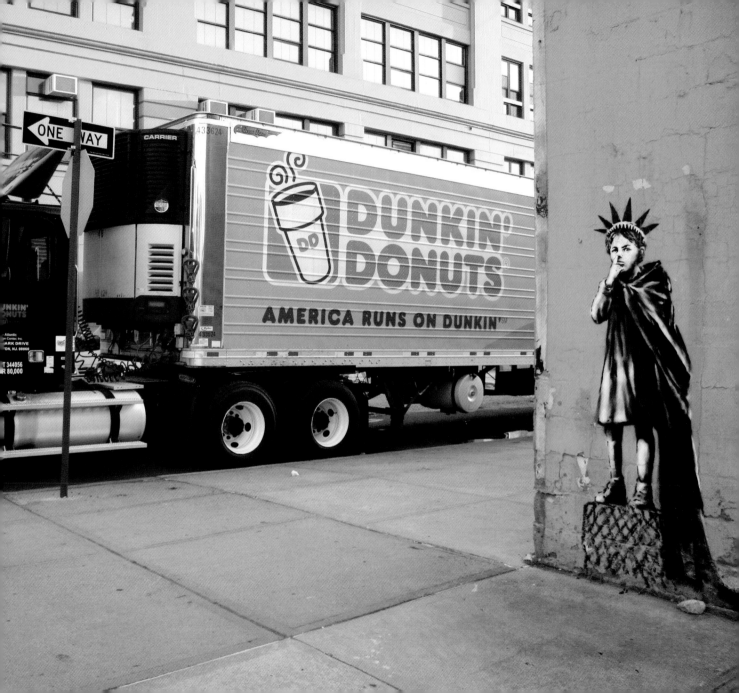

BELLY OF THE BEAST

(Has Banksy got his heart set on breaking America?)

With the movie, the collaboration with Shepard Fairey, the New York Pet Shop and trips to LA to promote 'Exit' just before the Oscars, it feels like Banksy is trying real hard now to break the states. But why does he choose to eschew all the other countries he could be hitting like his more internationalist comrades such as Blu, C215, Swoon, Os Gemeos and company?

"The Englishman starts with America at the breakfast table." - Derek Boshier, 1964

Which pretty much says it all. Since the 1950s the steady invasion of North American culture into the UK has been a story of both positives and negatives. For the teenager or teenagers who would become Banksy, Hip Hop was a beacon of hope in a depressed and angry 1980s Britain filled with riots, strikes and the inexorable rise of the yuppies, and like Blues, Rock & Roll and blue jeans it was a rebel culture that originated over the Atlantic.

When Bristol contemporaries Portishead released their third album they talked about wanting to give something back to Hip Hop. Perhaps Banksy wants, in his own way, to pay back his influences. Then again, there is another angle.

Banksy is against War, Corporate Capitalism and Hypocrisy; the USA is the Belly of the Beast as far as those things are concerned. The USA may do a nice sideline in exporting rebel cultures but mainly it exports unregulated free market capitalism in all its spectacular, technicolour, lifestyle-branding glory.

If you want to attack the status quo then where better to go than to the heart of it all. The USA invented the current status quo and maintains it with a combination of the most powerful propaganda machine ever known and the most expensive standing military force in history.

America is the belly of the beast for one thing. And it's also the source, the origin of the hip hop and graffiti culture that blew Banksy's suburban teen mind in the late 1980s. It has to be America. Their culture machine is flooding the world, he wants to reverse the trend. That would be the most ambitious thing he could do.

At a time when US hip-hop has become little more than a vehicle for aspirational marketing, selling luxury brands to people who can't afford them (looking at you Kanye), maybe Banksy can reverse the polarity and ship a little culture back to the states. Who knows, maybe some suburban American teenager will be inspired by British rebel culture for a change?

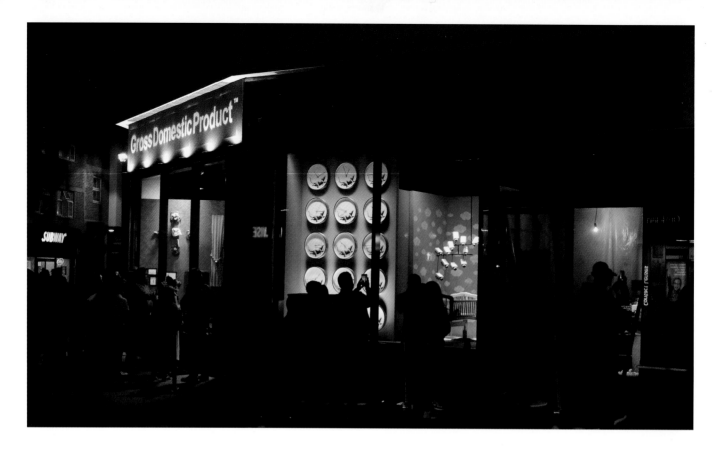

NO ENTRANCE TO THE GIFT SHOP

Banksy™ Where do you know him from? Isn't he that greetings card brand belonging to some 'Art Licensing' company? No, he is not. He's a shop in Croydon. Well he was, for a brief moment. Although it was less a shop really than a showroom:

"This showroom is for display purposes only." Banksy

You weren't actually allowed in, to do any 'shopping', however the products really were for sale - you had to buy them from grossdomesticproduct.com. This is key, because the whole thing was, according to the Artist, a piece of legal maneuvering to prevent aforementioned company from claiming total custody of the Banksy brand. (Something the company has vehemently denied they were trying to do.) So apparently, Banksy's attorney advised him to protect his trademark by opening a shop, because you can't just 'own' a trademark, one must 'defend it in the market'.

And so it was, that In the early Autumn of 2019, an empty corner unit in a busy commercial area of Croydon was being quietly refurbished behind the shutters. Without warning, October 1st there appeared a very slick looking shopfront, all polished black tiles, with (is that Helvetica?) a very graphic design looking shop sign featuring the now trademarked GrossDomesticProduct™ "Where Art Irritates Life". In what is apparently not even a joke, this is an actual trademarked trademark belong to the now trademarked Banksy™ and it represents™ a line of homeware™.

There are layers to this shop stunt thing. The official statement coming from house Banksy™ was:

"A greetings cards company is contesting the trademark I hold to my art, and attempting to take custody of my name so they can sell their fake Banksy merchandise legally...I think they're banking on the idea I won't show up in court to defend myself."

However, the shop was really a fully featured exhibition that took aim at a range of targets and gave real support to people trapped in the hellish scenes of mass migration that characterise our historical moment.

So far, so amusing. But as ever, there is a touch of Robin Hood to it all. Some of the money is earmarked for purchasing a new ship to replace the migrant rescue boat that was impounded by Italian authorities in August 2019. Italy's increasingly hardline approach to migrants crossing the Med remains part of a worldwide shift towards right wing populism, something Banksy is clearly attacking with this shop installation.

The shop will have closed its doors (which were never opened) in meatspace and hyperspace by the end of October 2019, which by now; is firmly in your past. Unlike the migrant crisis.

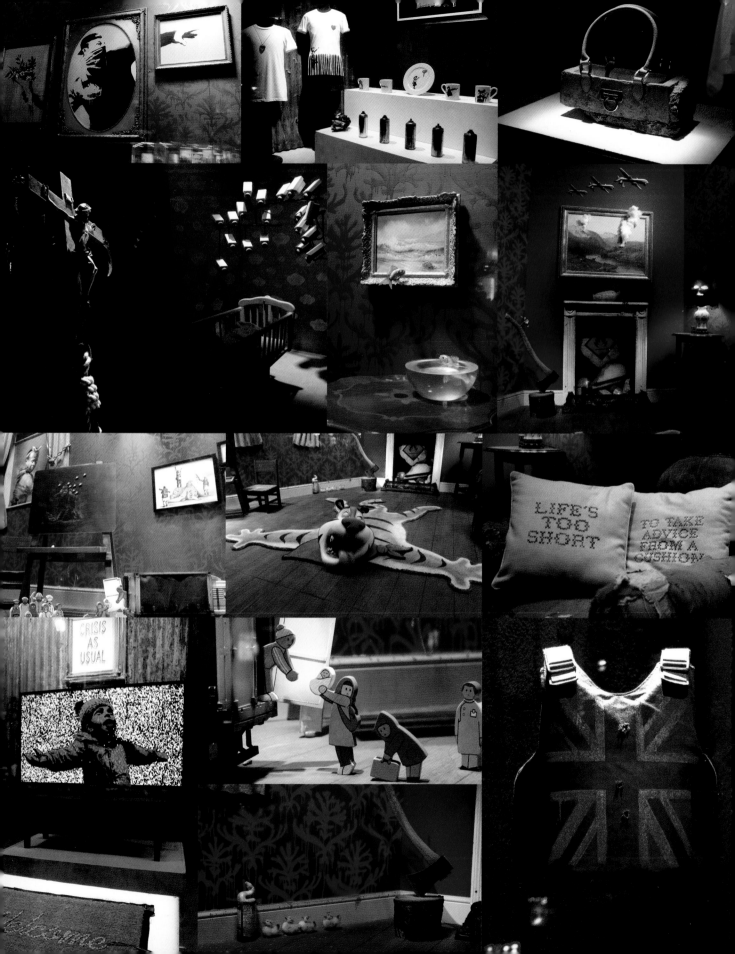

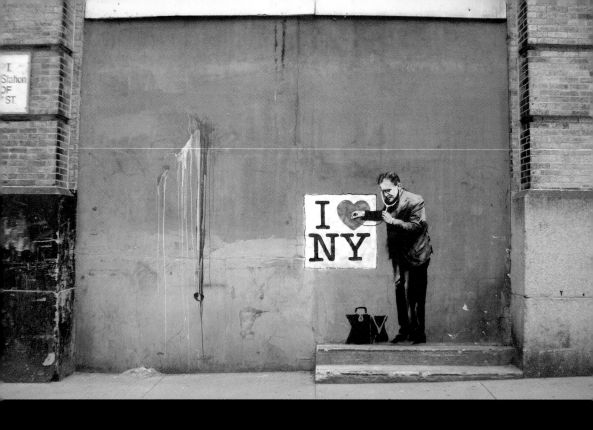
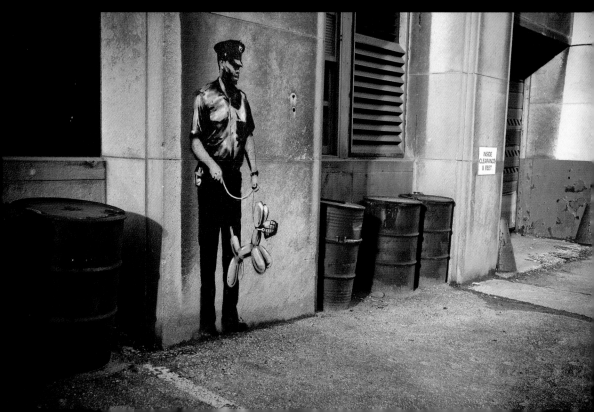

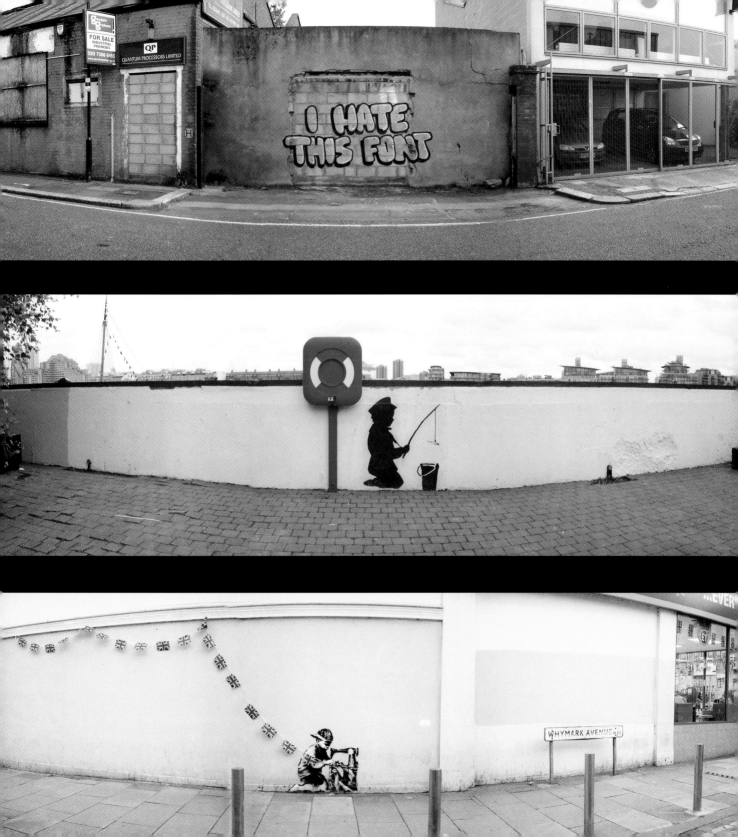

BANECDOTES
#6

LIGHT GROUP
ELATED OVER
POSSIBLE BANKSY
PISS TAKE

During the Academy Awards in 2011, Banksy (allegedly) bombed a large roadside billboard ad for a Las Vegas management firm called the Light Group. The original advert was selling the celebrity lifestyle itself, made into a product. The tagline: The Right Lifestyle. The image: a skinny teenage looking girl in a bra and jeans.

Whoever it was added two Disney-esque mice characters to the image, one lecherous, stubbly male, wasted on martini pawing at the teenage looking model's boob, and a Minnie the Mouse styled character hoovering up cocaine through a giant cartoon roll. It was tagged - 'Living the Dream'

Were Light Group upset by this slam? No, they lapped it up in a tone part nauseatingly sycophantic and part debased, defiled and degenerate in its obsequiousness. They cunningly kicked up a fuss when the piece was taken down by the billboard owner, CBS, in order to generate publicity, which we are here foolishly continuing to grant them. Forget about them!

No wait, it's too funny...

"We're extremely pissed ... It's our billboard that got tagged .. it's not their billboard ... CBS clearly has ZERO appreciation for art!!! We were flattered Banksy tagged on our ad -- it was epic."

I think I just epically threw up in my own mouth.

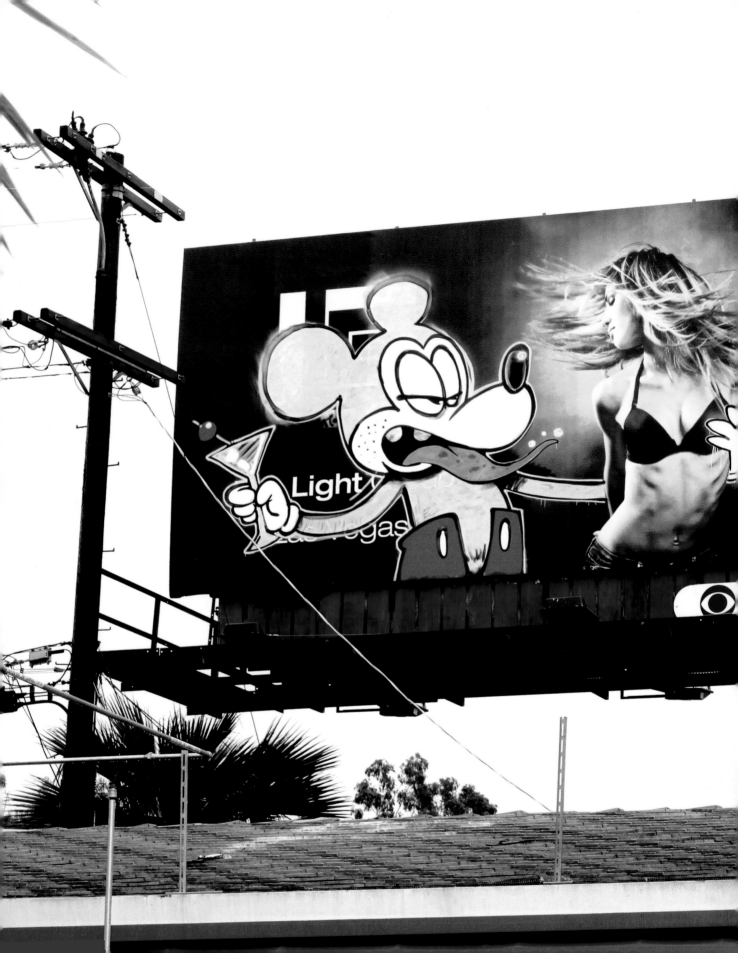

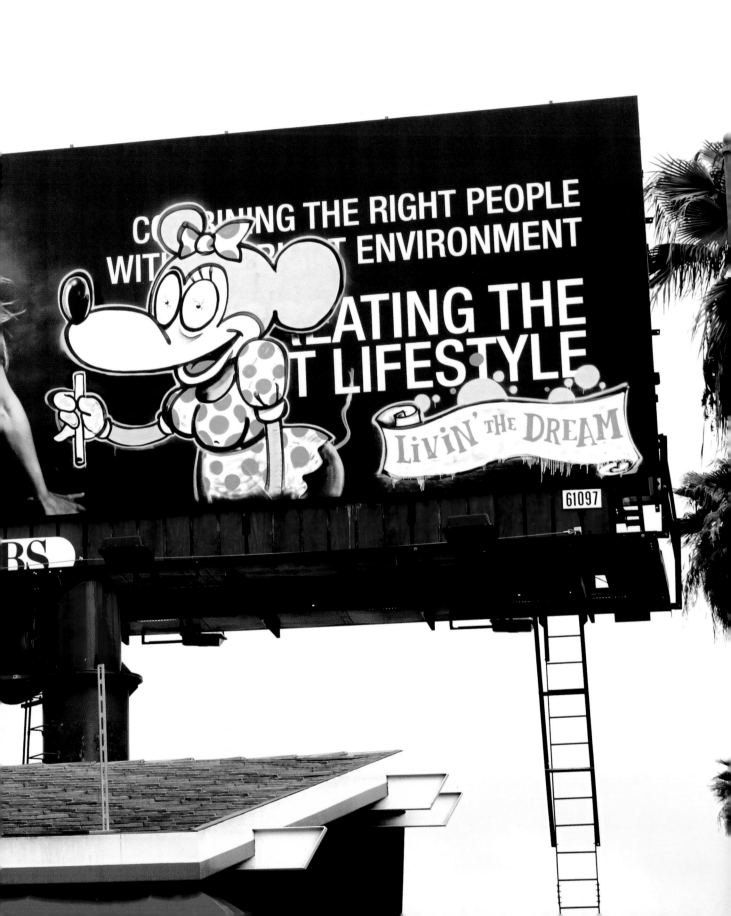

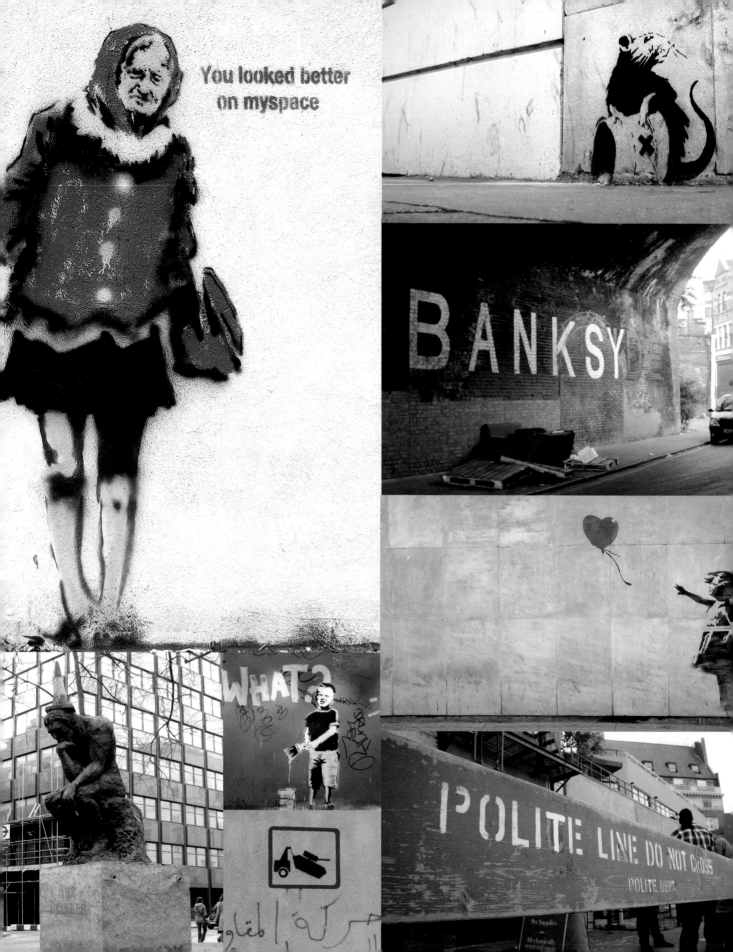

You looked better
on myspace

BANKSY

WHAT?

POLITE LINE DO NOT CROSS
POLITE DEPT.

FIRST TIME AS
PROPERTY DAMAGE

(Second Time As Theft)

There are environments right, in which we stage the situations of our everyday lives yeah? Within that, there are commodities yeah. Those things that are exchanged for money. And largely, we're all wrapped up in this process of exchanging things, am I right? These processes occupy most of our head space, and being largely predictable, we cruise through the mess of it all day, dreaming of more interesting shit. Now sometimes, some people act on these daydreams and all of a sudden, something unexpected happens. But like an ant nest that has been kicked, the disruption is very quickly absorbed into the rhythm of life (living or sleepwalking if you prefer).

Now we take 'environment' as given, it's just a backdrop to the business of exchange. But when someone paints a picture on a wall - that is a disruption because it is given freely. It's not a commodity, because there is no exchange. We get used to it as it gets more common, we see more pictures on walls. We ultimately come to believe that it's just another, subtler form of marketing. But then something even more unexpected happens. One group of pictures acquires a higher cash price through a mysterious process known as the 'market'.

Now the wall stops being 'environment' and becomes 'commodity'. All that remains is someone with a big enough reach to pick the wall up and take it to 'market' where it can be exchanged and thus the ant nest is rebuilt. The disruption is over. Back to work everybody. Nothing to see here.

And the beat goes on.

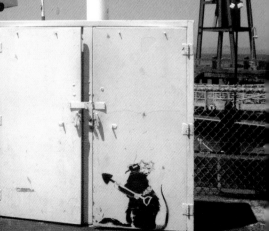

VIEW
ALCATRAZ

RED & WHITE
FLEET

HARBOR QUEEN

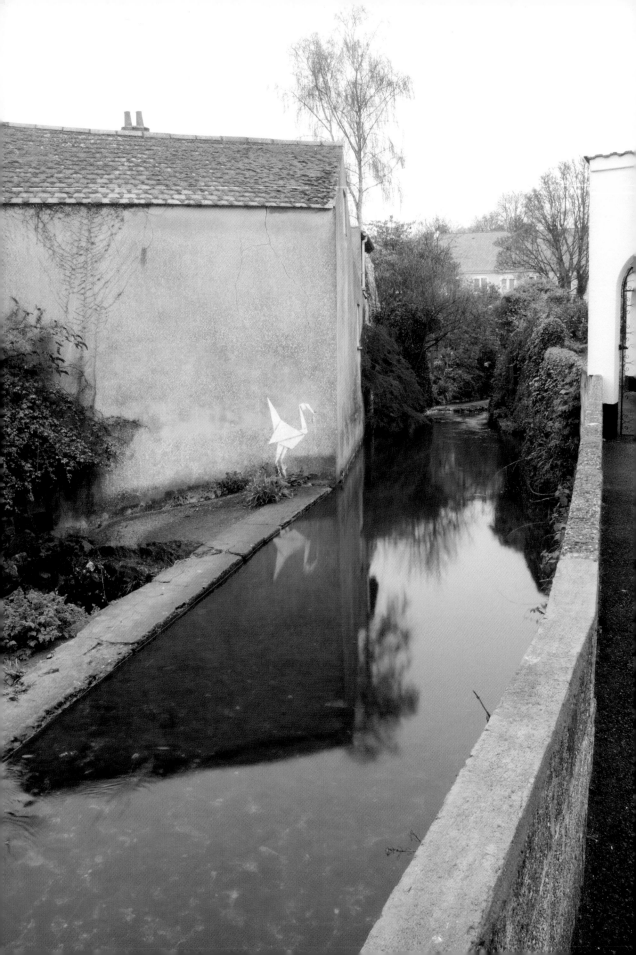

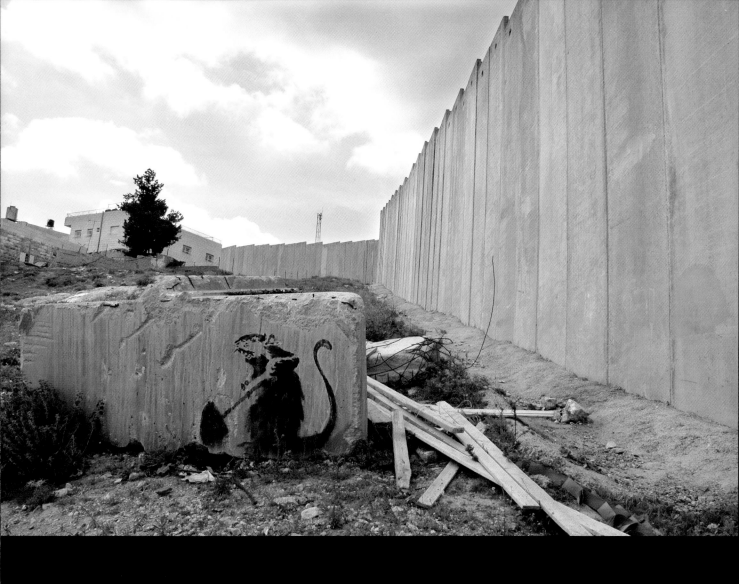

THE GREATEST CRIMES IN THE WORLD
ARE NOT COMMITTED BY PEOPLE BREAKING THE RULES

OH LITTLE TOWN

(Of Bethlehem)

Across Europe and America, every Christmas, Bethlehem is talked about in schools and churches, depicted on Christmas cards, Advent calenders and sung about by merry Carollers. And yet, the real Bethlehem is far from the collective imagination of the Nativity scene. It is an occupied territory in the middle of a war. Well, we say war but illegal occupation is more accurate. Our fantasy of Bethlehem has grown so great as to obscure the reality. This is the kind of whimsical hypocrisy that Banksy thrives on. It is a violence of sentimentality.

Banksy's 2007 event in Palestine arguably marks the point at which he became a truly interesting artist. OK, for some it will always be a crass publicity stunt. It wasn't a perfect gesture, but nothing ever is. It's not hard to believe that it was well meaning and it was very successful in raising profile for the cause and raising money for the people on the ground. Banksy's strength is that he has an idea and ploughs in without over-thinking it. Most people would have talked themselves out of it by the time they got home from the pub.

You can imagine that conversation taking place. It's late, perhaps they've all gone back to the studio for a few more cans, a reefer, somebody has put Orbital on. 'So where are we going to do Santa's grotto this year mate?' Silence for a minute. 'Fucking Palestine mate.' Silence. Everyone erupts in a fit of giggles. Silence. 'No but yeah right, we could actually go to fucking Bethlehem...' Pause. 'Think of all that bloody wall space though.' 'Yeah man! Palestine must be...

"...the ultimate activity holiday destination for graffiti writers" - Banksy

So the decision was made to do a charity art auction in Bethlehem and to take a small team of street artists to hit the division wall. Although Banksy is the one street artist even your mum has heard of, the crew that hit the wall included some of the biggest names in the scene. Faile for their huge paste ups, Blu for his epic surrealism, Swoon for her magical portraiture and Ron English the godfather of lowbrow were all there. Local artists such as Suleiman Mansour, who has been making work about the struggle for decades, were included in the show.

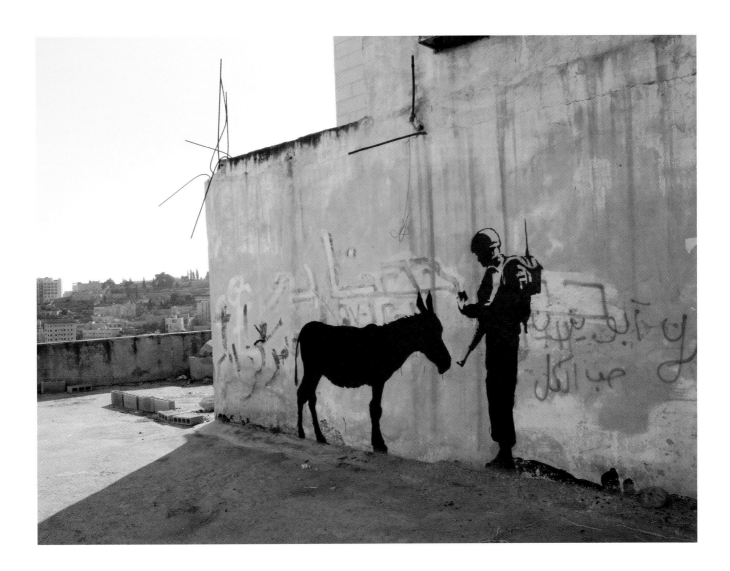

"How illegal is it to vandalize a wall, if the wall itself has been deemed unlawful by the International Court of Justice?" - Banksy

Not everybody got it, including some on the Palestinian side, (fair enough) however, most people who wrote about the event seemed to find it inspiring. The campaigner Nigel Parry talks about how he had been through a bizarre communication with another western 'artist' who attempted to persuade him that the wall should be made beautiful if it is to be permanent. Parry was furious, replying that decorating a gas chamber would hardly redeem its barbaric intent. For him, Banksy's mission was a breath of fresh air. Rather than beautify, Banksy highlights ugliness we find too easy to ignore.

"Banksy's the kind of guy who prefers to draw a 20 foot high arrow pointing at the ugliness to encourage us to ask why the hell it's there in the first place." - Nigel Parry, Electronic Intifada

The beauty of the gesture is that it is an adventure. The artists obviously had a lot of fun going into the lion's den to work. This is so far removed from our passive conception of 'charity' it jolts us into a state of awareness. It is a bold, romantic move, an action to inspire the imagination rather than another flaccid telethon, guilt tripping us into flinging a few shekels at the needy.

Soldier: What the fuck are you doing?
Banksy: You'll have to wait til it's finished

Parry goes on to say one of the nicest things about Banksy I've possibly ever read. Even Banksy isn't this nice about Banksy.

"Banksy is the anti-Leni Riefenstahl and anti-Richard Wagner, reclaiming public spaces as a space for public imagination and enlightenment where they have become propagandistic barriers to thought and awareness... Banksy's summer project on Israel's Wall stands out as one of the most pertinent artistic and political commentaries in recent memory." - Nigel Parry, Electronic Intifada

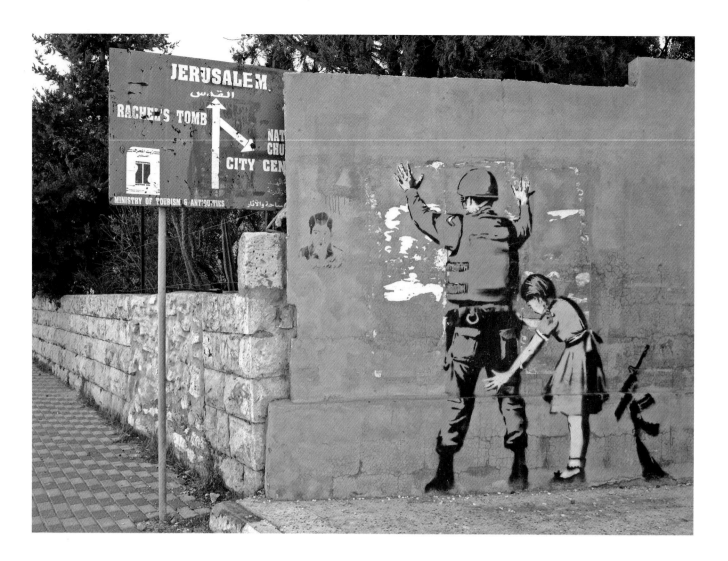

In the interests of journalistic objectivity (stop laughing at the back) we should probably include an opinion from the other side of the political fence. Have a read of this well thought out critique and make up your own mind.

"ohh Baksy...(sic) you're sooo coool.... in fact.. you're sooo cool, that you're a complete f**king d**dbeat ret*rd with your idiotic liberal politics.. you're so brave to go into a liberal country, like Israel, and vandalize the walls (only 10% of which are the security wall.. the other 90% is a chain link fence)... you must have gone searching far to find that piece of wall.... you should have shown your bravery and painted the actual chain link fence..why don't you try your s**t inside gaza? why don't you tell them to stop shooting rockets every day into Israel? why? because you're a complete p**sy who would get e**cuted for being a "collaborator" - Blome., Teh Internets

Some good points well made there.

To conclude. Banksy achieved something magical with the Palestine stunt. He made a lot of people see a region that exists largely in our imagination as either a living incarnation of hell or a soppy painting on a Christmas card, and he made it ordinary, real and humane. He took a place that we think of, like the 'Here be Dragons' area on an old maritime map, as a dangerous place far removed from our understanding, and rendered it mundane, in the sense of worldly, a place where our common sense could be applied, and we could be allowed to say 'Hang on, that's not fair!' without feeling out of our depth.

"Sometimes we catch a glimpse of realities other than our own, but if we are ten percent angel, we are ninety percent monkey. If we accept this then at least we are working from ground zero. This is the perspective that gets you into situations like spray painting a military patrolled wall in Palestine. The monkey idiot with a glimmer of consciousness goes where the wise man cannot." - Untitled. Street Art in the Counter Culture

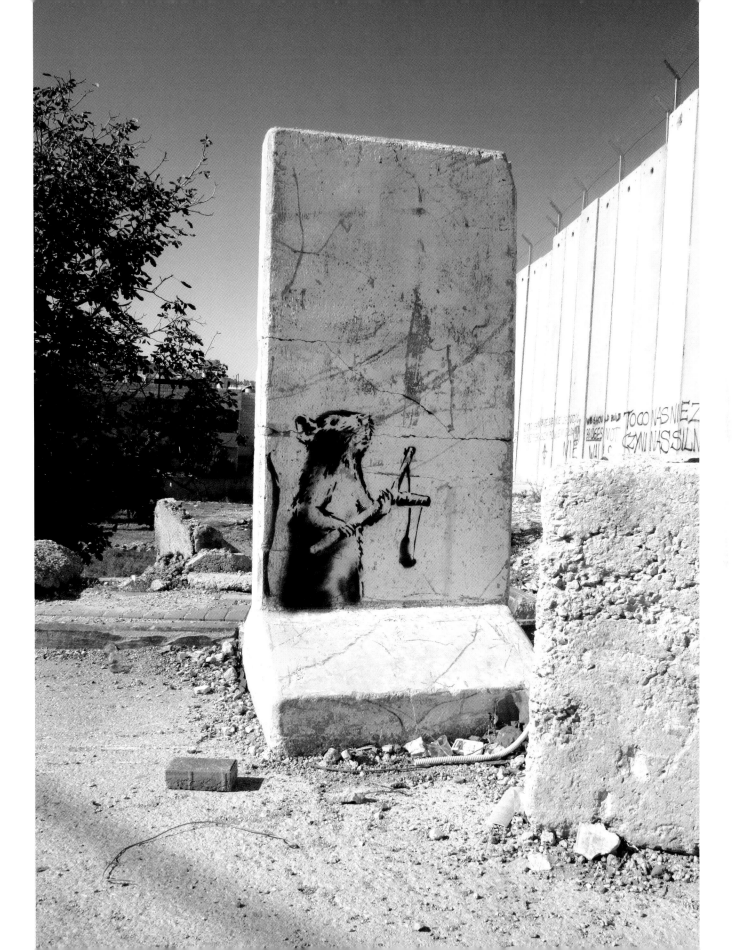

THE ART OF RESISTANCE

(Where next for Palestine?)

If Banksy triggered your interest in Palestine but you're freaked out about wading into all the complicated historical tensions, this should be a good jumping off point for you. It's always interesting when art is used as a political tool; it's also massively controversial. So hold onto your hats as we fling you into the debate with the catapult of badly researched banter.

Banksy wasn't the first person to use graffiti in the Palestinian cause. The image of a scruffy child with no shoes on called Handala, always with his back to the viewer and his hands behind his back has long been a symbol of the struggle. The child is ten years old which represents the age of the artist when he was evicted from his own country. The artist has vowed Handala will not show his face again until the refugees come home. There is now a third generation of Palestinian children growing up in camps who are not allowed into their own country.

"At first he was a Palestinian child, but his consciousness developed to have a national then a global and human horizon. He is a simple yet tough child, and this is why people adopted him and felt that he represents their consciousness." - Naji Al-Ali

This image is a powerful one, conveying the heart of the matter in simple terms. The barefoot boy is far from home, unable to grow up, stuck outside of time waiting for normality to return. Before you get caught up in all the politics and clever theories, this is what is at stake. The image is seen all over the middle east, and of course, in Brighton.

So why the wall? Israel states it is there as a security measure to protect Israeli citizens from terrorism. During the first and second intifada (civic uprising), suicide bombing campaigns and rocket attacks caused great suffering in Israel. Sporadic attacks continue to this day. Even so, there is

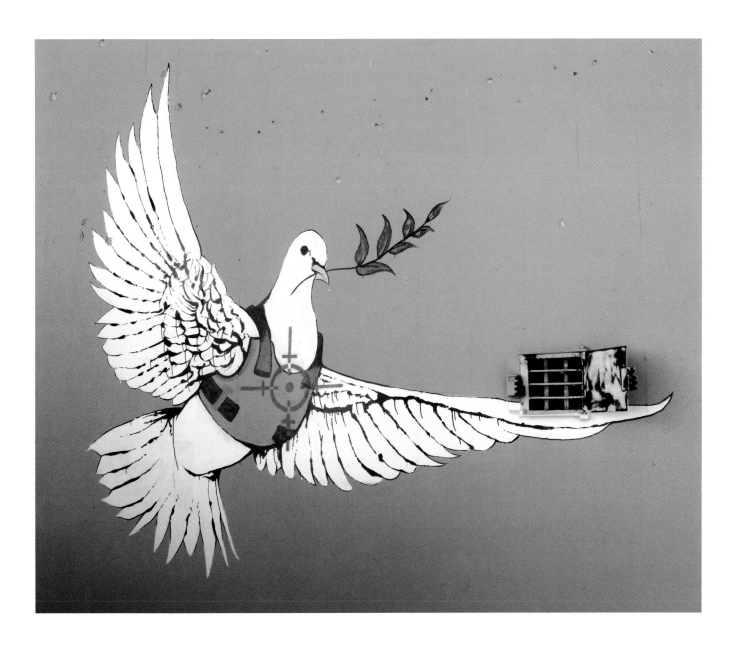

little evidence that the barrier is an effective measure against such attacks. Anyone who really wants to cross the barrier can do so with a variety of scams. A determined suicide bomber will get through sooner or later.

The wall is built deep in Palestinian territory, effectively annexing huge sections of farmland and expanding the state of Israel far beyond its internationally agreed borders. The barrier splits Palestine in half, surrounding the whole of Gaza, effectively making the country into an open-air prison. With conditions worse than Sub-Saharan Africa it is fast becoming a humanitarian catastrophe. The wall has destroyed the infrastructure of Palestine, the state is now dependant on international aid to survive. Israel does not even foot the bill for their obligation to protect civilians in an occupied territory. It is paid for by the international community. "The barrier is itself a massive violation of the Fourth Geneva Convention of 1949 which requires occupying forces to treat civilians "humanely". Among a long list of human rights violations, the barrier inhumanely consolidates Israel's illegal colonisation of Palestinian territory, prevents Palestinians from accessing schools, hospitals, and land necessary for their survival, and at many other levels represents the exact opposite of the Convention, which exists to protect civilian populations during times of war. Violations of the Convention are considered war crimes under international law." - Nigel Parry, Electronic Intifada

In 2011, comedian Mark Thomas walked the entire length of the division barrier for his 'Extreme Rambling' project. The book release is an excellent point of departure for anyone interested in learning more about the situation on the ground, without drowning in heavy history books. It's also funny. It's the way he tells 'em.

Along the route Mark stumbled across a Theatre Company in the middle of a Palestinian refugee camp. His experience there really shines a light on just how important art is to the Palestinian young people at the moment.
"You know, before I came here, one of my life options was to be a suicide bomber. To lay down your life for your community is an honour, right? But now I know art is my weapon." - Student at the Freedom Theatre in Jenin, Interviewed by Mark Thomas.

The theatre director was unfortunately assassinated by a Palestinian not long after. Divisions within Palestine are sometimes just as brutal as the conflict with Israel.

If you really want to help then you need to learn about the BDS movement: "We, representatives of Palestinian civil society, call upon international civil society organizations and people of conscience all over the world to impose broad boycotts and implement divestment initiatives against Israel similar to those applied to South Africa in the apartheid era. We appeal to you to pressure your respective states to impose embargoes and sanctions against Israel. We also invite conscientious Israelis to support this Call, for the sake of justice and genuine peace." - Palestinian Civil Society 2005 call for BDS

BDS is such a powerful force for change that the organisation was made illegal by the Israeli authorities. Finding out about companies like Veolia operating in your community and campaigning to get them replaced by companies that do not support the illegal settlements is one of the most powerful ways to act. British NGO 'War on Want' are also very active in supporting Palestine. If you can't be arsed to harass Veolia (fair enough)

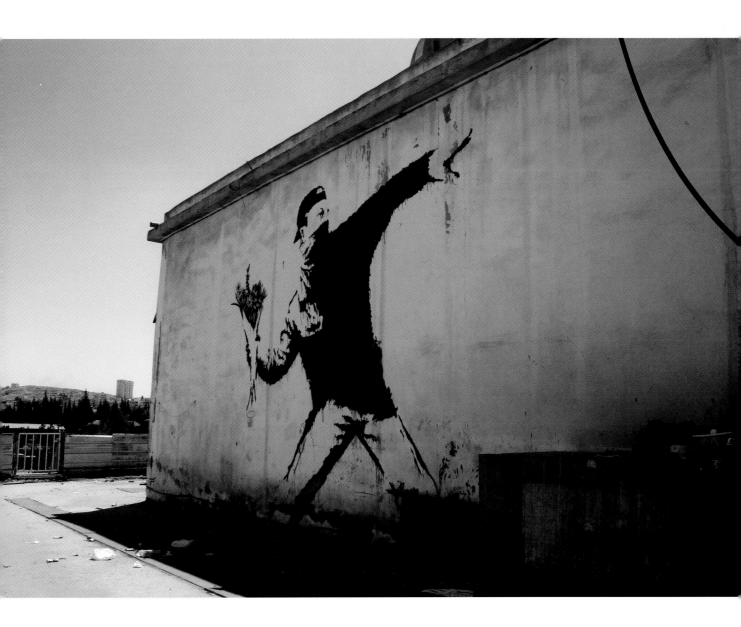

flinging a few shekels at 'War on Want' is an easy way to get involved.

"The catastrophe facing the Palestinian people is one of the defining global justice issues of our time. A third generation of Palestinian children is now being brought up in refugee camps inside and outside Palestine, living in chronic poverty and denied the right to return to their family homes. Hundreds of thousands more Palestinians suffer discrimination over access to public services, land rights and employment within Israel itself." - War on Want Palestine: Street Art Hope

When all is said and done, was Banksy's mission to Palestine a success?

"I asked the Palestinian artist Suleiman Mansour what he made of the graffiti on the wall. "For some people it could be a gimmick, for others it might make a difference," he said. Mansour has been working as an artist since the 1960s and remembers a time when Palestinians were banned from painting in red, green or white - the colours of their flag. "The Palestinian problem is full of contradictions and strange things: it's like heaven for artists," he said. "For westerners it's important they see the Palestinian problem interpreted through art. It's not like newspaper articles or speeches, art is something much stronger in getting a message to people." - Rory McCarthy, The Guardian

(Obviously, in keeping with a liberal and balanced view point we have to say that there are two sides to every story, and the truth is indeed out there. Go Google the Israel/Palestine thing and don't stop reading until you've done the situation justice. Capiche.)

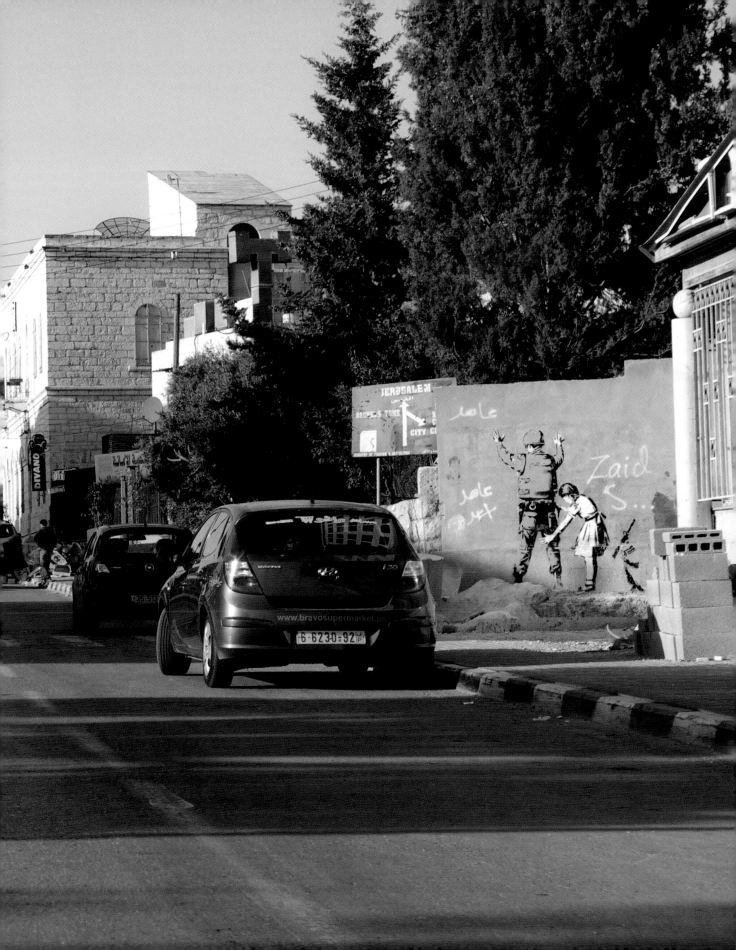

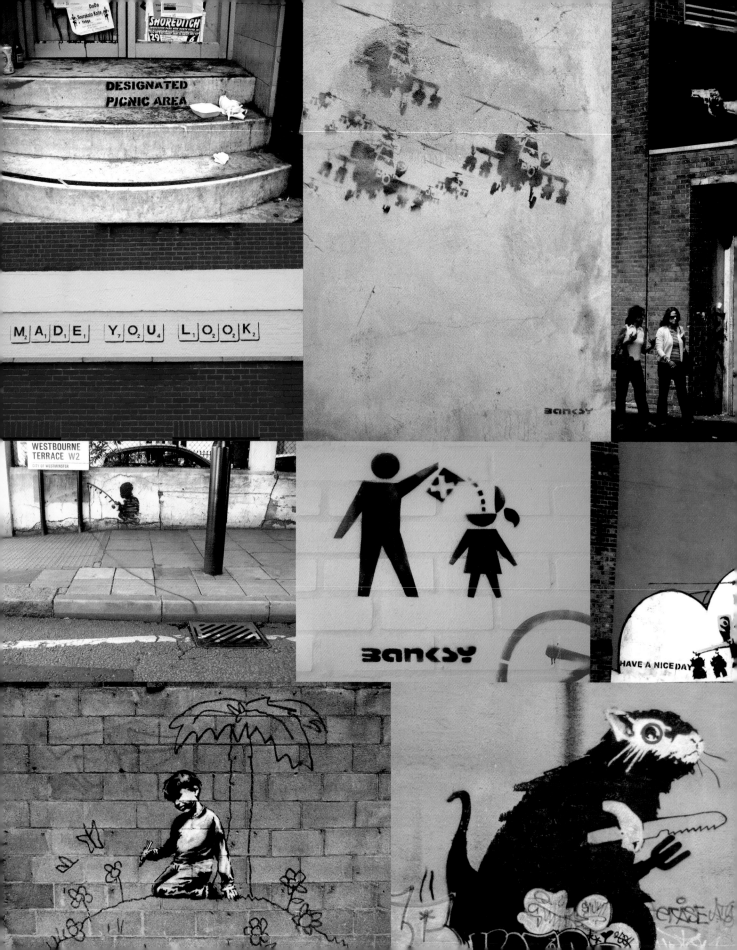

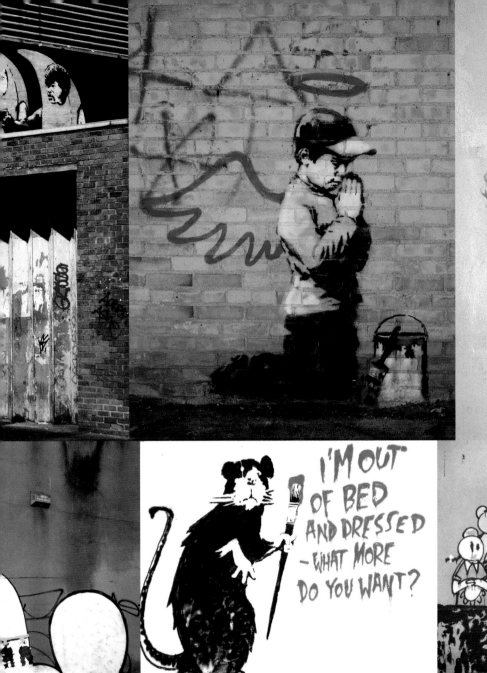

BANKSY

I'M OUT OF BED AND DRESSED – WHAT MORE DO YOU WANT?

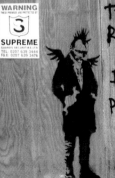

WARNING
THESE PREMISES ARE PROTECTED BY

SUPREME
GUARDS SECURITIES LTD
TEL: 0207 639 3444
FAX: 0207 639 3476

WARNING
THESE PREMISES ARE PROTECTED BY

SUPREME
GUARDS SECURITIES LTD
TEL: 0207 639 3444
FAX: 0207 639 3476

THIS REVOLUTION IS FOR DISPLAY PURPOSES ONLY

SWING LOW SWEET CHARITY

(Robbing the Rich to Pay the Poor)

A lot of people envisage Banksy sitting atop a pile of cash the size of Mount Everest, a honey on each knee, smoking blunts rolled up in 100 Euro notes, commanding legions of scurrying slaves to handle his empire while he simply laughs at the world, simultaneously reaching shuddering orgasms every fifteen minutes.

When you stop and do the sums he's (or they are) probably doing alright but he's still no Damien Hirst, buying up mansions for shits and giggles.

In any case like some twisted counter cultural version of Noel Edmunds, Banksy does a lot of good work for Charity. Cue flashback to the 'Feed the World' video. Have panic attack. Punch a Chugger. Feel better.

Banksy woke up one day to discover that he could print a photocopy of his own balls, sign it, number it and thousands of people would clamour to pay a pony for the result. If you or I suddenly discovered such a power we would probably use it for evil, soon racking up the kind of cocaine habit that ends in having one less than the standard quota of nostrils. And yet Banksy uses this power for good deeds.

Even better, he manages to do it and piss off the establishment at the same time.

Let's take a look at some of his greatest charity hit singles.

FREE THE VOINA 2!

Banksy sold 175 limited edition prints of 'Choose Your Weapon' via the 'Pictures on Walls' website to raise £80,000 for charity. In this case the charity was the legal fund for two imprisoned art activists in Russia. They go by the name VOINA and they are anarchists.

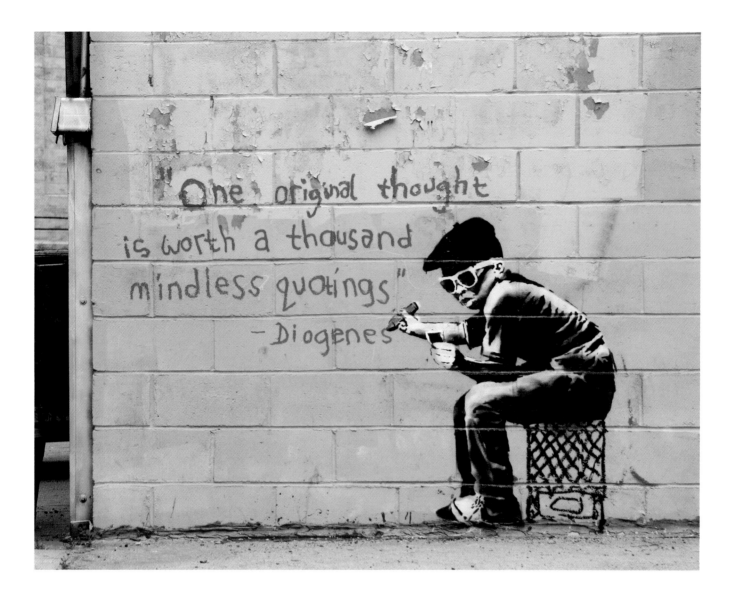

VOINA are a large collective but two of their number, Oleg Vorotnikov, 35, and Leonid Nikolayev, 27, were recently imprisoned for flipping over police cars in Moscow as part of an art protest action. (Balls of steel?) The group's stunts include invading a court room to perform a musical about cops being bastards, throwing cats at McDonald's staff and painting a 213 foot tall cock on the Liteiny Bascule Bridge opposite the headquarters of the Russian Super Cops, the FSB, so that when the draw bridge rose, the FSB was faced with a massive erection.

Among their stated aims VOINA want: "Rebirth of political protest art all over the world."

You heard them, soldier. This means you.

REBUILD PALESTINE!

If you leave aside all the politics for a minute and just concentrate on the bare facts, Palestine is a country in severe poverty. Santa's Ghetto made just under a million dollars, according to the organisers, and all of that money went to charity projects in Palestine. Thirty Palestinian kids went to University to study Art at Dar a-Kalima college in Bethlehem itself, on the back of money raised at that infamous auction.

This is charity at its finest, benefiting those in dire need at the same time as pissing off right-wing bigots in the west, by drawing attention to the illegal occupation that is being tacitly supported by European governments, including our own, by giving the state of Israel preferential trade status when we should be divesting from...ahem...sorry...wrong meeting.

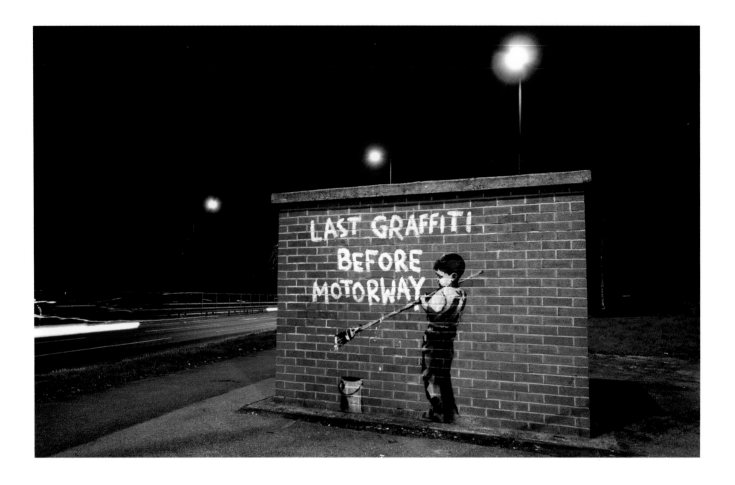

CHARITY BEGINS AT HOME

No Gods No Masters No Banks No Banksy

Paint Your Own World

It doesn't get any less like Pat Sharp doing a telethon than this. It's charity, but not as we know it. Selling a print of a Molotov Cocktail at an anarchist book fair just days after a riot in Bristol's Stokes' Croft area was a gesture that was not lost on some of Bristol's great and good.

"What a sad, sordid way to thank Bristol for providing this talented, privileged but misguided young man with a springboard for his career as a graffiti artist." - Barbara Janke, Councillor

The money was raised to aid the People's Republic of Stoke's Croft, a community organisation who at the time were providing legal aid and other support to people who had been involved in the Tesco riots.

For those who don't know, Stoke's Croft is an area with a history of community organisation and anarchist politics. The locals took it as an insult when Tesco applied to open a store there and fought the planning application for a long time. When they finally lost, protests flared into clashes with the police and the new store was smashed.

SUPPORT YOUR LOCAL OXFAM!

During the Banksy at Bristol Museum exhibition, a mysterious alien appeared in the local Oxfam shop and vomited two boxes of valuable Banksy prints, postcards and stickers onto the counter. It then vanished.

The shop, being just over the road from the museum was soon swarming with sticky fingered Banksy fans eager to pour their sweaty coins from their fetid pockets onto the charitable counter. Oxfam turned over three large a week during the exhibition.

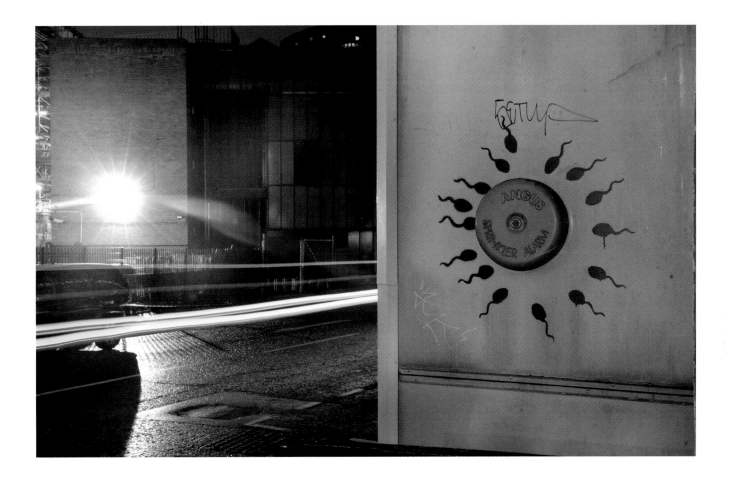

KEEP YOUR EYES OPEN!

Banksy allegedly gave his blessing for the sale of a street piece, which is unusual. But in this case, the vandal with a heart of gold had to make an exception. It is said he even helped the City Road Hospital to remove the piece and sneaked into the auction to touch it up at the last minute. Sale of the rat raised 30K for people with eyes what have gone wrong. A fitting cause for a visual artist, no?

As Banksy himself says on his website: "I mostly support projects working to restore sight and prevent eye disease. Or as I like to call it 'expanding the market'. "

BLOODY IMMIGRANTS!

What happens to people after they fail their application for political asylum? I suppose you think they get thrown in the back of a van and immediately deported. Apparently not. A great many of them prefer to remain destitute on the streets of London, rejected by our state rather than possibly face death, or worse, in their own. Pretty bleak eh? Well there is one place they can go for help. That's the New North London Synagogue drop in centre.

The NNLS organised a celebrity pants auction and Banksy wanted to join in but was afraid that his pants might reveal his identity through clever DNA analysis, so he painted some pants instead, re-working his kids saluting a Tesco flag image to a pair of Union Jack pants.

Perhaps the point Banksy is making is that Nationalism is pants?

It's a point that asylum seekers must be keenly aware of.

Remember kids: No Borders. No Bosses. No Bombs. Oops...wrong meeting...again.

ONLY WHEN THE LAST TREE HAS BEEN
CUT DOWN AND THE LAST RIVER HAS
DRIED UP WILL MAN REALISE THAT
RECITING RED INDIAN PROVERBS MAKES
YOU SOUND LIKE A FUCKING MUPPET.

BANKSY - BANGING YOUR HEAD AGAINST A BRICK WALL

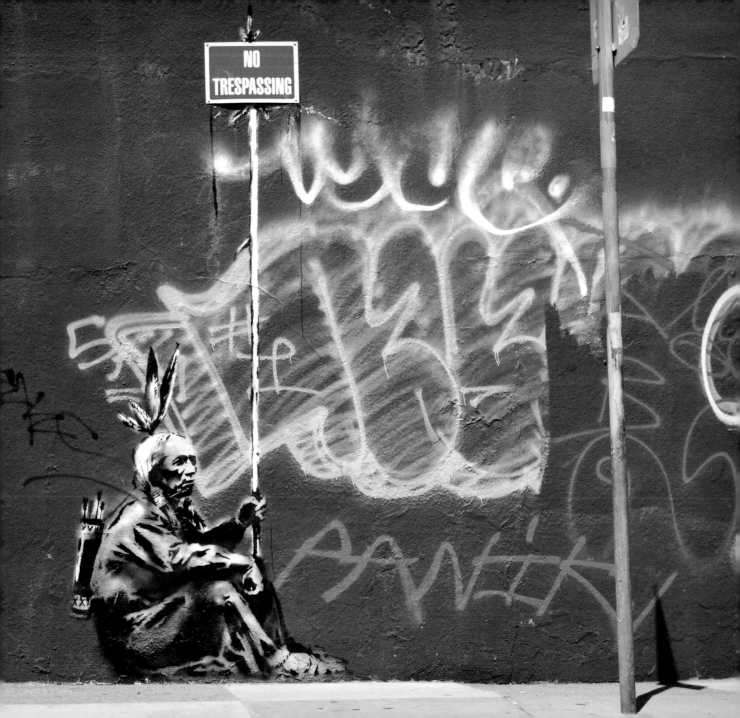

BANECDOTES
#7

THIEVING BANKSY

"La propriété, c'est le vol!" - 'Property is theft'
Pierre-Joseph Proudhon

In May 2010 a Banksy worth around 80 grand was stolen from Kate Moss' flat in Maida Vale. Two other prints worth 16 large collectively, were stolen by a couple from a London gallery the same month. In December 2011 a Banksy print was 'legally' stolen as part of a lame PR stunt by some 'bleeding edge' hotel group. Way back in April 2004 Banksy's first foray into bronze sculpture 'The Drinker' was stolen by Arto-Politico-Terrorist AK-47 who tried and failed to ransom it back. Banksy would only go as high as two quid. It was later stolen from AK-47's back garden.

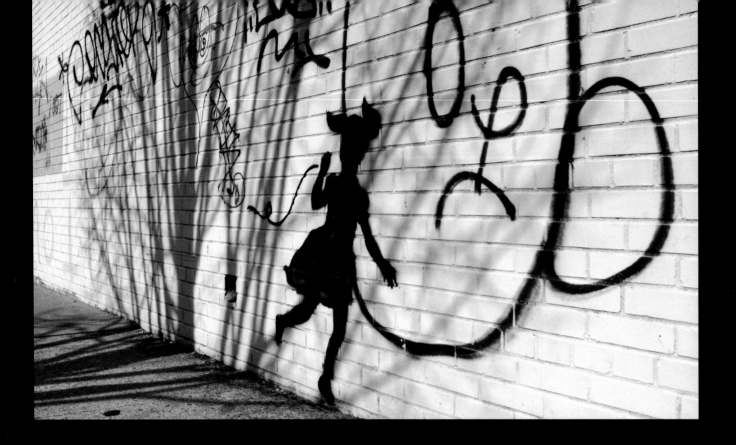

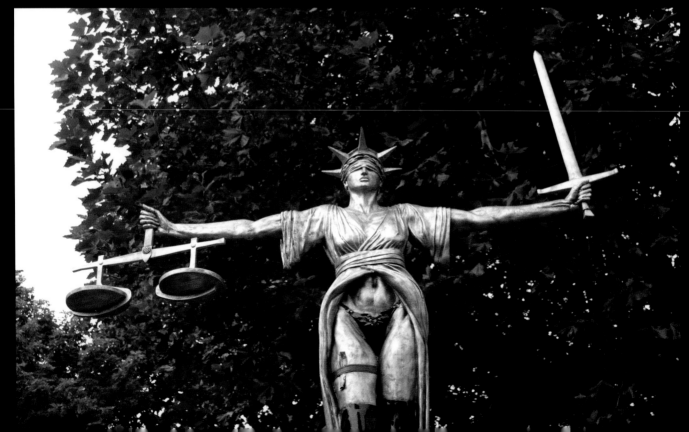

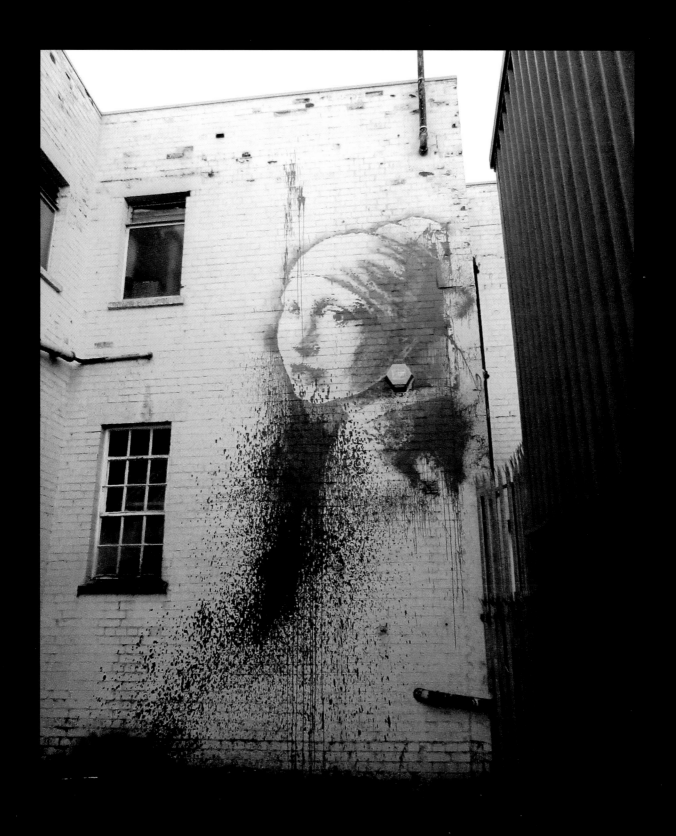

BANKSTONBURY FESTIVAL

(Don't Worthy - Be Hippy)

Rumoured sightings of the Bristolian Stencilista at Glastonbury Festival are now part and parcel of the event itself. Not surprising, given that it's only a lift in the back of a mate's Fiesta away from Bristol to the magical muddy fields of Britain's biggest rock festival. Then all you need is a leg up and you're over the fence. Though perhaps these days, he can afford a ticket.

Banksy is more attracted by the miles of perimeter fencing, an epic blank canvas begging to be adorned, than by the magic mushrooms and tribal drumming workshops.

From comedy backstage signage to ice cream van decor and even tagging a police car (allegedly), Banksy always seems to have fun at Glasto. A flag saying 'Flags are for twats' brought a nice counterpoint to the tradition of revellers representing their nations with flags in the big crowds around the televised stages. A pagan stone circle constructed of portaloos combined two of the key elements of the Glastonbury experience - hippy shit and hippy's shit.

Best of all, a lost child floating away on a bunch of balloons.

Queue here to complain that street art's not as good as it used to be.

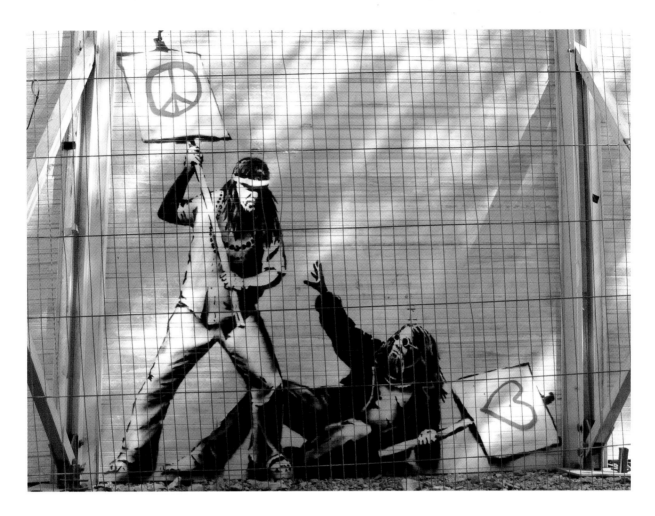

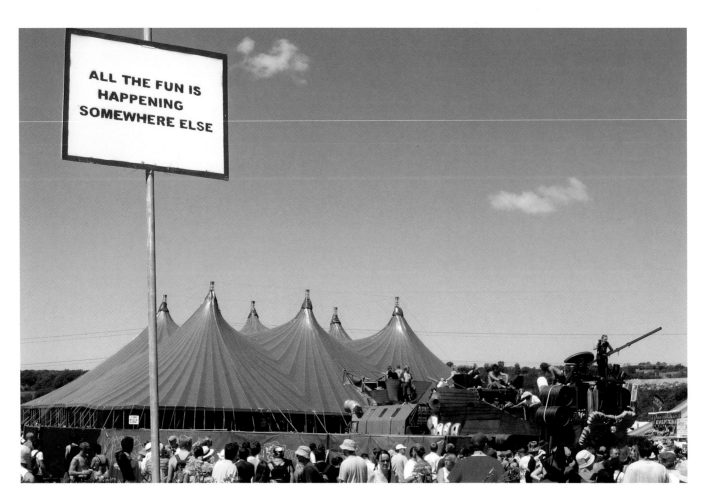

QUEUE HERE TO
COMPLAIN FESTIVAL
IS NOT AS GOOD
AS IT USED TO BE

PLAIN CLOTHES
DRUG DEALERS
IN OPERATION

FLAGS
ARE FOR
TWATS

DUE TO
RECESSION
FESTIVAL CLOSES AT
5 PM TODAY

BANECDOTES
#8

HANGING OUT WITH DANGER MOUSE

In 2006, as you are probably aware, Banksy doctored 500 fake versions of Paris Hilton's album and sneaked them into HMV and Virgin music shops. Perhaps less widely known is that the album featured remixed versions of her tracks by the producer Danger Mouse. In hindsight, it makes perfect sense. Danger Mouse shares a similar taste for theatrical, semi-legal stunts such as remixing the sacred 'White Album' by The Beatles, a band not known for a relaxed attitude to Intellectual Property laws, and distributing it free of charge on the Internet. You can imagine the larks they had dropping a gormless Hilton mumbling '10,000 dollar watch' over a fuzzy beat. Even funnier, when thirteen year olds across the world stick their new album on, only to be confronted by this heinous trickery. We shouldn't laugh. But we do.

> "They are demons set loose on the Earth to lower
> the standards for the perfect and holy children of God!"
> Bill Hicks

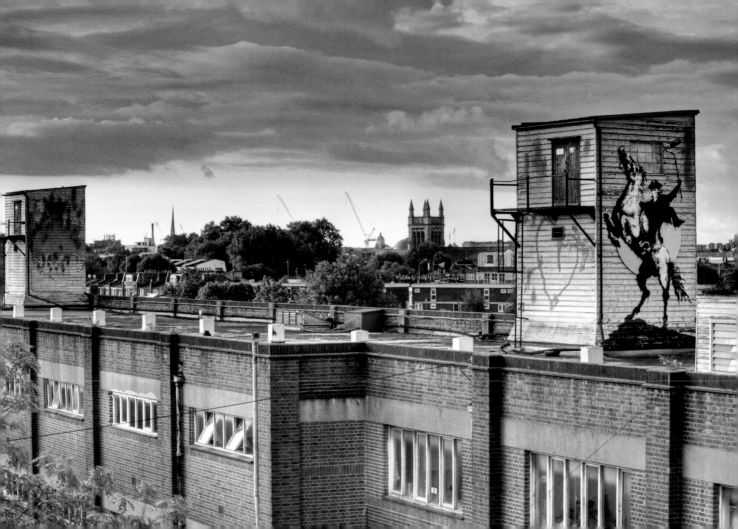

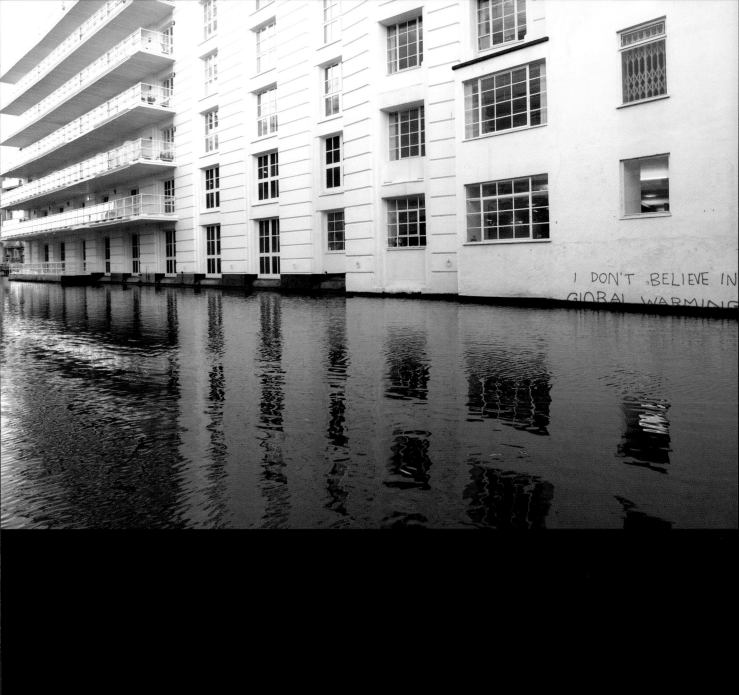

TOXIC LOVE

(I'm Addicted to You)

Being honest, we'd never have heard of TOX if Banksy hadn't adopted him, paying homage to the prolific young vandal in his image of a young boy blowing a TOX bubble in Camden, TOX's 'manor'. But that's because we're unrepentant street art fans with no street cred whatsoever. We're too busy trolling street art forums to actually go outside and see any graffiti.

You're probs bare cooler than that, fam.

So what is it about the territorial pissing of tagging that endears TOX to Banksy, bearing in mind that most people blessed with their product appearing on the garage doors would call Banksy an 'Artist' (ie how much is it worth) and Tox a 'C*%t' (ie, where's the paint stripper). Strange bedfellows?

There is something in this graffiti business that the armchair critic often misses. It's the buzz. Pick a target, prepare your supplies, stake out, attack, escape. Try it. You'll be amazed how terrifying it is. Chances are the last time you did something really naughty was years ago. We don't realise how conditioned to obey the rules we are. Even very minor acts of naughtiness come with a heavy adrenaline hit, unless of course you're a hardened criminal, or an advanced sexual fetishist and are feeling pretty jaded.

That's why it's laughably inappropriate to sit and discuss the artistic merit of tagging. Tagging is more of an urban sport than an art. It turns the city into a giant computer game complete with high scores and a chance to get your name at the top of the leader board. It makes your life exciting. Fuck the audience.

Even more hilarious then that the artistic merits of tagging the word TOX on a train should be discussed in a court of law. No word of a lie.

Small wonder that Banksy loves TOX.

TOXIC or more commonly TOX was the undisputed king of London's writers for most of the noughties, usually tagging TOX05/06/07/08 depending on the year, which in the end contributed to his downfall. After blagging that he had retired in 2005 he unsuccesfully claimed that other tags were done by an army of imitators. Hundreds of TOX06 tags suggested his retirement story might be greatly exaggerated. The jury didn't buy it and he finally went down in 2009.

"I don't know where you can't see a Tox tag," said a London Underground manager. "They are in places even I don't know how to access."

Banksy put up his TOX bubble piece during the trial, presumably as a show of support. Again in 2011 during the Occupy London rally at St Paul's cathedral, the house in the middle of Banksy's monopoly sculpture featured a massive TOX tag.

The trial was stunningly surreal in that expert witnesses were called to make a statement about the quality of the artwork. You couldn't make it up.

It is a measure of how far Banksy has impacted our mindset that anybody felt it was neccessary to ask the question 'but is it art?'. Now, with some councils treating Banksy's work as public heritage and others buffing it as normal, a serious spanner seems to have been thrown into the public sector works.

If the judge and jury had accepted that TOX was producing stuff of 'Artistic Merit' (Whatever that means) then would he have gotten off? If that's the case, is it legal to paint good art on walls but illegal to paint bad art? And are the courts going to make that distinction!?

There was even some attempt to explain that the decline in the quality of graff was due either to shoddy fan boy imitators or due to the lack of time the guilty party had available to do their work. As if the judge would then say - aw well, we probs have been policing that shit a bit too effectively, I guess we should share some of the blame.

The argument across comments sections around the web tends to revolve around the quality of the art. Taggers might care what other taggers think about what they do, there seems to be some pride in technique, but artistic merit is just not relevant. TOX may have sold his tags as art but he was obviously taking the piss and it's a joke that is right up Banksy's street.

"Banksy is an artist. Tox is a vandal." - Aldridge, Bradford, Comment on Daily Mail website.

RISE UP! OCCUPY!

No Banks, No Borders, Do Not Pass Go, Do Not Collect £100

(Games the 99% Play)

Nobody expected the Occupy movement. A generation that had only ever previously occupied the Old Kent Road during a childhood game of Monopoly suddenly got all political.

Of course the old guard, like Banksy, were straight in there saying 'Yeah, we were political before it was cool.' And to be fair, he was. So putting a sculpture up at the Occupy LSX camp in London of the Monopoly board was a logical move.

Now, not a lot of people know this, but Monopoly was actually invented to teach people why Capitalism sucks. Lizzie Magie took her 'Landlord's Game' to the patents office in 1903. The object was to show the mechanics of greed impoverishing tenants in the city, and then show how the situation could be resolved by applying a Robin Hood tax based on Land Value.

Years later, the version we know and love evolved, dropping the boring happy ending and serving largely to teach people how much fun it is to screw each other into the ground and amass obscene piles of cash.

There is a lesson here somewhere.

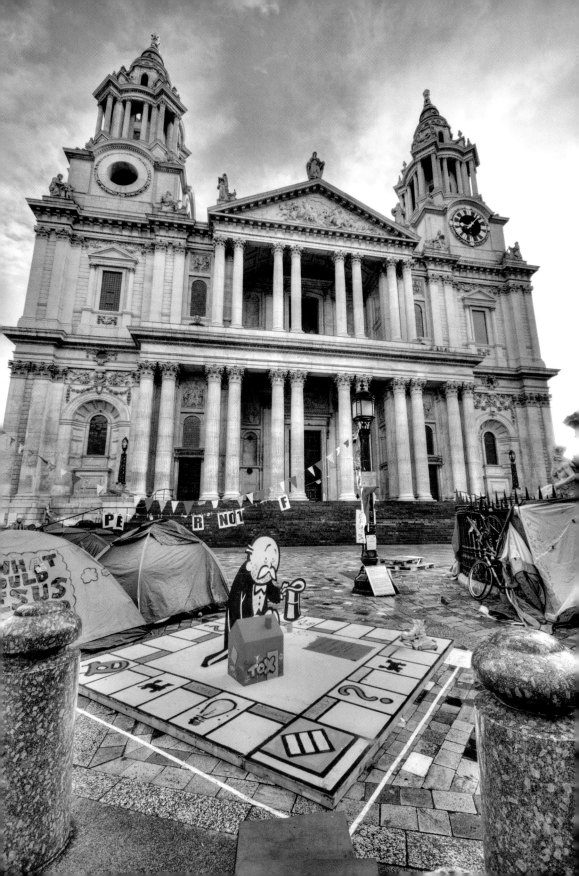

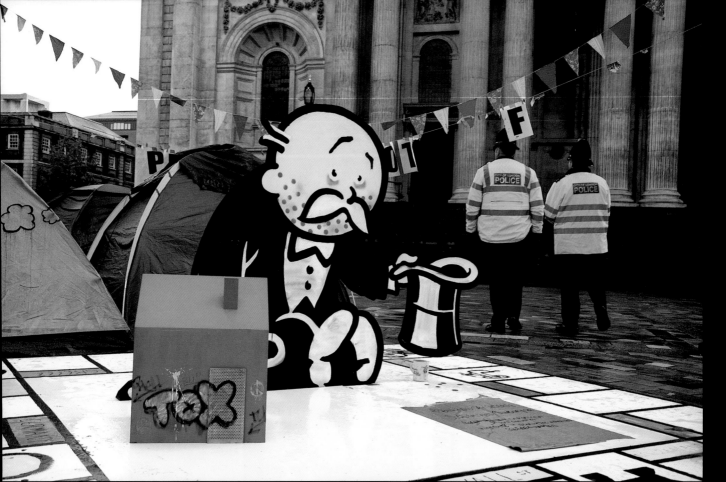

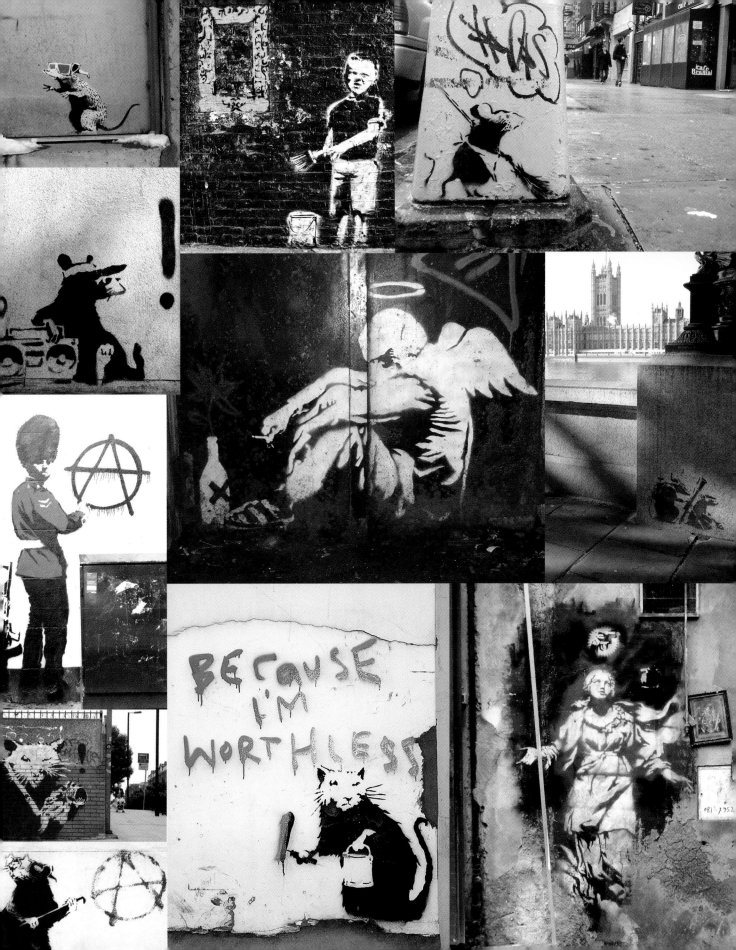

THE GREAT ART SWINDLE

(Subverting the Kunst Market)

Did you ever see the Power Rangers?

When faced with a really big enemy, such as global capitalism, the Power Rangers take their Zords and join them together to become a Megazord. The question on everybody's lips is...

Is Banksy a Megazord?

"...yea, for those of you who haven't figured it out yet Banksy is a brand, not saying that's a bad thing I'm just saying it's about time folks start referring to "Banksy" in the same context as Nike. He's the CEO of the Banksy empire..." - The Neorevivalist

A typically melodramatic quote about Banksy. Whatever you feel about Banksy's gallery sales, Banksy isn't yet exploiting teenage girls in Bangladesh, well at least not any more than we all are. Nevertheless it highlights a train of thought a lot of people are on, even if they've dodged the fare.

In his early days it seems likely that Banksy was one guy, these days there are reasons enough to suspect that there might be more than one artist working under the cypher. For example, in situations requiring the artist to hit a spot repeatedly surely the risk of being caught is too great now? If Banksy really did go back to the Camden canal every time that King Robbo mural got hit, wasn't that a massive risk for him to be taking?

Banksy no longer tags any of his street pieces. No doubt an astute move on his part. The sense of sending a member of Team Banksy is undeniable. If busted, they can plead copycat and defend the identity of the real Banksy thereby avoiding anybody going down for his entire back-catalogue of property damage. (As Tox recently demonstrated)

In this case, perhaps for practicality's sake Banksy is simply employing staff just like any number of artists have done in the past, including Damien Hirst and Andy Warhol.

"...it's possible he chose to become a collective or to subcontract work from himself to other artists, and maybe lend his name as a cloak of anonymity to certain creators and projects, building a collection of anonymous but thematically linked work." - Mark Hughs, Screenwriter

There's always the thought that even some high profile gallery pieces might include the work of other hands. It seems a likely Banksy concept, and the execution in some instances is very painterly for someone who claims he

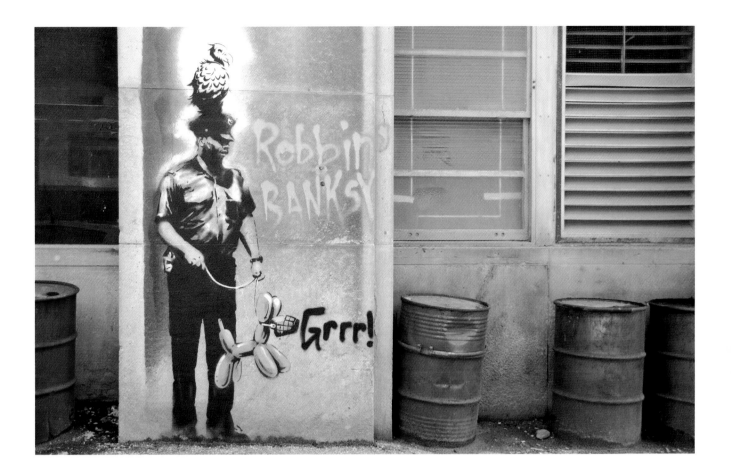

can't even draw. But then, it's always important to remember that Banksy has never once called himself an artist. He prefers the term vandal.

Maybe the point of Banksy the collective (if it exists) is to attack the sacred cows of art. The idea of 'Individual Genius' and the sacred notions of 'Authorship' and 'Originality' we all share, without thinking about them, are deeply conservative and reactionary. These ideas are the cornerstone of the 'Art Market', the very concepts that convince us that artists are super human creatures and art is something beyond us mere mortals.

These are the ideas that perhaps Banksy is deliberately attacking both in his anonymity and the dilution of authenticity that lending his name to other artists would produce. It's another great way of fucking with the art market. Is he deliberately trying to make his art worthless? Wouldn't it be the perfect ending if all the hedge fund collectors discovered their authentic Banksy's weren't Banksy's after all?

Think about it. He openly invites people to bootleg his work, he tells the press that copies are often better quality than the originals, these strategies confuse the market wonderfully.

This kind of attack on the precious attitudes towards the genius of the individual author has precedents. In the 1960s the San Francisco diggers shared the name Emmett Grogan freely as an author of art or any other subversive activity. Robert Desnos was another name used by Dadaists including Marcel Duchamp and in the 1970s Monty Cantsin, Karen Eliot and Luther Blissett were all used in similar ways to pervert the notion of authorship.

Or maybe it's just good plain strategy. Team Banksy is at war with the authorities. At the heart of it all, enraged by the abusive and disrespectful invasion of our everyday lives by corporate advertising Banksy has been striking back without asking permission for years. This has earned him real enemies, although it's easy to forget that, as everybody is so quick to assume that he has sold out, which is of course exactly what the man wants you to think about all your heroes because the man wants you to despair. People in despair buy more shit.

"All warfare is based on deception." - Sun Tzu

In the end the Megazord must sacrifice its powers in order to finally defeat the generic baddy.

Perhaps that's for the best. Peace.

GRAFFITI DOESN'T ALWAYS SPOIL BUILDINGS. IN FACT,
IT'S THE ONLY WAY TO IMPROVE A LOT OF THEM.
IN THE SPACE OF A FEW HOURS WITH A COUPLE OF
HUNDRED CANS OF PAINT, I'M HOPING WE CAN TRANSFORM
A DARK, FORGOTTEN FILTH PIT INTO AN OASIS OF
BEAUTIFUL ART – IN A DARK, FORGOTTEN FILTH PIT.

BANKSY

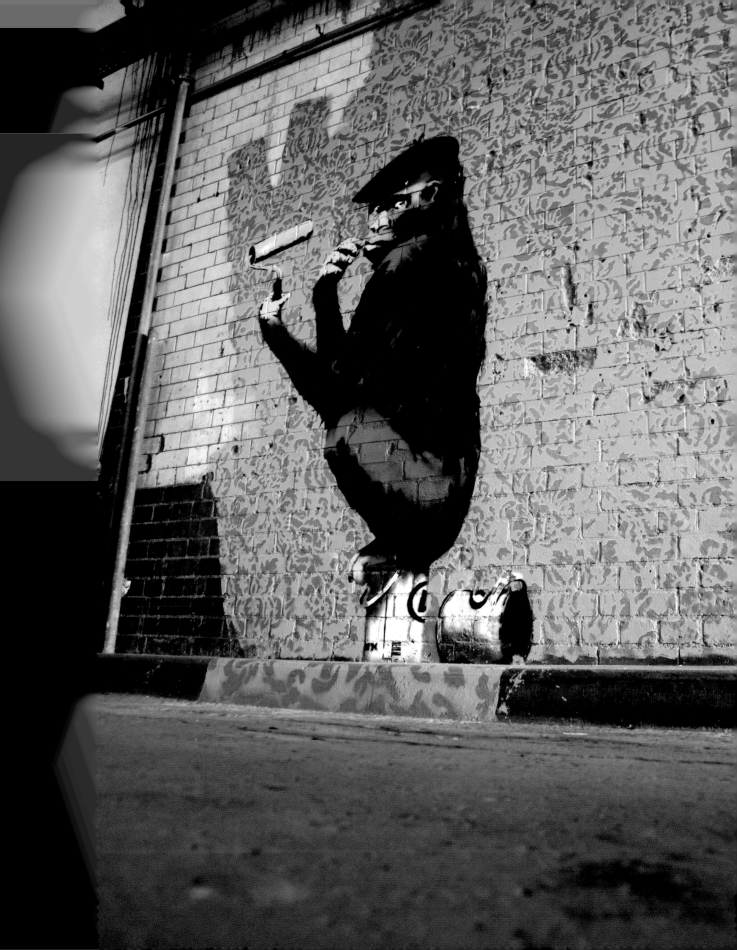

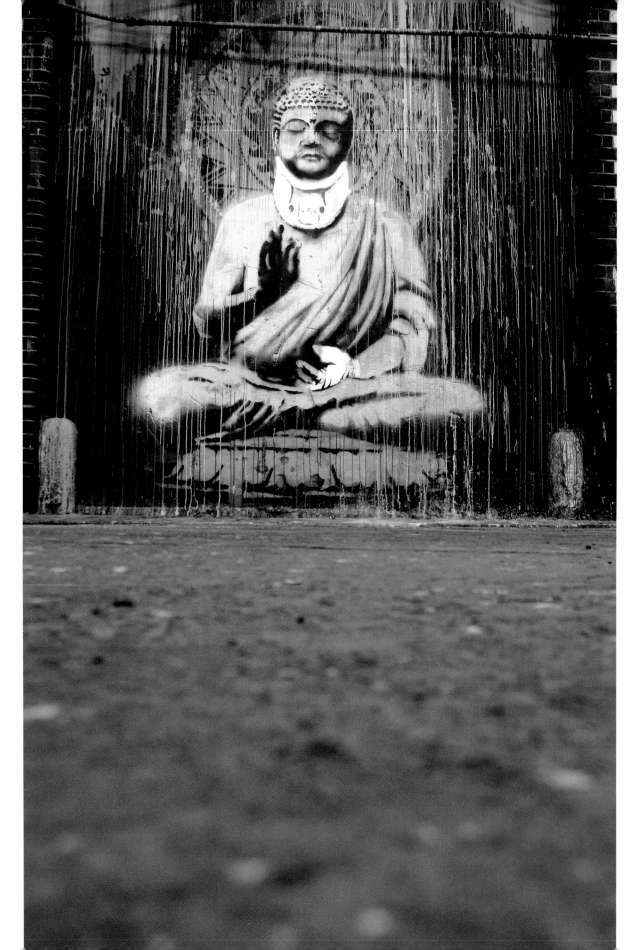

CAN IT

(Gentrify that!!!)

"Graffiti doesn't always spoil buildings. In fact, it's the only way to improve a lot of them. In the space of a few hours with a couple of hundred cans of paint, I'm hoping we can transform a dark, forgotten filth pit into an oasis of beautiful art – in a dark, forgotten filth pit." - Banksy

It was the May Bank Holiday weekend of 2008 in London and Banksy had discovered a dark corner close to Waterloo ripe for a bit of painting and decorating. This was Leake Street, an old access tunnel for the Eurostar fallen into disuse, populated by half a dozen homeless gentlemen. In what must have been an impressive bit of logistics from camp Banksy, the artist managed to round up the cream of the international vandalism crop for a festival, having rented the road for six months off the train company.

(Eurostar wanted the tunnel back in the condition it was when they rented it, so teams were brought in six months later to soak the walls with piss and scatter used needles.)

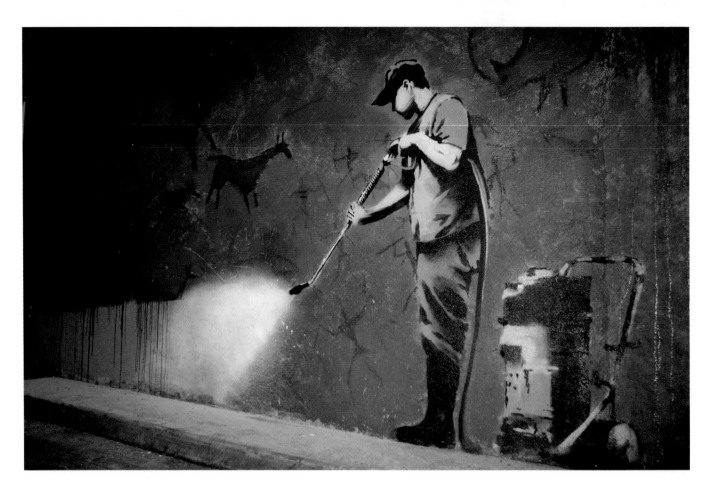

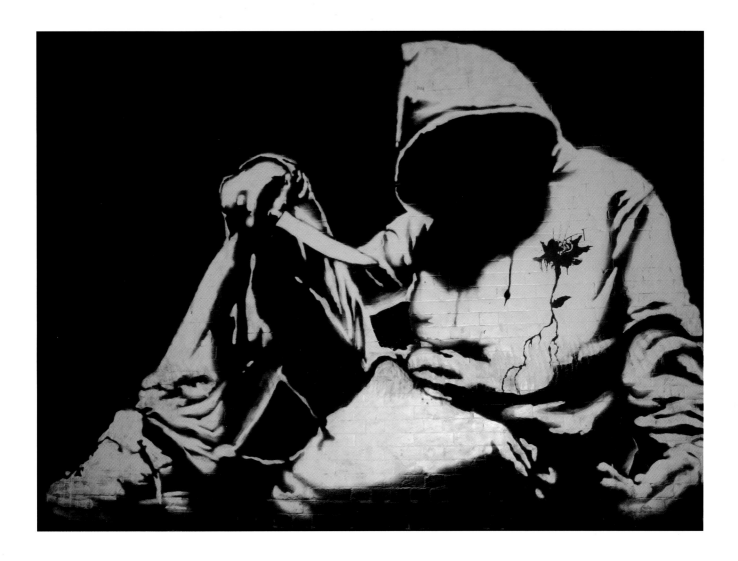

The tunnel was closed off for a time, while an army of street artists got to work, with Banksy himself putting up a number of installations to create a truly immersive art experience.

Joe public were invited to paint their own stencils at Cans. The only rule was stencils only, no freehand. But before the war between graffiti and street art erupts and destroys us all, Cans 2 was freehand only. The second festival took place later the same year featuring some world class Graffiti crews, to keep all you traditionalists happy. ;-)

For those who see Banksy as a cynical opportunist, Cans is a bit of a difficult one to grumble about. Working completely for free, putting on a show at no charge and inviting the audience to join in with the creative process shows a side of Banksy the media too often forget. He is a genuine populist. What Brit Art star would do the same?

Much of the tone and subject matter of both Cans events had a common thread. There was comedy, politics, surrealism, pop culture, religion and a lot of romance. Much of it critiqued power in the urban environment. 'Who owns what' and 'how they use it' is brought into question.

Why should we let architects and advertisers have sole control of the visual language of our environments? Young lovers trapped in a barcode. Why should we allow ourselves to be filmed constantly? A flock of living CCTV cameras in a tree. Who decides what is art and what is vandalism? A council worker buffing a cave painting.

Aside from its curled lip and punk sneer Cans Festival proved once again that a lot of street art is about the sublime and the possibility of beauty. In all the angels and kissing and heartfelt portraits of real people and oppressed figures there is a hope that there is something better, just maybe, coming - if we can find a new way to live with who we really are (Angels with Special Brew?). If we can learn to laugh at power - the Queen pulling a mental face, the Pope in a Marilyn Monroe pose, Gordon Brown with his third eye open - we may find a way to be free at last of this malingering belief that we need leaders to keep us safe.

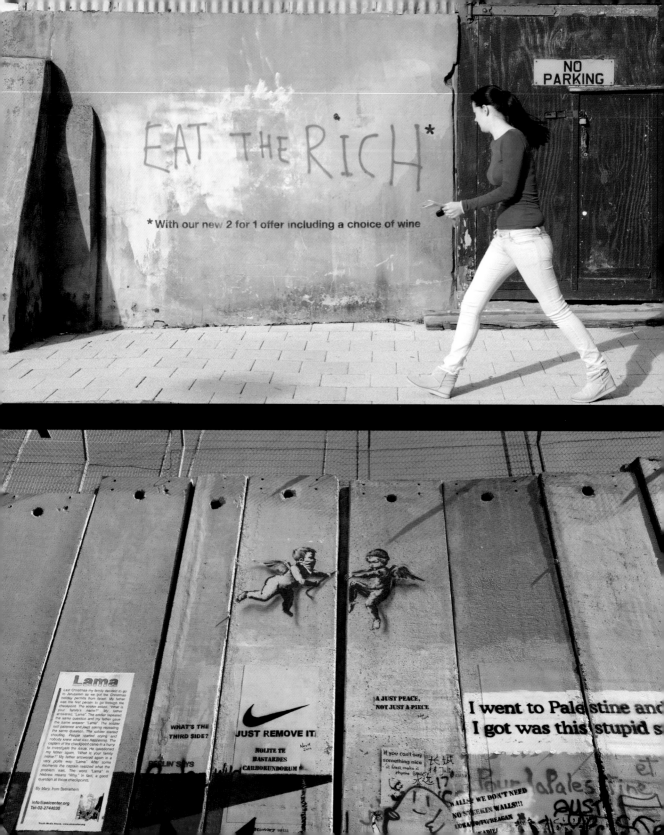

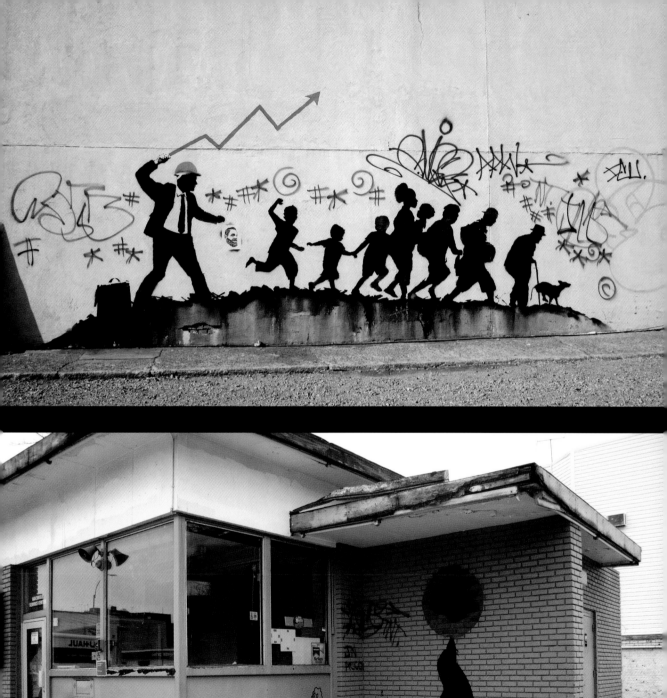

BANECDOTES
#9

THE REAL MEANING OF CHRISTMAS

Just when everyone thought he was going soft, Banksy returned to the world of shit kicking controversy by talking religion at Christmas time. During a trip to Liverpool Banksy placed a bust of a cardinal in the Walker Art Gallery, this time with the gallery's permission. The piece was altered to look like the face had been digitally blurred, an aesthetic associated with victims of crime, or alleged criminals. The piece seems on first glance to be a pretty unambiguous attack on the Catholic Church in response to the child abuse cover up scandals of recent years. But, just in case it was too conceptual, Banksy followed it up with a clarifying statement.

"I love everything about the Walker Gallery – the Old Masters, the contemporary art, the rude girl in the cafe. And when I found out Mr Walker built it with beer money it became my favourite gallery. The statue? I guess you could call it a Christmas present. At this time of the year, it's easy to forget the true meaning of Christianity – the lies, the corruption, the abuse."

The piece was placed in the context of a collection of Catholic artwork for added poignancy, in Liverpool where the greatest congregation of Irish immigration into England brought with it a strong Catholic influence.

On an entirely subjective note, what is interesting is how the aura of art dazzles us into suspending our disbelief when dealing with institutions of immense earthly power and wealth like the Catholic Church. Like Shepard Fairey, Banksy seems so often to try to make the language of power more obvious in an attempt to vaccinate us against it. This is why it is so tiresome to hear educated art critics dismiss him for being 'too obvious' - as if we should only be interested in subtlety.

"It makes such an obvious point that it does not reach the depths that real art does. It does not touch the viscera, the soul, or the remoter parts of the brain." - Johnathan Jones

The depths that only educated men with properly refined tastes may appreciate?

If you want to reach the whole world you have to make the song simple.

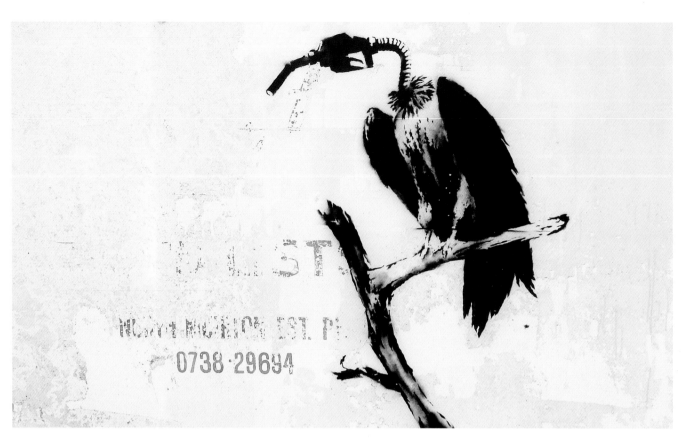

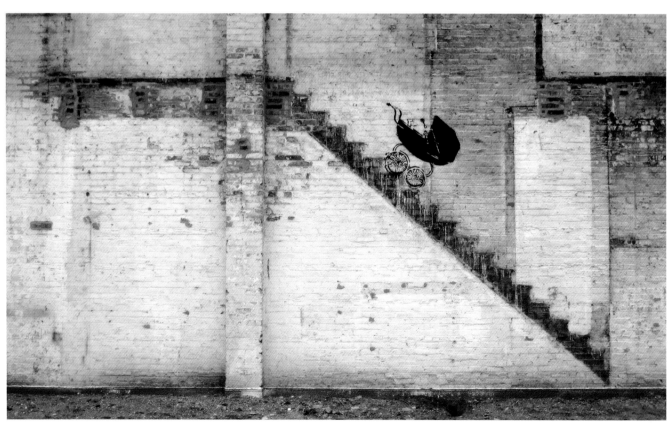

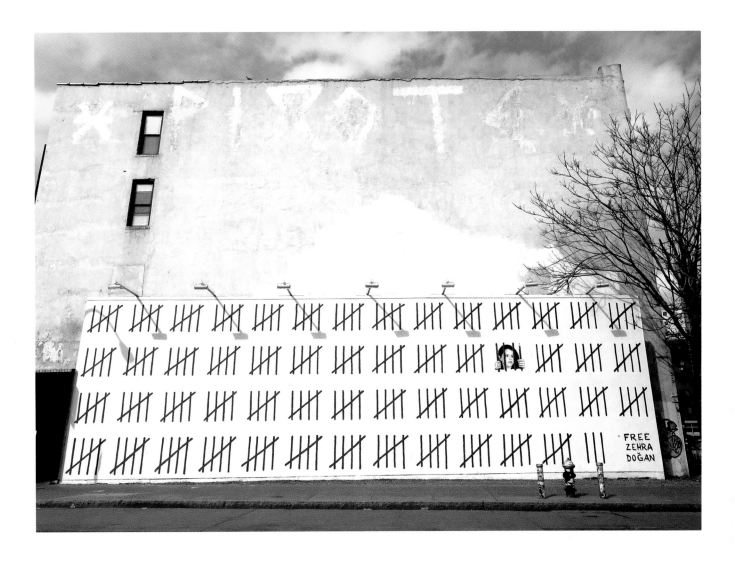

#FREEZEHRADOGAN

In 2017 the Turkish Army attacked the city of Nusaybin near the Syrian border as part of a crackdown on the Kurdish PKK militia. A Kurdish journalist, Zehra Doğan, protested the destruction of Nusaybin by painting a watercolour based on a photograph of the bombed out town, featuring Turkish flags on the ruined buildings. She shared the image on social media, without any comments attached. For this horrifying thought crime, Doğan was sentenced to nearly three years of jail time.

March 2018 Banksy and Borf painted a mural in Lower Manhattan, East Houston and Bowery to protest against Doğan's imprisonment. The image shows tally marks counting off the days of her sentence, and an image of Doğan trapped behind the bars, holding a pencil.

Zehra Doğan managed to smuggle out an illegal letter to Banksy from her group holding cell where few visits are permitted.

"In a moment of pessimism, your support made me and my friends here enormous happiness [sic]. Far away from me and our people, it was the best reply to the crooked regime that can't even tolerate a painting."

Banksy encourages people to repost Doğan's painting and tag in the strongman nationalist President of Turkey, Recep Erdogan. The Turkish repression of the Kurds continues today.

BUILDING CASTLES IN THE SKY

(The other side)

The iconic image of the girl with the wind swept hair, losing her heart shaped balloon always stood out in Banksy's street work. It seemed almost out of place, for an artist who can't resist the punchline, the visual joke, the twist, to paint something quite simple and emotive like that. Modern society robbing children of their youth and innocence, anyone? It's still the most popular Banksy rip off canvas / poster you can buy at pound shops.

There is another side to the prankster vandal in evidence at times. He's just a big softy really. There is the little aeroplane in Liverpool doing a loop the loop in the shape of a heart. And what about this...

"You don't need planning permission to build castles in the sky."

Of course the deeply buried truth about any punk is that they just want everybody to love each other really. They only get so angry because they're so disappointed.

Go on. Hug a vandal.

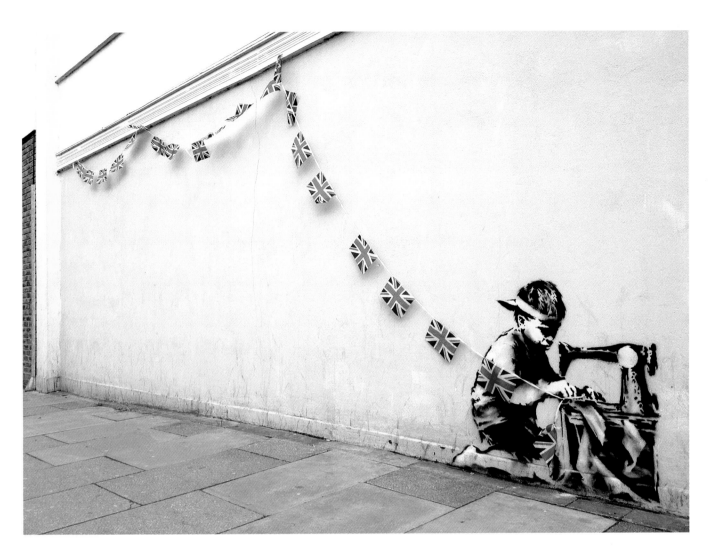

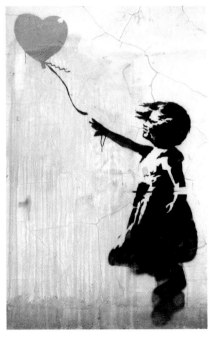

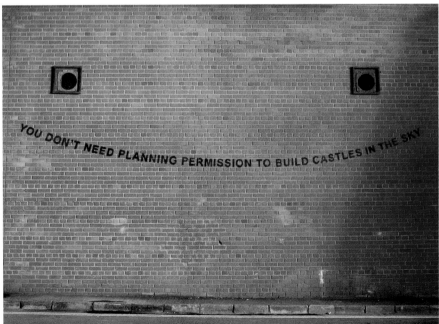

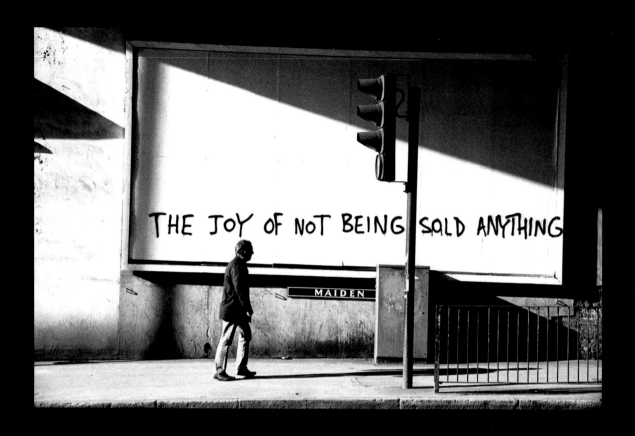

THE PEOPLE WHO RUN OUR CITIES DONT UNDERSTAND
GRAFFITI BECAUSE THEY THINK NOTHING HAS THE RIGHT
TO EXIST UNLESS IT MAKES A PROFIT...

THE PEOPLE WHO TRULY DEFACE OUR NEIGHBORHOODS
ARE THE COMPANIES THAT SCRAWL GIANT SLOGANS
ACROSS BUILDINGS AND BUSES TRYING TO MAKE US FEEL
INADEQUATE UNLESS WE BUY THEIR STUFF....

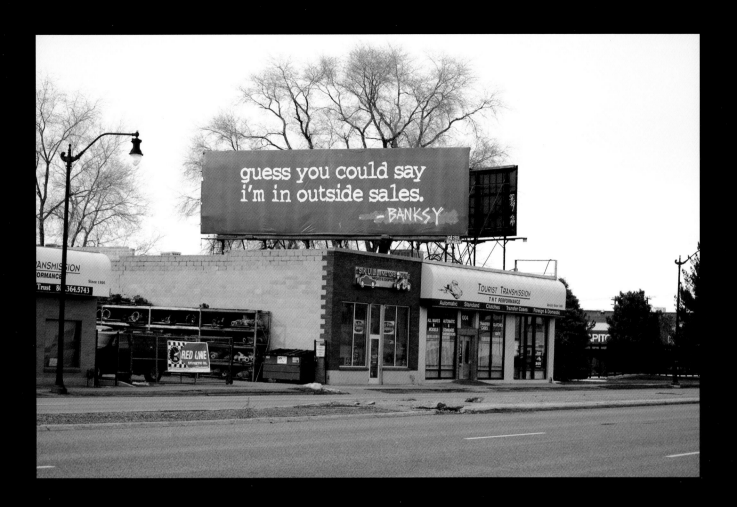

ANY ADVERTISEMENT IN PUBLIC SPACE THAT GIVES YOU NO
CHOICE WHETHER YOU SEE IT OR NOT IS YOURS, IT BELONGS
TO YOU, IT'S YOURS TO TAKE, REARRANGE AND RE USE.

ASKING FOR PERMISSION IS LIKE ASKING TO KEEP A ROCK
SOMEONE JUST THREW AT YOUR HEAD.

BANKSY

WATCHING YOU,
WATCHING ME

(or how to be famous for 15 minutes)

Banksy attacks the paparazzi as often as he attacks the CCTV camera in his street work of the last ten years. His Paparazzo Rat character chimes with the secret camera peeking out of a bin. The cult of celebrity goes hand in hand with the authoritarian state.

"It should by now be common knowledge that the camera is primarily a tool of social control. The camera as used in advertising presents to the populace the goods and lifestyles that are deemed desirable. The camera as used in film and TV then educates the populace on how to live one's life in a proper manner, so that one can acquire these goods and lifestyles (whether by legal or illegal means)." - Not Bored

Not Bored is the web home of the Surveillance Camera Players, a group that performs plays to live CCTV cameras in order to amuse / freak out the people watching the footage. Good idea eh? Could be a laugh if you're bored. Don't be bored.

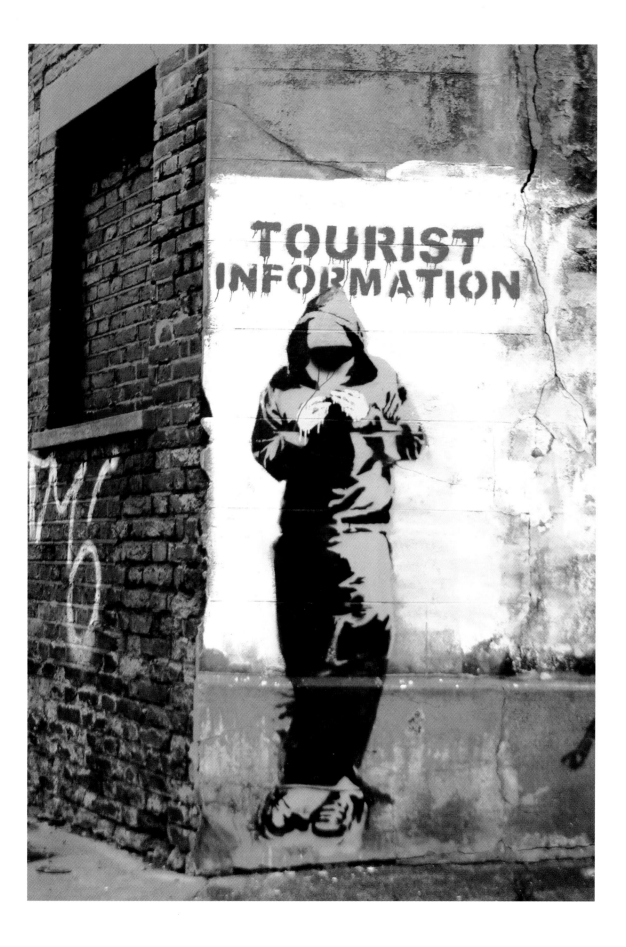

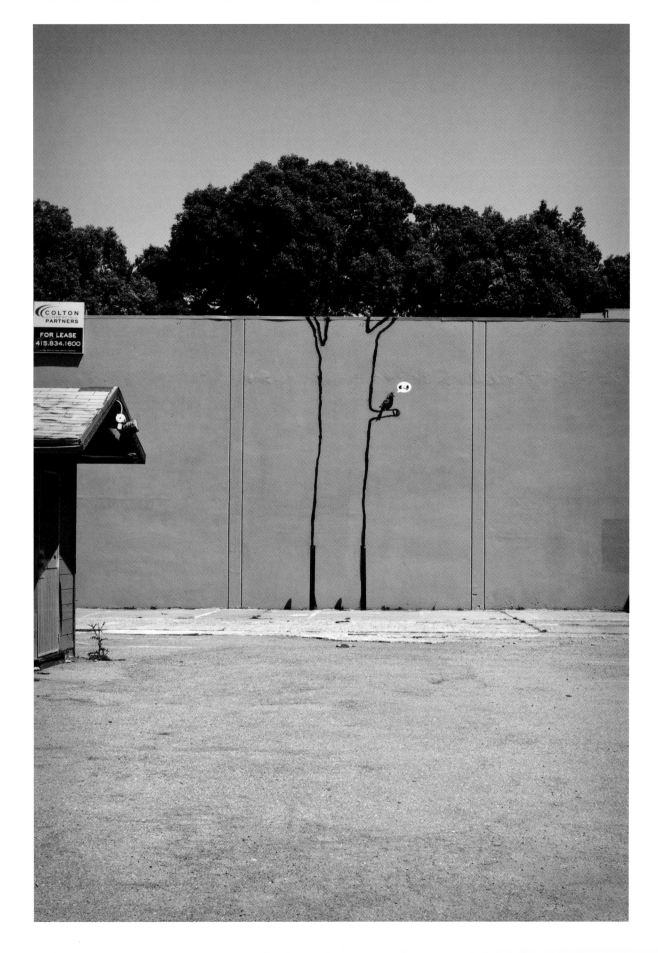

OVER THE COUNTER CULTURE.

Bethnal Green, London

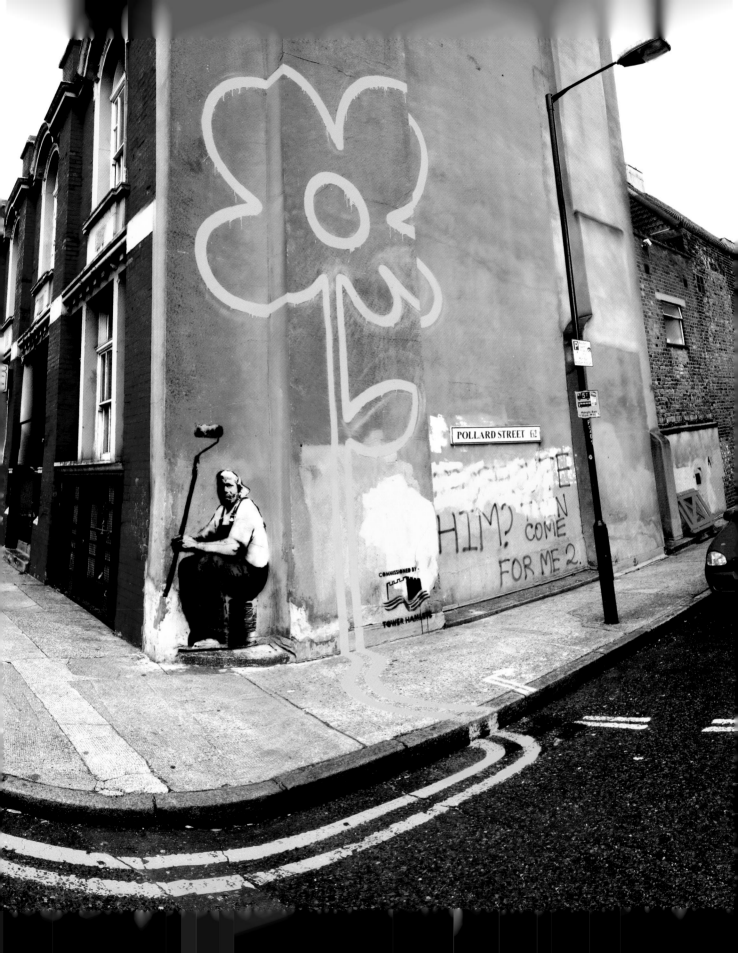

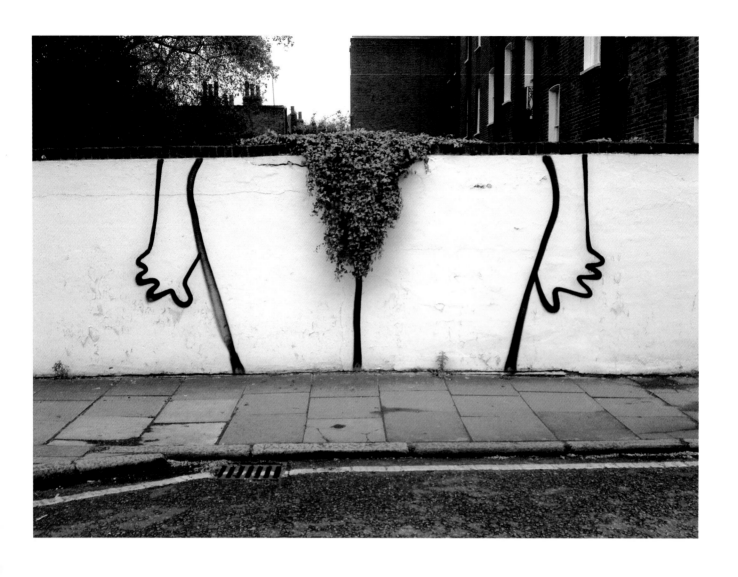

TREAT THIS BOOK LIKE SOFT PORN - INSPIRATION FOR ACTION

CHEER IF YOU WANT.
BOO IF YOU WANT.
YOU'RE STILL JUST THE AUDIENCE

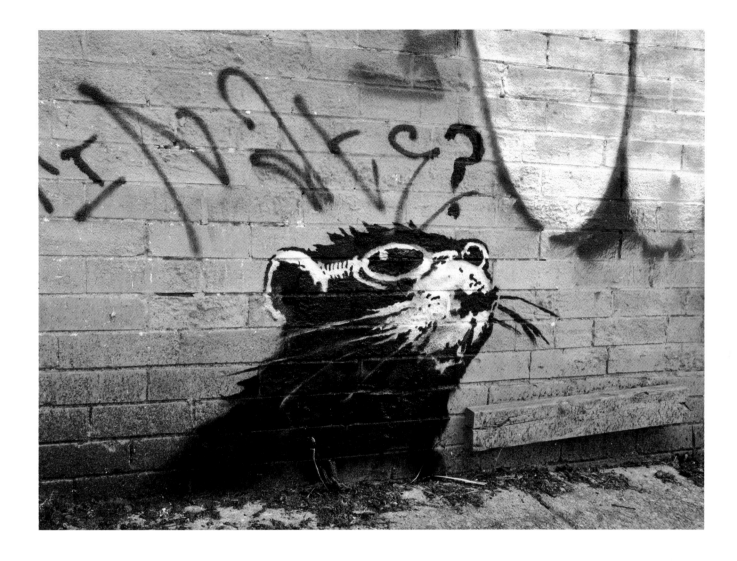

ORIGINALITY

Remembering What you Heard. Forgetting Where you Heard It.

Dr. Laurence J. Peter

Rewind back to the early 1980s and Blek Le Rat can be found beautifying La Ville-Lumière. Le Rat, often referred to as 'the Godfather of Stencil Graffiti' was one of the pioneers of illegal stenciling, saying that it better suited the aesthetics of his totality (it looked better in Paris). After another period of time, perhaps a 'while', Blek graduated to pasting, often images of himself with a suitcase. Genius? Perhaps. Fast forward thirty years and his contribution to pushing things forward seems to have been lost on some.

Banksy swears down he never copied Blek, as recently as 2011 he said as much in so many words etc. Blek disagrees, and let's be fair on the man, the circumstantial evidence is in his favour, but should vandals and revolutionaries quibble over such things? Le Rat has collaborated with B in the past and has been generous in his statements to the press, sometimes saying 'hey, it's all good' and sometimes saying 'grrr' (These are imaginary quotes).

However you call it, Blek is more famous now, for good or ill, than he would otherwise have been. Is that a win?

Remember, creativity is merely the arrangement of existing forms into new relationships.

STENCIL + RAT = ?

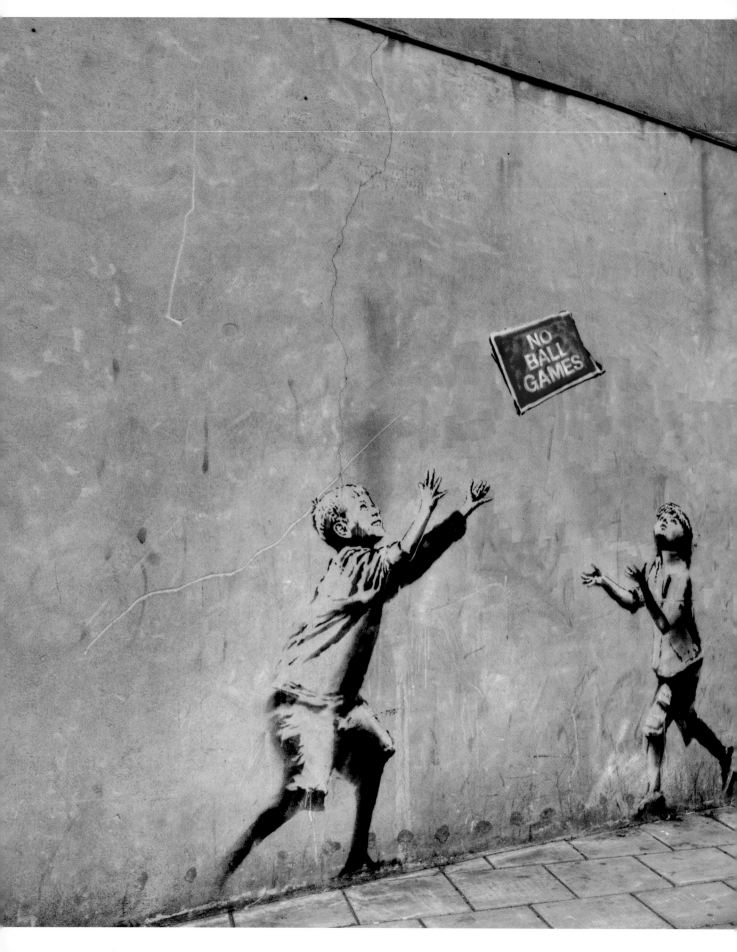

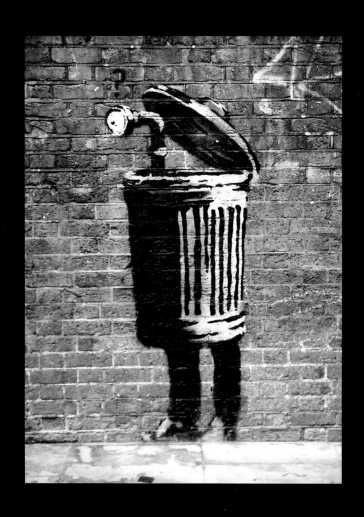

IT'S A SICK WORLD.

BANKSY

FEEL AFRAID, FEEL VERY AFRAID

(Social Control and The Suffragette)

Banksy is in good company when it comes to camera surveillance. The use of cameras as a surveillance tool in police work was pioneered against the Suffragette. The Suffragettes imprisoned at Holloway in 1913 refused to have their mugshots taken and were so successful at flaying around, shaking their heads and pulling gurns during portrait sessions that the police gave up and resorted to sneaky tactics.

"In September 1913, the British Home Office gave its approval and provided the necessary funds for prison officials at Holloway Prison to start using covert tactics (secret surveillance) to photograph the suffragettes as they walked about the prison's exercise yard. The plan was, after the women were released from prison, to distribute copies of their photographs to the agents assigned to follow and keep tabs on them, and to the guards stationed at places the suffragettes had already attacked or seemed likely to attack in the future."

So you see the camera has been a tool of social control right from its beginnings. Not only as a stick with which to beat the criminal (including any kind of political dissenter) but also as the carrot with which to drag them into service. It is in pursuit of the perfect life presented to us on TV that we submit ourselves to working mindlessly for the interests of others. The celebrity is there to make us feel inferior, the CCTV camera to make us feel afraid.

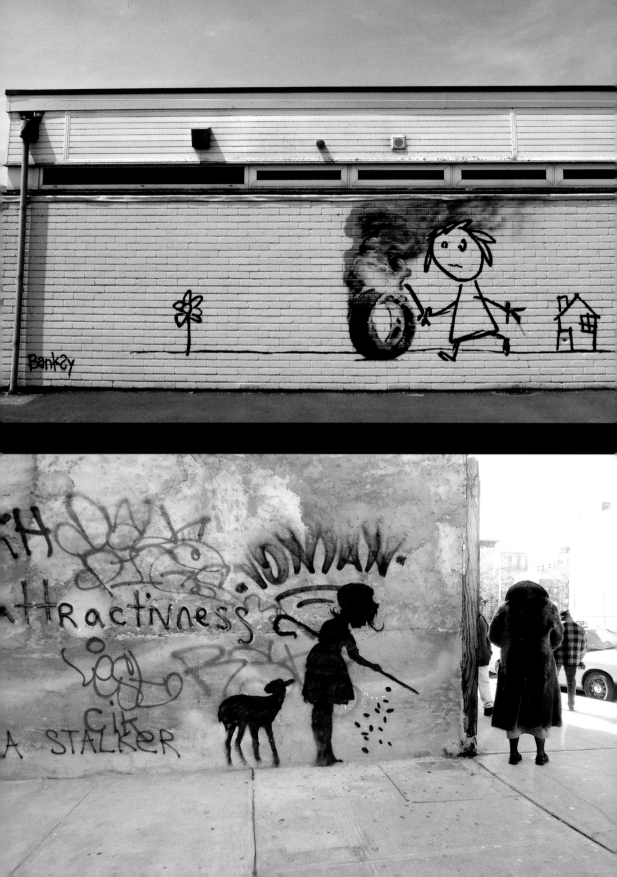

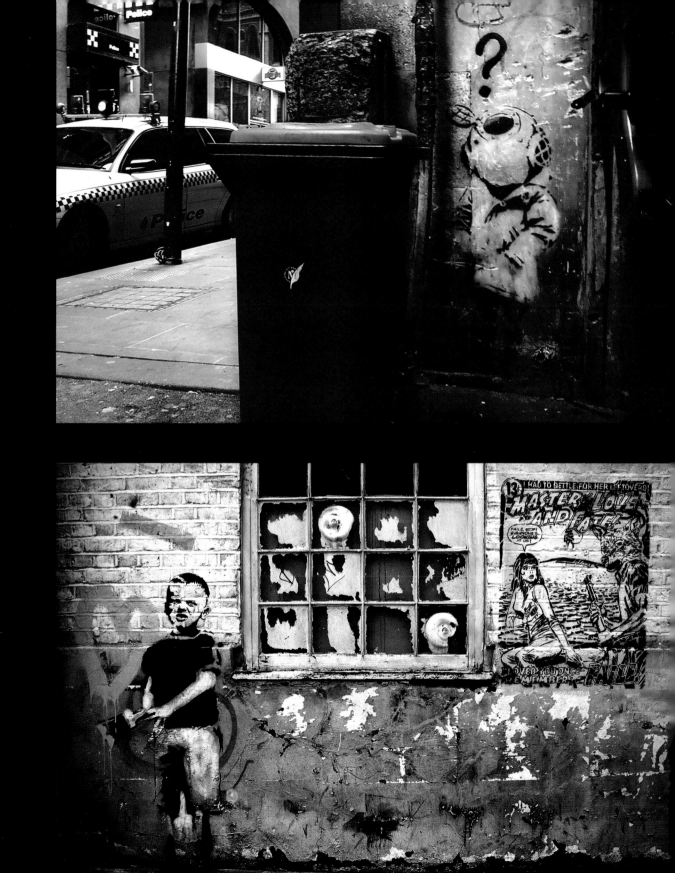

META TAGGING

(WTF)

It might seem obvious to say, but Banksy wouldn't be what he is today without the Internet. It seems difficult to remember now that people didn't have the Internet at home in the early Nineties when Banksy was learning the ropes. But the all pervading sharing machine that the Internet became is undoubtedly what allowed for street art to become a phenomena that in earlier days may simply have been a disconnected sub-culture destined to live on only in indy fanzines.

The work is always worthy of a photograph and those photographs can be shared and argued over online. Moreover his pranks and stunts are perfect fodder for gossip, comment and vicious troll wars. He is quite simply, digital gold.

You only have to go to Google trends to bear this out. Compare the search term 'street art' with 'Banksy'. Banksy has a search index of 1.4 to Street Art's 1.0 (Averaged out since 2004). That means that as far as the Internet is concerned, Banksy is Street Art.

If you write about Street Art online you have to name drop Banksy or people won't find it and read it. You have to use his name as a meta tag. Think about that. That's the ultimate accolade for a tagger, surely?

So this is why journalists always say stuff like 'The new Banksy' whenever they write about another street artist. It's the only way to get traffic.

PR agencies also abuse this 'traffic magnet' feature of Banksy's name, like the hotel chain that staged a competition whereby people were encouraged to steal a genuine Banksy.

Publishers abuse this feature to draw attention to their whole range of fabulous coffee table books about subcultures. Ahem.

Further analysis of Google Trends data shows that while 'Street Art' trundles along at 1.0 occasionally spiking out at 1.5, which demonstrates a consistent audience for the genre, Banksy averages just over 1.2 but frequently spikes out up to 5.0 or 10.0 when major stories break. This shows how Banksy, beyond the firmly established audience for Street Art, is the only Street Artist most people have any contact with in the media.

Google Trends also helpfully demonstrates that the UK towns of Poplar and Brentford are by some distance the most Banksy obsessed, searching for him by name in Google more than anywhere else in the world over the last eight years. Congratulations guys. Has anyone told you how to use RSS?

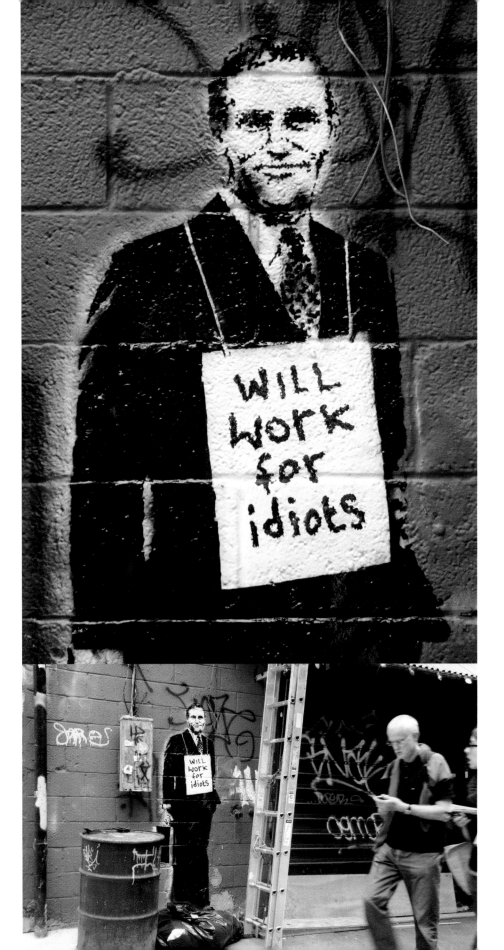

ANY LAST WORDS?

(The Crux of the Matter)

"A wall is not just a wall, it is somebody else's opinion and you do not have to accept it." - Untitled, *Street Art in the Counter Culture*

The thing about street art is, it all comes down to property. If you've never thought about the idea of property before, and really thought about it, then that might come as a surprise. But it's quite simple. Street art. like graffiti before it, regardless of what the content of the image may be, is a criticism of the idea of property itself. If it was not illegal, it would not be street art. Therefore its illegality is what defines it. Take it out of that context and you are left with 'art'.

If there ain't no property damage then it ain't really street art.

Anyone from the kid scratching his name in the back of the seat on the bus with his keys to the most beautiful and sophisticated Swoon portraiture is engaging in this power struggle whether consciously or not.

Boredom is political.

Banksy made it clear from the start that he was consciously angry about 'property'. He spoke explicitly about being annoyed by the huge billboard at the end of his street in early interviews. This is public space being owned by private interests. Here is the guy who said 'asking permission to paint on their property is like asking for permission to pick up the rock someone just threw at your head.'

The truth about property is that it is a relationship between people and things. Like all relationships it is negotiable and like many relationships it is dominated by one fat kid who spoils it for everybody else.

The people who live in the street surely have more right to determine the state of their environment than the fat kid who can afford to buy their physical and mental space?

And what motivates this metaphorical fat kid?

Why is he defended by the full force of the law?

Banksy calls bullshit on this wholly deferrent and unquestioning attitude we have to 'property'.

No matter how much you squawk 'hipster' at him his art is powerful for this reason alone.

It is radical.

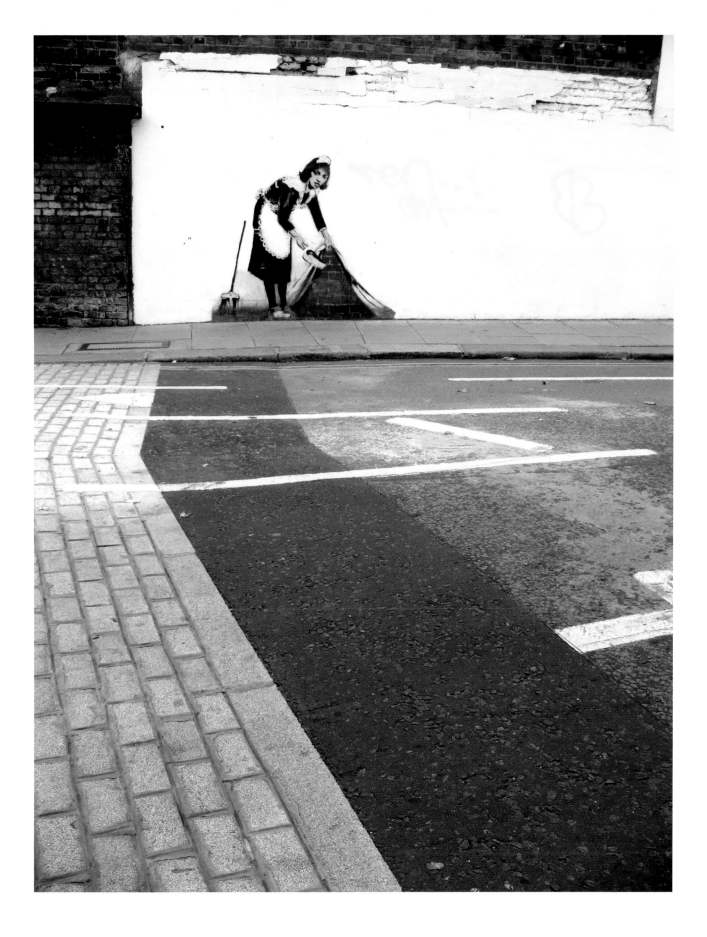

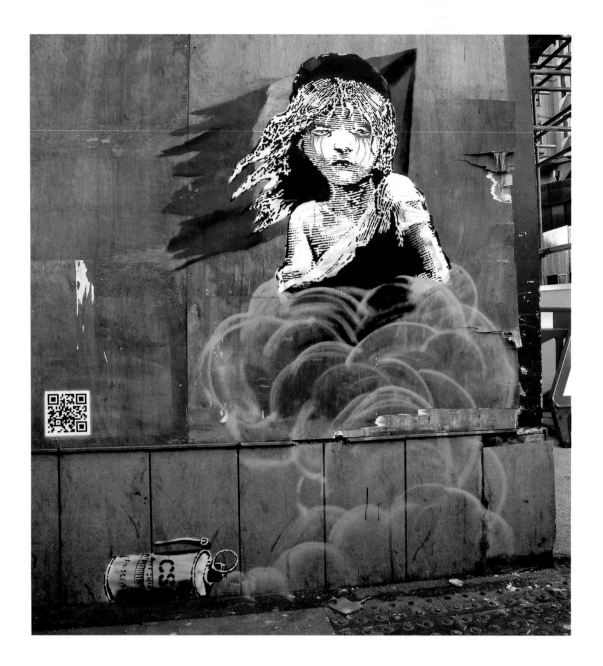

THE MISERABLES

The girl from 'Les Miserables', the French inspired musical that celebrates the doomed revolutionary fervour of 19th century France, and an iconic symbol of London's West-End theatre district, materialises like a ghost from a cannister of tear gas. She weeps copiously. You or I would too with a faceful of tear gas. Hence the name.

Next to her there is a QR code that links to a YouTube video of a dawn raid in the Calais Jungle. Although French police deny using Tear Gas in the camp the video clearly shows it being used.

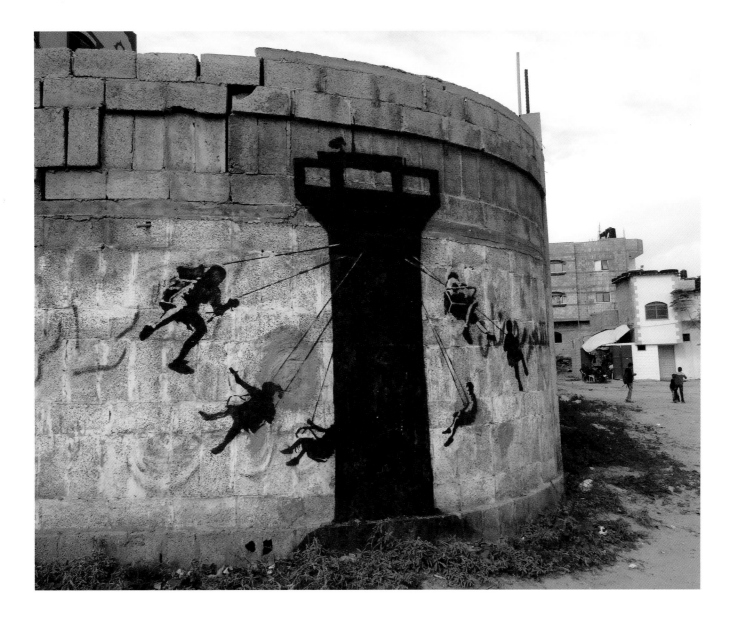

GAZA

It's fashionable these days to accuse people who support the rights of Palestinians, of hating all jews. I don't remember this happening in South Africa. When we supported the boycott against apartheid nobody accused us of hating all white people. But there you go.

Banksy doesn't hate Jews. He invited Israeli artists to participate in Dismaland. Relax. It's OK to enjoy bagels and still object to elements of Israeli foreign policy.

All the Israelis I have met have been really cool people. I've never met any Palestinians. They're not allowed to travel.

After the 'Summer War' of 2014, Banksy returned to Gaza to paint three pieces and make a short video drawing attention to the devastation in the region. An estimated 17,000 homes in Gaza were completely destroyed during the conflict.

Banksy painted a cute kitten because 'people on the internet only want to look at kittens' which was somewhat awkward to explain to the grief stricken locals.

BETTER OUT THAN IN

The corpulent young man belched loudly as he drained his massive bucket of soda pop and tossed it into the street. Better out than in, muttered a limey street artist as he passed by. Or something like this.

Nobody can know what exactly inspired Banksy to do his month long residency in the October of 2013 in New York City. It would be irresponsible to simply ask him, as he may not even know himself. One thing is for sure though, the colloquial phrase 'Better Out Than In', used as a title for the month long series of works, is a charming double entendre. In one sense alluding to his preference for illegal street art over gallery work and in another sense perhaps equating his own work with the act of vacating wind from a gastric system.

If there can be any greater warning not to take him seriously on his own terms it is the inclusion of helpful 'explanations' of the work. These phone numbers included alongside some of the pieces give the viewer access to an audio guide in the style of art galleries and museums the world over. Each one 'rips the piss' out of the very notion of interpreting the work, rendering the work of people who write about Banksy's work effectively useless. But we soldier on.

Why? Because, in spite of all the smoke and mirrors, Banksy clearly does want to say something that he actually means. The pathos of the twin towers tribute sits uneasily alongside crap jokes about dogs pissing on fire hydrants. Then there is the fascinating horror of listening to soldiers' banal chatter (courtesy of wikileaks) about killing kids, in the audio guide accompanying a mural of horses charging with night vision goggles.

Banksy can't seem to avoid giving a shit, even while he tries real hard to pretend he doesn't. The 'residency' lashes out at militarism, cultural

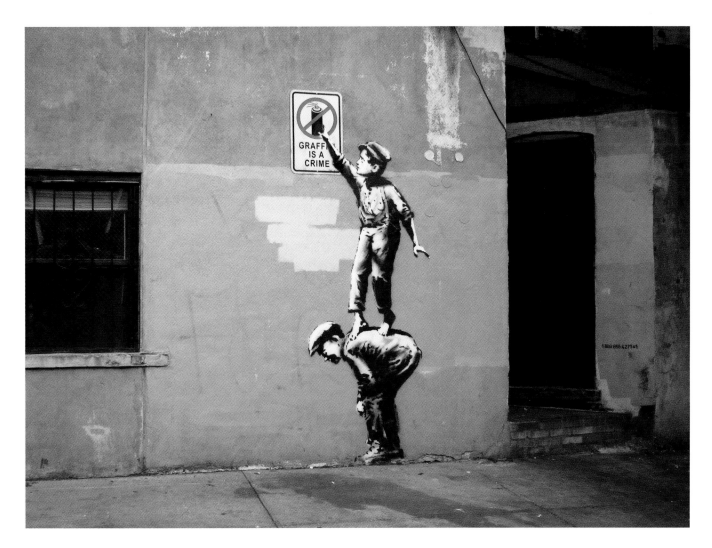

hypocrisy and the art market among other favourite Banksy targets. It also pays homage to the alternative history of New York as the birthplace of the Hip Hop culture that spawned Banksy himself.

New York itself can be seen as either the 'Mecca' of Graffiti or the 'Canterbury' of Graffiti depending upon your persuasion. Or maybe it's just the 'Lakeside, Thurrock' of Graffiti. Whichever it is, New York is also the 'Rome' of the American Century. It's pretty important any way you look at it. Banksy signed off the month with a free gift for the fans in the form of a souvenir t-shirt design satirising the iconic 'I Heart NY' logo. His battered and bruised heart balloon covered in 'Band Aids™' (plasters) nicely captures the critical undercurrent running through the residency. Perhaps Banksy is disappointed with New York, if he is it's still a disappointment rooted in love. A love for all the amazing subcultural stuff that came out of the city.

But all that now seems to have fizzled out and faded away with the increasing gentrification. Real grass roots urban cultures gave way to lifestyle consumerism. Resistance became commodified, branded and repackaged to buy over the counter. The rage against the machine giving way to hipster posturing. 'City living' is now an expensive caricature of an imagined bohemia long lost in the neoliberal onslaught on the poor.

It all started in 1975, when a posse of financial super bastards pushed NYC into bankruptcy by refusing to roll over the city's debts. What followed was a bailout deal 'so punitive, the overall experience so painful, that no city, no political subdivision would ever be tempted to go down the same road.' It was in effect a takedown of the municipal democracy of the city by the financial class. The unions were shattered. The city was deliberately starved of federal funding to create the crisis that would in turn justify heavy-handed austerity measures. The infrastructure of the city went completely tits up. Everyday life in New York became brutal and hard.

Two years later, with the city now completely at the mercy of an all-powerful financial class, real New York was sacrificed on the altar of tourism and real estate speculation, the basic elements of neoliberalism. This culminated in the city hiring the hippest ad agency on Madison Avenue to sell this new dream of New York to Generation X. The agency delivered the world famous 'I Heart NY' logo.

The very idea of commodifying a city as a tourist attraction (even while you gutted it's social institutions and hung the city population out to dry) was still new then. The New York balance of payments crisis was the first time

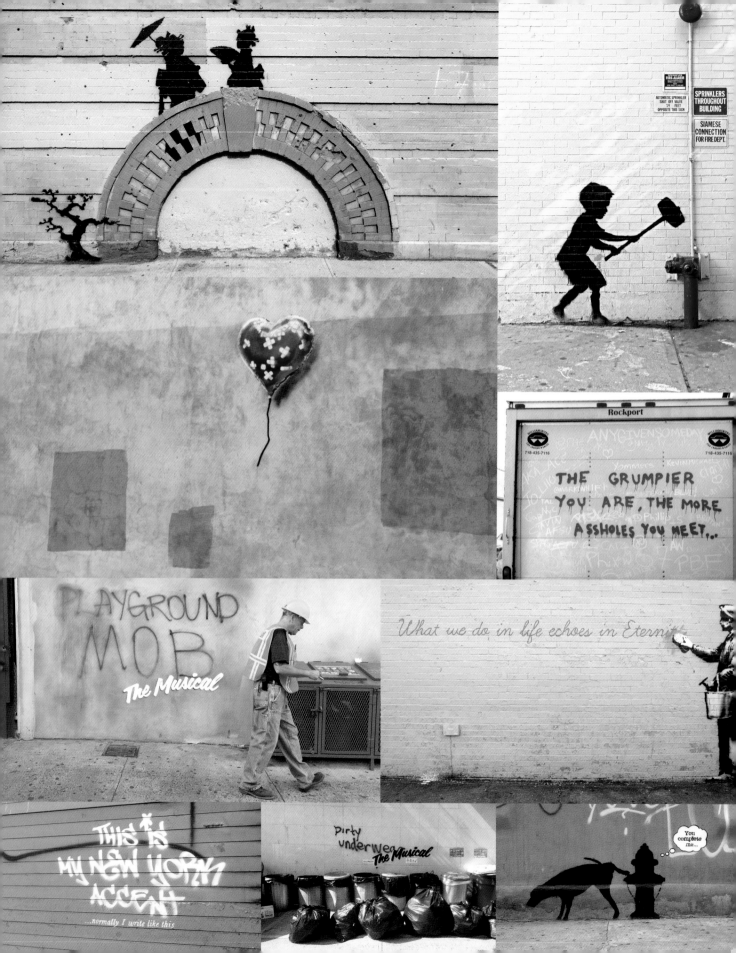

neoliberal economic theories were applied in the real world, and the rich were very pleased with the results. Pinochet followed suit in Chile, closely watched by Margaret Thatcher. Reaganomics was simply the New York situation played out at National level. The 'I Heart NY' logo became the flag of a new type of city wherein citizens with a democratic voice became replaced by disenfranchised consumers or an underclass of excluded and structurally unemployed populations.

So, it is very relevant then for Banksy to hijack that symbol in the wake of the Occupy movement (which sadly seems to have failed to slow down the Bull of Wall Street even momentarily).

The effects of the bankruptcy and subsequent 'restructuring' of New York in 1975 created the social landscape which in turn gave rise to Hip Hop, Punk and Disco. With the dissolution of the old social structures came the wild partying, the chaos, the creativity and the danger that made 1970's NY not only hell but a kind of weird heaven too. A lost generation grew up, ignored at home, their parents broken by their failure to adapt to the infernal new world of all against all created by neoliberal policy. Whole groups were excluded from the labour market and subsequently criminalised.

Out of this backdrop came the explosion of graffiti culture, and echoes from

that blast eventually washed ashore in the little English port of Bristol where a young Banksy was listening. No wonder then he wants to save 5pointz - a little piece of that other history of the city.

The main problem with forms of resistance that emphasise individuality is that they very easily become commodified and sold back to us as lifestyles. So begins the awkward dance for the 'subcultural' actor. Struggling for authenticity and rebelling while finding that your acts of rebellion fit all too comfortably into the schema of consumer society, in fact helping not hindering your enemies.

This is an absurd situation for the rebel - no matter which way you lash out you seem to hit the wrong target in the process. And it's an issue Banksy always seems to be hyper aware of, which goes some way to explaining why he tends to use strategies to undermine the value of his own work, to abuse the trust of the viewer deliberately. If he is awkward enough it won't be easy to turn him into another lifestyle brand.

But therein lies the idea 'You are an acceptable level of threat and if you were not you would know about it.' - or as he himself puts it, 'If graffiti changed anything it would be illegal.' And the most damning indictment, or cleverest containment strategy pursued by the establishment is to

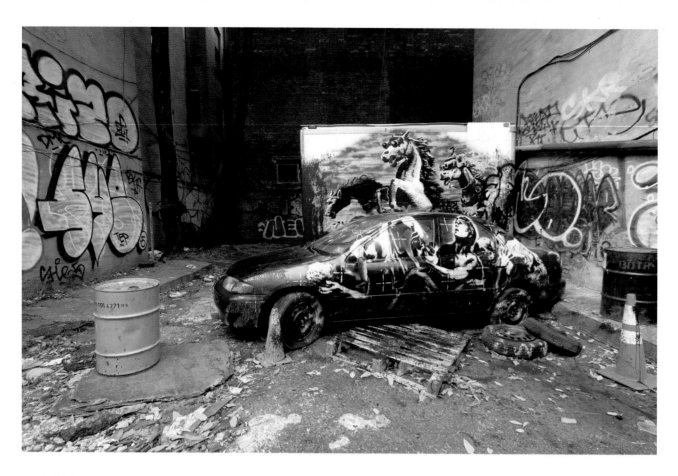

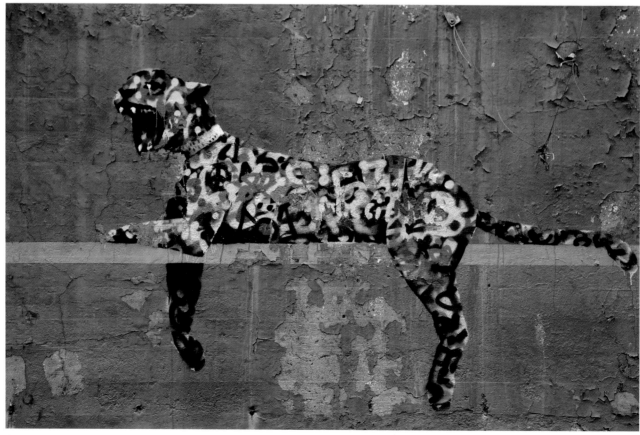

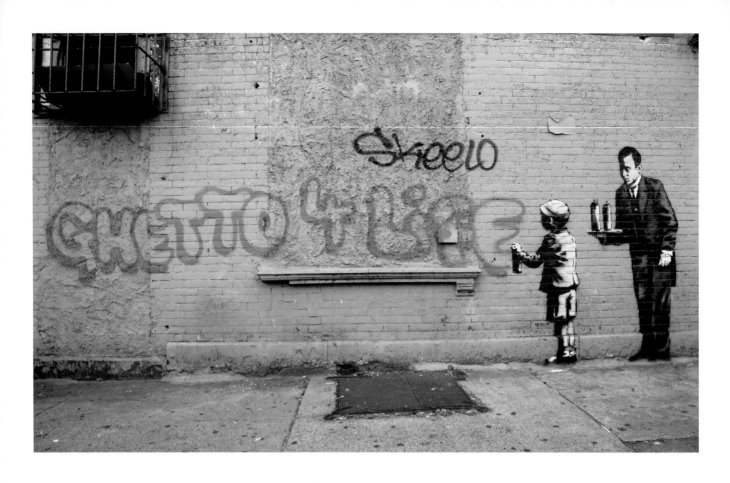

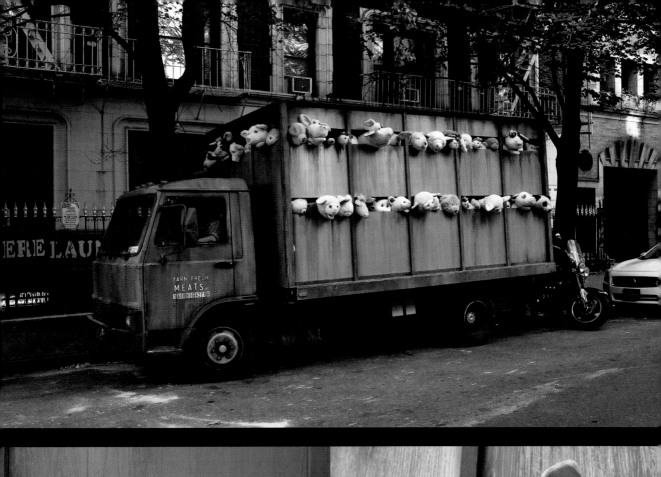
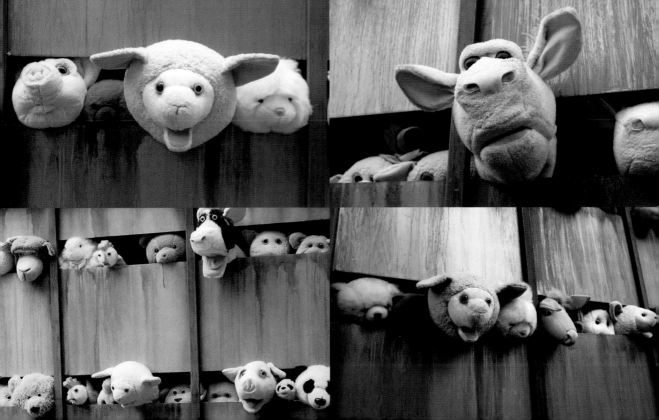

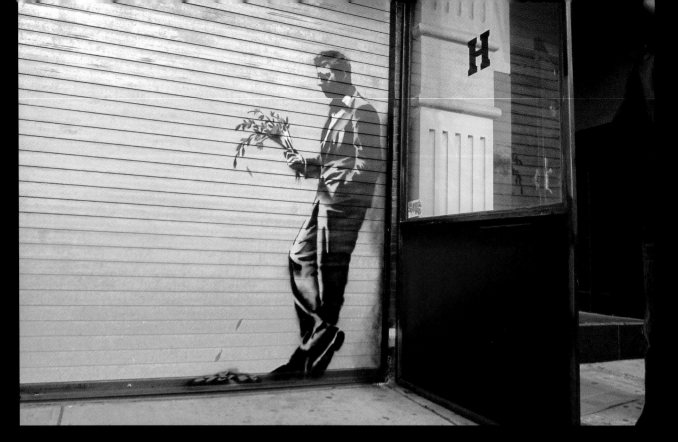

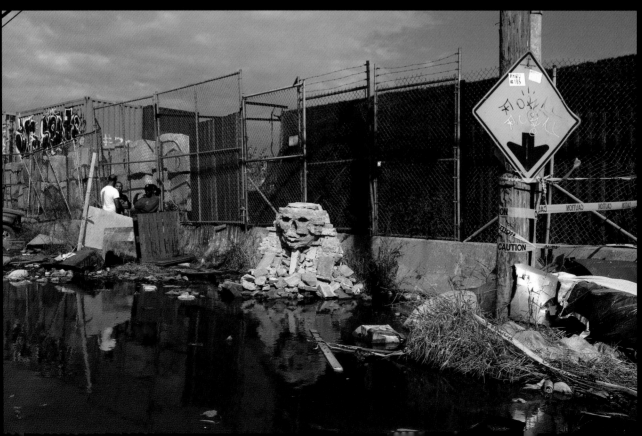

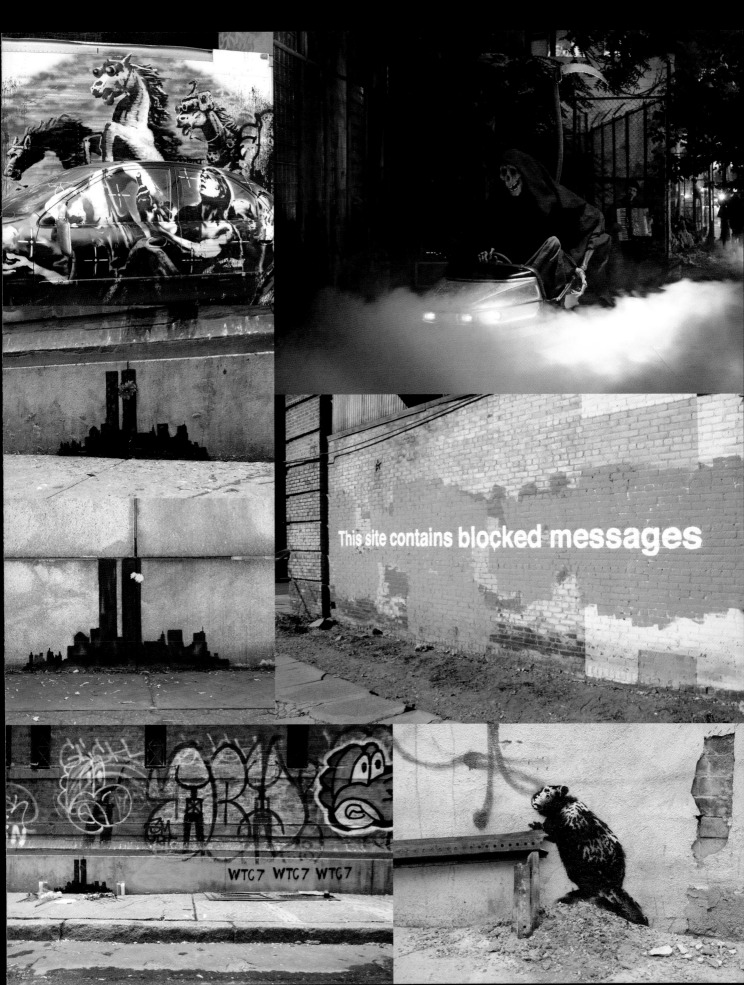

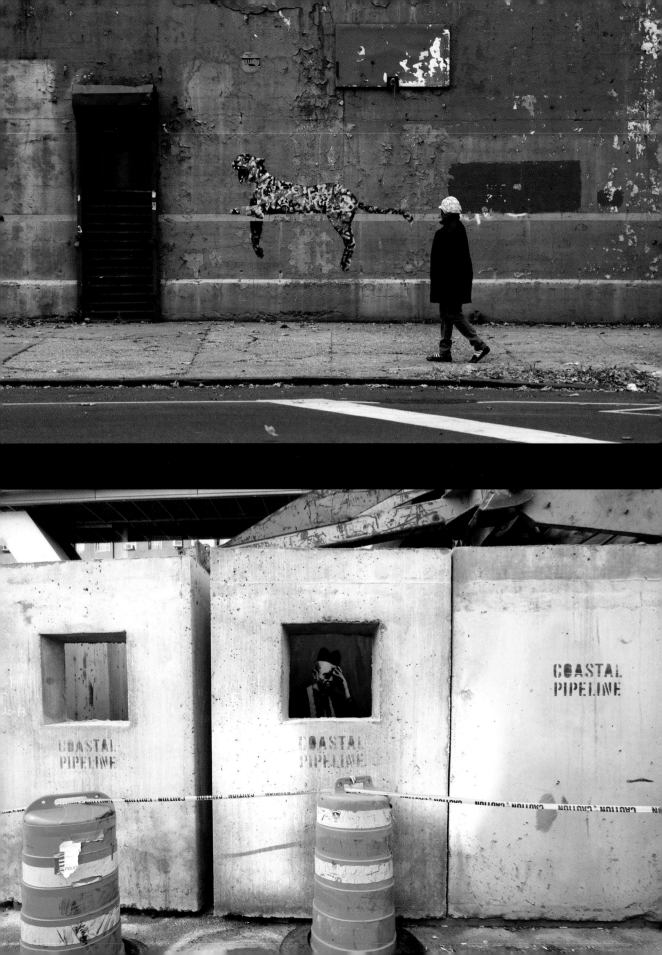

simply treat Banksy as an exception to the law. The NYPD made no real attempts to stop him and have even protected his work from thieves. And this remember in a city with the most draconian anti-graffiti laws in the western world.

One periodical bitched about Banksy failing to measure up to the cities 'homegrown graffiti tradition' as if he wouldn't be aware of that. But there are two art cultures in New York. The Art Market itself is so in bed with the financial markets that the collapse of Lehman Brothers would have been felt as much at MOMA as anywhere. Fine Art is an investment asset to be speculated on just like real estate. And when Banksy sells his pieces for sixty bucks from an anonymous market stall (is this a play on 'art market'?) he is taking another well deserved pop at the ridiculous economy of value in 'High Art' of 'Fine Art' or whatever you want to call it to make it sound expensive.

Fabricating million dollar values out of smoke and mirrors is precisely what Wall Street does, and this is echoed in Galleries and Auction houses the world over, ironically extending even to the valuations on Banksy's own work.

"These are the two New Yorks, the financial and the cultural, both adept at making vast sums of money out of utter bullshit." - Plato

And absolutely none of this money ever touches the streets of the city of course. Which is why you can't help but smile when a group of hood entrepreneurs cover up the Banksy beaver who has just gnawed down a street sign and then start charging tourists money to take photographs. "If you care about the artist you'll pay, I don't give a fuck about it, I'll just break it."

In a city where most children have no idea that meat comes from dead animals and have only ever seen wildlife on Sesame Street it seems cruel,

albeit pretty funny, to drive a truck full of soft toys around the meatpacking district. Again Banksy is on about the hypocrisy of our sentimental attitudes towards animals given the horrors of our industrialised agriculture, echoing his earlier Pet Store show.

One of the more telling pieces in the 'residency' is the young boy with the butler spraying 'ghetto for life'. Given that the Daily Mail supposedly unmasked Banksy as being (horror of horrors) middle class, is this a spin on his own class guilt? Probably not.

It's an old right wing strategy in any case to undermine dissenting voices by recasting them as privileged. Witness the banging on and on about how the Occupy protestors had iPhones and went to Starbucks. If you're middle class you can't complain. So shut the fuck up etc. But it's more likely that this piece refers to the widespread adoption of 'street' culture by middle class teenagers. The notorious middle class rudeboys of suburban London for example, parodied by Sacha Baron Cohen with Ali G.

Banksy said goodbye to New York with his balloon letters, a clever tribute to the city where balloon letters in graffiti were probably* first used. The whole thing was like doing penance for crimes against the code of the street. (Witness the confession box) Has he made amends for his dalliance with proper art galleries and that? Thirty days of work in a row seems dangerously like a real job. No doubt he will need to rest back at the lab for some time and think about what he's done. Meanwhile, everybody is talking about Banksy again...

Still, better out than in I suppose.

*cue endless geeky arguments about whether Philadelphia or Paris did it first.

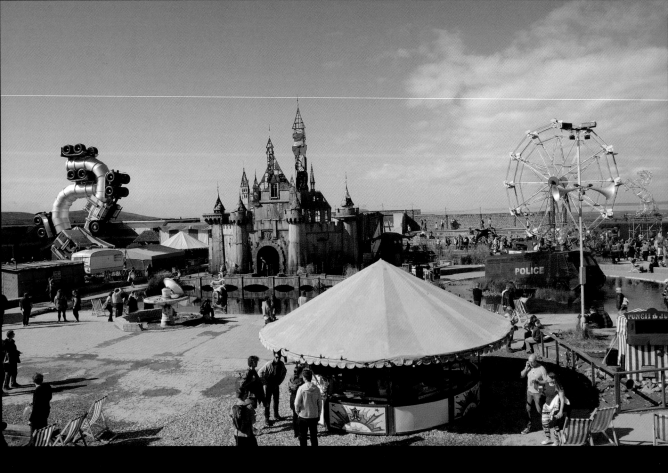

DISMALAND

The Little Theme Park with a Big Theme

A long time ago, before the orange splashed air buses started ferrying the British working class down to the Costas, hardy blue-collar-folk would flock to the Great British seaside resorts to swim in Baltic outdoor pools as if they literally did not give a monkeys. Now these coastal towns, that may have forgotten to close down, play host to more sinister pleasures...

One such resort, Weston-super-Mare, Venice of the West, and home to the 'Tropicana' lido just outside Bristol, happened to be a boyhood haunt of Banksy. Inspired by the now derelict site, Banksy decided to use it for a large scale art prank.

In his biggest collaboration yet, with 58 other artists, funded by his own fair wallet, Banksy and crew transformed the old lido into a 'Bemusement Park' packed with agit-prop installations designed to provoke, amuse and enrage. Disney lawyers were, understandably, banned from the park.

"It's a theme park unsuitable for children." - Banksy

The event was so successful that it appears Banksy may have unwittingly invented 'popular contemporary art.' With a visitor rate that many large museums would cream themselves over, the event brought a shedload of cash to the local economy, whatever that means - usually it means the money flew out of the area into the pockets of whoever owns the local economy and from there to Mossack Fonseca in Panama.

If you missed the real thing then you can console yourself by strolling through the websites of all the contributors handily listed on the Dismaland wikipedia page. It's a fascinating little trip and will make you sound like an edgy political art boffin the next time you go to a pop-up gourmet burger bar with your workmates.

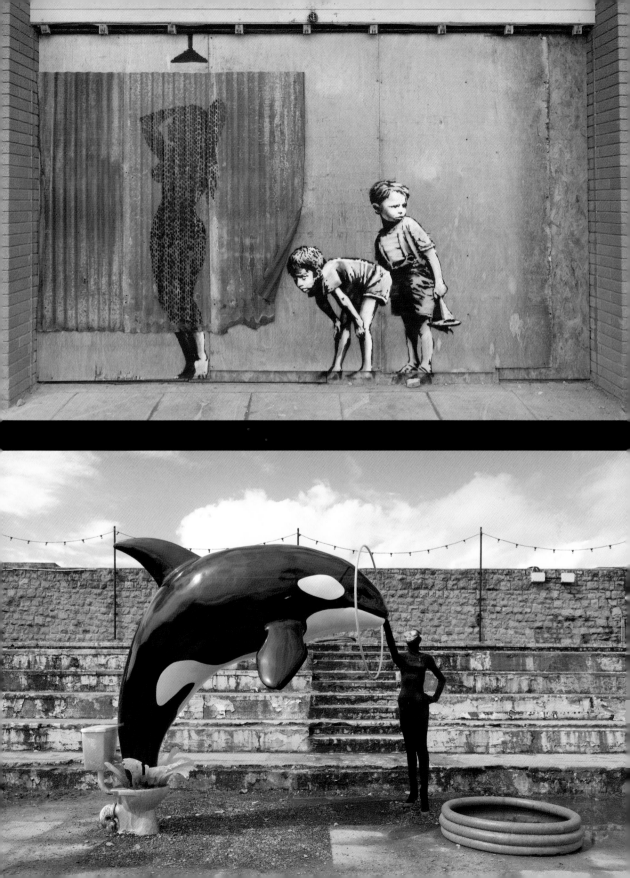

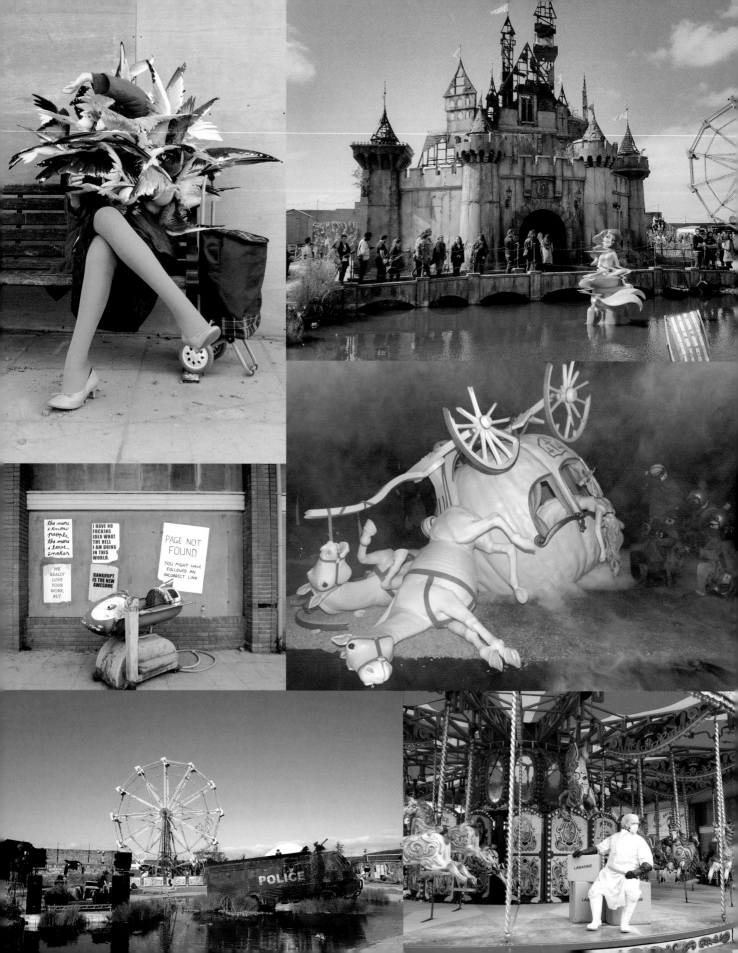

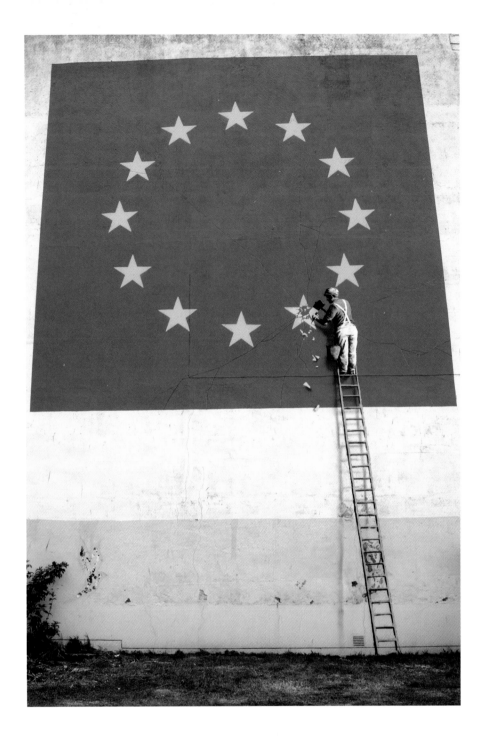

BEEN DOVER

In 2016 a millionaire banker with a French surname and a German wife saved the NHS from the migrant workers that make up it's staff. 52% of Britons voted to leave the European Union although it was later revealed that many of them didn't really know what that meant and they just wanted to mug off the Westminster elite or something and they never really hated foreigners - just Londoners. But also maybe foreigners a bit.

Banksy celebrated this historic balls up with a lovely big drawing of a bloke chiselling a star off the European flag. He done it in Dover cause it's where they'll have to build the wall to shut Europe out.

Fun fact: 45 tins of blue paint had to be mixed specially by the Valspar team at B&Q. Other paint mixing services are available. This is a lie.

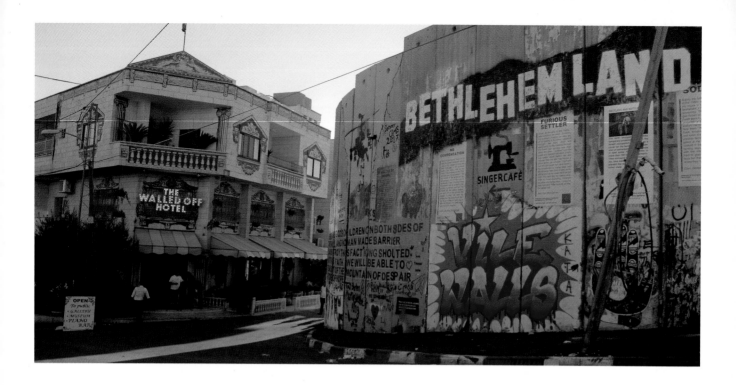

THE WALLED OFF HOTEL

Banksy has now opened a hotel in Bethlehem. You might know Bethlehem from such popular hits as Christmas.

Now of course, Bethlehem is a stone's throw away from the border wall between Israel and Palestine. Whatever you might think about the conflict - it shouldn't be too controversial to describe this as occupied territory. It is controlled by a foreign power. Life is hard in Bethlehem, something that is easy to ignore from a distance. So what if you could entice people from the other side of the wall to come and have a look?

"Walls are hot right now, but I was into them long before Trump made it cool." ...Banksy

Team Banksy claim that the hotel is both a real business venture and a work of art. Being ideally situated for a tour of the murals on the West Bank barrier it seems like it might really create a mini-tourist industry perhaps even attracting young people from Tel Aviv.

"Our Palestinian management and staff offer an especially warm welcome to young Israelis who come with an open heart."

The exterior echoes the style of exclusive gentlemen's clubs in London. Such clubs would have been the engine rooms of British politics a hundred years ago when London's political elite were discussing how to carve up the Middle East in a pungent atmosphere of pipe smoke and after dinner Port. The hotel is intended to mark the centenary of the Balfour Declaration - a document which set the wheels in motion for the creation of the state of Israel.

Banksy wants to remind people that Britain is very much implicated in the conflict - a fact that many Britons probably don't know, because they were too busy doing poppers in the back of the history class. Actually it probably isn't even taught. I don't know because I haven't got time to read the bloody national curriculum for history. You can do it yourself.

If you print it out you can read it in one of the military surplus camp beds in the 'Budget' suite of the Walled Off Hotel, all kitted out like an IDF (Israeli Defence Force) base camp.

Up in the 'Scenic' rooms, all of which look beautiful, you can see the graffiti on the barrier and even the nearest IDF guard tower. Or if you enjoy cognitive dissonance (mindfuckery) you can take the deluxe Presidential Suite. There one might get naked in a hot tub with four pals situated in a room fit for 'corrupt heads of state'. Then, take a sumptious breakfast while gazing lovingly at the guards in the surveillance tower above.

The hotel also features a graffiti supplies store - if you've got the stones to go and hit the division wall. How certain are you that those young conscripts in the tower wouldn't find it funny to douse you in 'Skunk', a malodorant yellow mist that leaves you smelling of sewage.

If that isn't enough to get you on the plane to Tel Aviv - there is a hugely informative museum featuring the Biography of the Wall, and the hotel has an art gallery, with a real actual curator who is on a genuine mission to revolutionise arab art.

Could this spark a conversation that might lead somewhere? Might a handful of Israelis and Palestinians start chatting in the lush dining room one evening? Stranger things have happened. It is after all, in one of the few areas that both Israelis and Palestinians are allowed to go.

Has Banksy managed to hunt the most elusive of snarks...political satire that actually achieves something?

. . . And of course you can exit through the gift shop.

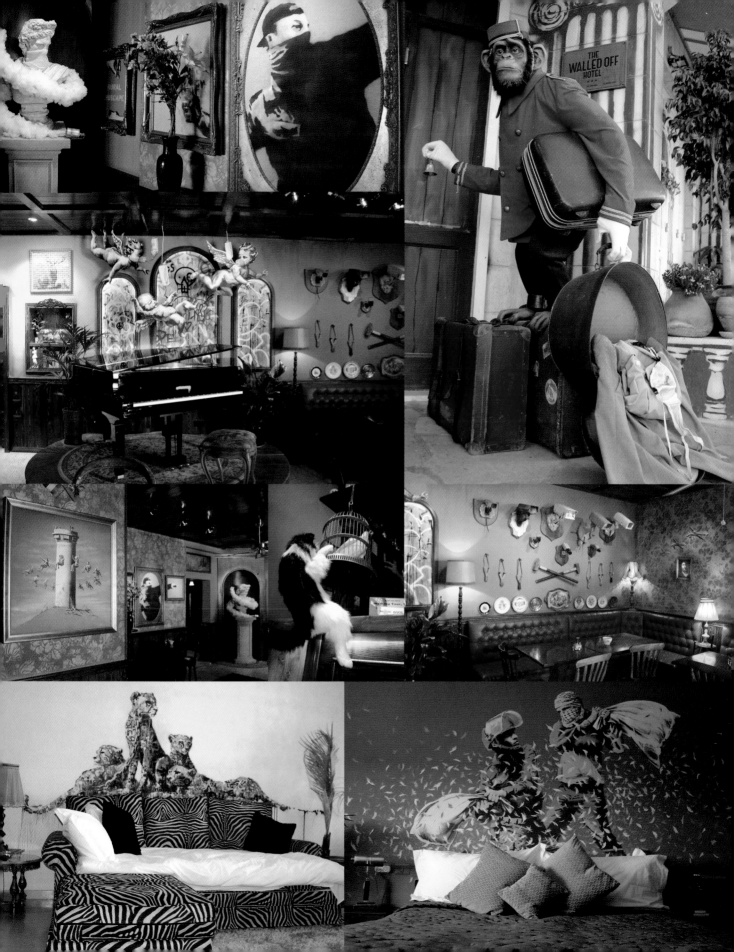

MISTER SELF DESTRUCT

Shredded Art

Going once at £860,000, going twice, gone! A cheer bubbles up from the crowd, followed by a shrill alarm and stunned silence as an ornate frame appears to defecate a version of 'Girl with Balloon' in a spectacular diarrhea of canvas ribbons. A European woman drops her chicken sandwich. A journalist quietly ejaculates.

Sotheby's auction house in the heart of Mayfair, a cathedral of haute bourgeoisie power, an art shop for the global elite. Situated in the square you don't want to land on when you're playing Monopoly, in a slice of London dotted with galleries that sell the most expensive pretty things known to humanity. It's a far cry from the rough end of Bristol, where the DryBreadZ Crew once forwent the luxury of margarine in favour of spending money on spray cans. But now, it's precisely the place you would go to buy an original Banksy.

A European woman, who does not wish to be named, like Banksy, innocently splurged a million on a Banksy original. (Well, it was a much replicated original. But what does original even mean these days?) And anyway, it soon became an original when it self destructed immediately after the hammer fell. A shredder built into the frame chewed up half of the 'Girl with Balloon' before it jammed, much to the annoyance of Banksy who claimed it had worked properly in rehearsal, two years previously.

She may have dropped her chicken sandwich in shock, but the mysterious buyer soon realised that the whole affair had effectively tripled the value of the work. Sotheby's turned it all into a publicity coup, saying that it was the first time a work of art had been produced at auction, and taking the liberty of re-christening the piece, 'Love is in the Bin'.

But why tho? Banksy offered this Picasso quote to the Independent "The urge to destroy is also a creative urge" The whole shenanigan was described as 'Viral Performance Art'. At first glance it is an attack on the art establishment of which Banksy has apparently accidentally become a part. At second glance it looks like an incredibly cynical marketing ploy from a superbrand who actively supports and sustains his participation in the fine art market by running a Pest Control print authentication service.

But maybe there is a glance between the first and the second? A kind of squinty eyed, daft looking moment of clarity, that might take us away from the central paradox - that attacks on the hypocrisy of the art market revitalise the art market. Attacks on the commodity, make the best commodities.

Not so very long ago, Banksy was an outsider, a bona fide broke ass rebel in the wilderness preaching against spectacular society. So, when did Banksy first become a producer of dizzyingly expensive fine art? In the twilight of the Twentieth Century he was picking up national recognition in the press, but it was after the millennium that his street art began to work it's way indoors.

Between 2002 and 2006 Banksy pursued a vigorous courtship of the hipster art world, starting with Existencilism in LA. In the mid-noughties street art, in part thanks to the 'Banksy Effect', was in it's halcyon days. When celebs like Christina Aguilera started buying his work, the value soared. She spent a mere 50 grand on half a dozen prints. The wheels were set in motion and the mysterious mechanisms of the art market took over. By 2007 you could pay six times what Christina paid for a Bansky in 2006. The value of his work has continued to grow and grow.

This is the impenetrable process of value. Like a ten pound note, (even with lady Diana's face on it) a Banksy print has no intrinsic value whatsoever. But the collective belief in it's value is as real as a punch in the kidneys. Value is a thing without substance that has substantial effects. Effects like being evicted or having bailiffs at the door.

This is why people get so angry about Tracey Emin's bed - because they know it is no different to their own bed, but they cannot sell their own bed for a million pounds, they can barely sell their own labour for a few hundred quid a month. Nobody really knows how value works in any market, but in Fine Art in particular it's internal contradictions are highly visible.

The Fine Art market seems ridiculous to us peasants, it seems like a good kicking might bring it down, like a house of pretentious cards.

'Exit Through the Gift Shop' can be seen as a good kicking performed upon the hipster art market of Los Angeles. Mr Brainwash is a sort of Frankenstein's monster, created to take the piss out of LA art buyers, but it was a joke that backfired because somehow his work acquired value through the very process of making the film.

To be fair, Banksy never claimed to be against making money. In fact, he's rarely stated any firm position on anything, being a trickster god like Loki off the Avengers.

There has always been a touch of Robin Hood to Banksy's manipulation of the art markets, and it makes sense in the tradition of situationist rebel entrepreneurs like Malcolm Mclaren, to play the capitalists at their own game while simultaneously sawing off the branch you are sitting on. He has championed other artists, bringing them along with him, at events like Cans Festival in London. He has used his wealth to support anarchist groups in Russia, and to direct media attention to Palestinian suffering.

There is a long history of radical, auto-destructive art, going back to Man Ray and the Dadaists of the early 20th century. His 'Object to be Destroyed' was a metronome with a photograph of an eye attached to it. It was stolen from an exhibition in 1957 and shot with a handgun. But there is an even more relevant precedent from 1994, the KLF burned a million pounds on an island off Scotland. Where Banksy failed to destroy the value of his work, Bill Drummond and Jimmy Cauty successfully destroyed all the value gleaned from their success as pop group the KLF. Sadly, nobody got the punchline.

In neither case has the spectacular society suffered any kind of lasting damage. These radical gestures not only bounced off the thick skin of 'art as commodity', but they arguably fed into it, making it stronger. This is the paradox so well illustrated in Charlie Brooker's Black Mirror episode 'Fifteen Million Merits'. A young man subverts a reality TV show by threatening to kill himself live on TV with a shard of glass, he buys himself the time and space to speak his heartfelt message of anti-establishment rage.

Of course, they give him his own show and a penthouse suite, he spends the rest of his days holding a shard of glass to his own throat and raging against the machine to the delight of his audience. His rebellion is no longer an acceptable level of threat, it's an essential element of the system's survival. It somehow stops the flies from struggling in the web, to know that one fly has escaped on their behalf.

In the spectacle the eye meets only anti-art pranks and their price tags.

Ceci n'est pas un Banksy.

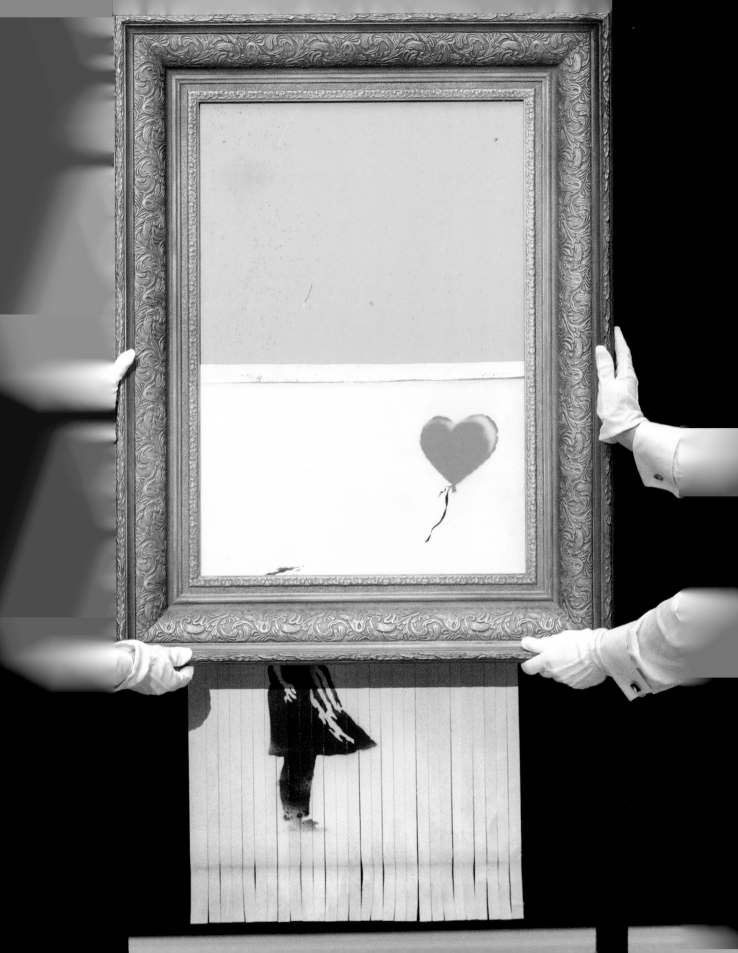

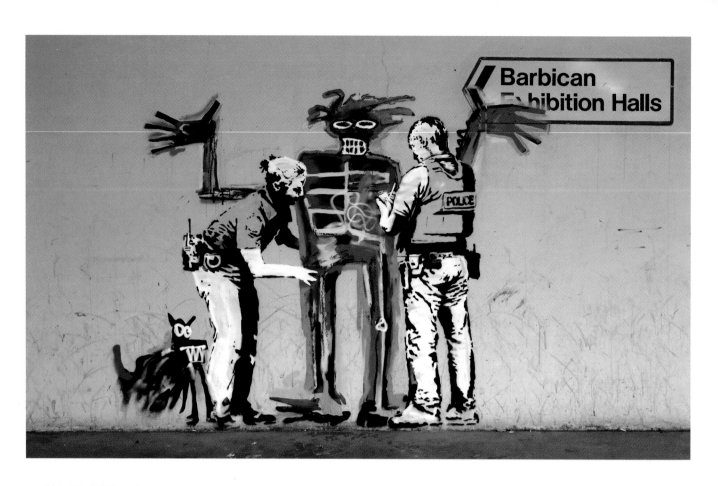

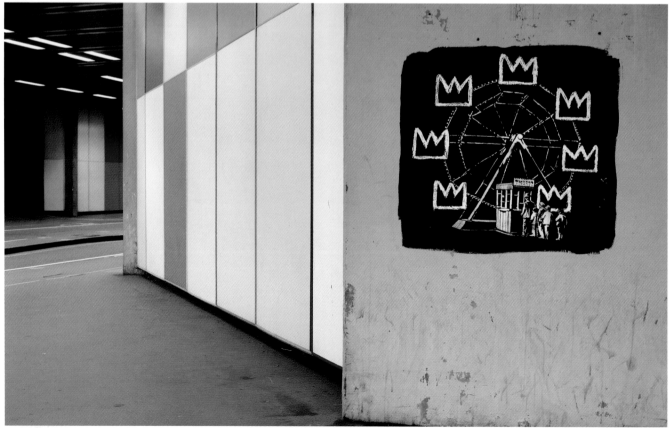

RESPECTTOALLTHOSETHATMADETHISBOOKPOSSIBLE

p1 New Orleans, Rex Dingler / **p2** Bethlehem / **p3** Bristol, Brian Garwood, Actual Colour / **p5** London / **p6** London, Alex Ellison / **p8** New York / **p10** London, Annar 50 / **p13** Detroit, Billyvoo / **p14** San Francisco, Glenn Arango & San Francisco, Glenn Arango / **p15** San Francisco, Glenn Arango / Folkestone, Sam Millen / **p17** Liveprool, Annar 50 / **p18** Dungeness, Karl Beaney / **p19** London, Kevin Flemen / **p20** New York, Sam Horine / Liverpool, Mark McGowen / **p21** New York, Luna Park / Hull, Jim Bolton / **p22** London, RomanyWG / **p24** New York, Sam Horine / **p26** London, Glenn Arango / London, Glenn Arango / Lyme Regis, brian@actualcolour.com / Liverpool, Embleton / **p27** Glastonbury, David Jones / London, Eddie Dangerous / London, Dan Browne / London / London, Wade M / Liverpool, Erokism / London, Glenn Arango / London, Silverfox09 / London, Andrew Skudder / **p28** London, Zub4ik / Boston, Ray Mock / **p29** Glastonbury, Brian Garwood / Los Angeles, Lord Jim / **p31** San Sebastian, Macu Masari / **p32** Chicago, Kevin Tao / **p33** Los Angeles, Ryan Cooper / **p35** New York / **p36-37** Port Talbot, Wales, Phil Rees/REX/ Shutterstock / **p38** St Leonards on Sea, Karl Beaney / San Francisco, Eva Blue / **p39** Bristol, Ray Mock / San Francisco, Glenn Arango / **p42** Cheltenham, Rich Devine / **p43** Valentine's Day Bristol, mgphotography.uk / **p45** London, Kriebel / **p47** London, A. Reid / **p48** London, Ray Mock / **p49** Pet Store, New York / **p50** Los Angeles, Lord Jim / **p51** Shanklin, Isle of White, Tim Rawling / Dalston, London, Phil Rushton / **p53** London, Eddie Dangerous / **p55** New York, Ray Mock / **p56** London, Eddie Dangerous / **p57** London, Kevin Flemen / Brett Landrum / **p59** London, Kevin Flemen / **p60** London, Kevin Flemen / **p61** London, Kriebel / **p63** Southampton, Martin Goble / **p66** Camden, London, Dr Andrew Hudson-Smith digitalurban / New York, Sam Horine / **p67** New York / **p68** Toronto, Tong Lam / **p69** Boston, Maris / **p70** Toronto, Tong Lam / **p71** San Francisco, Robert L. Archuleta / **p73-p81** New Orleans, Rex Dingler / **p74** Will Tuft / **p75** Rex Dingler / **p76** Will Tuft / **p77** Will Tuft / Rex Dingler / **p78** Sam Balen / **p79** New Orleans, Mark Gstohl / **p80** Will Tuft / Will Tuft / John d'Addario / **p81** Sam Balen / Rex Dingler / John d'Addario / **p82-83** London, Eddie Dangerous / New York, Lord Jim / London, Kevin Flemen / London, Kevin Flemen / London, Glenn Arango / London, Kevin Flemen / Bethlehem / Los Angeles, Lord Jim / London, Kieran McMillan / London, Sam Martin / London, Kevin Flemen / London, Kevin Flemen / London, Kevin Flemen / London, Sam Martin / **p86** Pet Store, New York / **p87** Pet Store, New York / Pet Store, New York / **p88** Detroit, Jamie Schafer / **p89** Toronto, Catherine Solmes / **p90** Liverpool, Embleton / **p91** Los Angeles, Mike Laan / **p92-93** Los Angeles, Brett Landrum / **p95** Bristol, Steve Bevan / **p96** London, Eddie Dangerous / Los Angeles, Glenn Arango / **p97** Vienna, Roland Peschtez / London, Kriebel / **p98** London, Glenn Arango / London, Kevin Flemen / **p101** San Francisco, Jonathan Percy / **p103** Glastonbury, Paul Holloway / London, Kriebel / Brighton, Mat Walker / San Francisco, Robert L. Archuleta / London, Alexandru Costatin / Glastonbury, Mark Crossfield / London, Sean Jackson / New Orleans, Infrogmation / Glastonbury, Robin Knight / New Orleans, Karen Apricot / Los Angeles, Lord Jim / **p104** Mayfair, London / **p105** Croydon, RomanyWG / **p106** London, Annar50 / **p110** Venice, Matteo Chiusso / **p111** Venice, Mara Guglielmi, Getty Images / **p113** Camden, London RomanyWG / Zub4ik / RomanyWG / Alex Ellison / **p115** Camden, London, Paul Le Chien / Sam Martin / Annar 50 / **p116** Camden, London, Sam Martin / Alex Ellison / **p117** London, Sam Martin / London, Dan Beecroft / **p118** Paris, Olivier Suon / **p119** Paris, Olivier Suon / **p120** Paris, Olivier Suon / **p121** Paris, Olivier Suon / **p122** Brooklyn, Marc Corsiglia / **p123** Detroit, Brian Day / **p124-125** Torquay, Brian Garwood / **p126** London, Joe at LDNGraffiti.co.uk / **p127** London, Dan Beecroft / **p128** London, Alex Ellison / **p131** New York, Luna Park / **p135** Los Angeles, Lord Jim / **p136-137** GrossDomesticProduct, Croydon, London, Rob Flack / **p138** New York, Alan Molho / Toronto, Kathryn Bailey / **p139** All images London, Joe at LDNGraffiti.co.uk / **p142** Los Angeles, Lord Jim / **p144** Los Angeles, Lord Jim / London, Jessica Webster / London, Kevin Flemen / London, Lydia Heard / New York / London, Silverfox / Bethlehem / London, Eddie Dangerous / **p145** Detroit, Brian Day / **p146** Los Angeles, Brett Landrum / **p147** San Francisco, Nimobimo / **p148** Lyme Regis, brian@actualcolour.com / **p149** Jerusalem, Peter E. Mulligan / **p151** Bethlehem / **p152** Bethlehem / **p153** Bethlehem / **p155** Bethlehem / **p156** West Bank, Michael W. Rose / **p157** Bethlehem / **p158-159** Bethlehem, Michael W. Rose / London, Glenn Arango / London, Kevin Flemen / London, Fabio Venni / Utah, Stephen Mack / London, Kevin Flemen / London, Eddie Dangerous / London, Kriebel / Utah, Kristin Abercrombie / Los Angeles, Lord Jim / London, Kevin Flemen / London, Silverfox / Detroit, Rebecca L. Solano / London, Stefano Blanca / London, Kevin Flemen / London, Sam Martin / London, Anna C. / **p163** London, Ray Mock / **p164** London, Sam Martin / **p165** London, RomanyWG / **p167** San Francisco, Jonathan Percy / **p170** New York, Sam Horine / London, Nick Pickard / **p171** Bristol, Marc Leverton / **p173** Glastonbury, Peter York / Glastonbury, Audrey Scoulla / **p174** Glastonbury, Kev Walker / Glastonbury, Kev Walker / **p175** Glastonbury, Tim Parkinson / Tim Parkinson / Darren Cornwell / Warren Christmas / Mark Walton / Mark Walton / Fussy Onion / **p178** London, RomanyWG / **p179** Camden, London, RomanyWG / **p181** London, Alastair Mackay / London, Dan Beecroft / **p183** London, Dan Beecroft / **p184** London, Dan Beecroft / **p185** London, Sam Martin / New York, Ray Mock / London, Kevin Flemen / San Francisco, Eva Blue / London, Kevin Flemen / London, Kevin Flemen / London, Kevin Flemen / Utah, Joe Castilo / London, Kevin Flemen / London, Brian Garwood / Napoli, Barbara Roncoletta / **p187** Toronto, Tong Lam / **p189-195** Cans Festival, London / **p196** London, RomanyWG / Bethlehem, Anneke Schapelhouman / **p197** Brooklyn, New York, Ilona Dabrowska / **p200** Dungeness, Karl Beaney / Chicago, Bryan Chang / **p201** New York, Clay Hensley / **p203** London, Richard Kuoch/PodgyPanda / London, Kevin Flemen / Bristol, Ben Alfred Hockman / **p205** London, Embleton / **p206** London, Glenn Arango / London, Glenn Arango / **p207** London, Kevin Flemen / **p208** Alabama, Ginger Ann Brook / **p209** San Francisco, Jonathan Percy / **p210-211** London, Kriebel / **p212** Toronto, Tong Lam / **p214-215** London, RomanyWG / **p216** London, Kevin Flemen / **p218** Bristol, Bridge Farm Primary School, Marc Leverton / New York, Ray Mock / **p219** Melbourne, Will T. Dennithorne / London, Sam Martin / **p221** New York, Ray Mock / New York, Ray Mock / **p223** London, Kriebel / **p224** London, Alastair McKay / **p225** Gaza, Daryl Crowden / **p227** Manhattan, Ray Mock / **p228** Bed Stuy, Williamsburg, Ray Mock / Upper West Side, Ray Mock / Sunset Park, Nic Garcia / Queens, Ray Mock / Midtown, Stephen Kelley / Williamsburg, Stephen Kelley / West Side, Stephen Kelley / Delancey, Stephen Kelley / Brooklyn, Amy Feezor / **p229** All city, Daniel Albanese / **p230** Lower East Side, Daniel Albanese / Yankee Stadium, Ray Mock / **p231** 23rd Street Thrift Store, Ray Mock / All City, Nic Garcia / All City Alan Molho / Brooklyn, Amy Feezor / Queens, Nic Garcia / Queens, Dana Panda / **p232** South Bronx, Ray Mock / East New York, Ray Mock / **p233** Meatpacking District, Ray Mock / Daniel Albanese / Ray Mock / Helen Alfvegren / Daniel Albanese / **p232** Hell's Kitchen, Scott Lynch / Queens, Ray Mock / **p233** Lower East Side, Ray Mock / Bowery, Ray Mock / Greenpoint, Stepehen Kelley / East New York, Ray Mock / Tribeca, Daniel Albanese / Ray Mock / Tribeca, Stephen Kelley / **p236** Yankee Stadium, Ray Mock / Manhattan, Daniel Albanese / **p237** Coney Island, Clare Kopelakis / **p238** Weston-Super-Mare, Kathryn CC BY-ND 2.0 / **p239** Weston-Super-Mare, Brian Garwood, Actual Colour / **p240** Dismaland, Weston-Super-Mare, Brian Garwood, Actual Colour / Radames Ajna, Creative Commons / Brian Garwood, Actual Colour / Kent Wang, Creative Commons / Kathryn CC BY-ND 2.0 / Platysplug Creative Commons / **p241** Dover, Pete Covill / **p242** Bethlehem, Walled Off Hotel / **p243** Bethlehem, Walled Off Hotel / **p245** London, "Love Is In The Bin", Ray Tan/REX/Shutterstock / **p246** Basquiat, Barbican London, Alex Ellison / **p248** London, Arkadiusz Waloch / Additional images by G. Shove / Many thanks to all the photographers who contributed worldwide. / All images are the copyright of their respective owner. / None of the photographers whose images are used under the Creative Commons attribution licence either endorse us or the title itself.